ENCOUNTERS

'Vision is the key:
having the eye to
frame something
beautiful, meaningful
and truthful.'

For Alberto,
who taught me
to always follow
the light.

LEVISON WOOD
ENCOUNTERS

A PHOTOGRAPHIC JOURNEY

ilex

CONTENTS

I have spent the majority of the last ten years in the wild and on the road, travelling in more than a hundred countries. Whether filming a documentary, writing a newspaper article or researching a book, I have always been accompanied by my camera. It has been a time of great and rapid global change, and I have been lucky enough to witness many of these changes at first hand and document them in images that preserve these moments in time. In truth, the photographs in this book represent just a fraction of the thousands of people I have met all over the world. For me, every single picture conjures a memory of an individual, a family or a whole community, and the stories that they shared with me. I hope this collection of images can go some way towards distilling the diversity and wealth of human experience that I have been fortunate enough to encounter on my journeys.

In 2009, when I was in my final year of service in the Parachute Regiment in the British Army, I decided to buy my first 'proper' camera, a Nikon DSLR with a few good lenses. My intention was to learn the intricacies of the art form. I never had any formal photography training though, and most of what I learned came from books, imitation and lots of trial and error.

When I left the army in the spring of 2010, I decided to go and spend a few months living in Mexico, a colourful country teeming with photographic opportunities. It was a good idea in theory, and I was very excited to turn what had been just a hobby into a vocation. However, my plans were scuppered when my camera and all my photography gear were stolen in the first week of my trip. It was ruinous financially (I couldn't afford the insurance) and the loss threatened to end my dream of becoming a travel photographer. But, like many disasters, it came with a silver lining and a fortuitous opportunity. As a result of the theft, I was introduced to a Mexican studio photographer called Alberto Caceres. He encouraged me to continue pursuing my dream and not only loaned me his own camera, but also took me under his wing, ultimately becoming both my photography mentor and a lifelong friend.

Between 2010 and 2013, I undertook a number of expeditions and assignments around the world. I drove 10,000 miles through 27 countries, from England to Malawi, photographing people across Europe, the Middle East and Africa. I rode on horseback across Northern Afghanistan and climbed mountains in Iraq. I walked across Madagascar, trekked in the Arctic and scaled volcanoes in Patagonia, always learning new skills with my camera.

I took my inspiration from all around: not just the places I was visiting but also people who I looked up to. When I was back home in the UK, I trawled through art galleries, devoured exhibitions and stared at the pages of an enormous stack of coffee-table books that I had collected. I was mesmerized by the work of the great photographers of our time, heroes like Don McCullin, Steve McCurry and Sebastião Salgado, and dreamed of following, however modestly, in their footsteps.

I started to publish some of my images in magazines and guidebooks, and on the side, to make ends meet, I photographed weddings and even took a few family portraits. The hard work paid off, and in the winter of 2013, I was commissioned by Channel 4 to set off on a tremendous adventure: to walk the length of the River Nile. It was the big break I'd desperately wanted, and knew I needed, to commit fully to the lifestyle I so craved. So, I spent my savings on a brand-new Leica M240 camera with a single 35mm lens, and, almost a year later, came back with several thousand images from that grand continent. I hosted a well-received exhibition called *Visions of Africa* in a prominent Pall Mall gallery in London. As a result, Leica – my dream camera brand – invited me to become an ambassador. Of course, I was very happy to accept.

Since 2015, I have embarked on many more long walking journeys, covering the length of the Himalayas, all of Central America, the Caucasus Mountains and most of the Middle East. I've undertaken dozens of photography assignments for several broadsheets and other prominent publications, and to be honest, I still have to pinch myself at how lucky I have been.

When I was first asked to compile this book, I was faced with the rather daunting task of navigating my way through dozens of hard disks, computer files and broken old laptops, and sifting through something like 50,000 images. I'm afraid to say I'm not particularly organized when it comes to my image archives, and I suppose my only excuse is that I've been quite preoccupied this last decade with the rather time-consuming business of travelling and photography itself, which hasn't left much time for sorting my files.

'A photograph can be hugely powerful. One image can change public perception, bring empathy to a cause and tell an untold story.'

Even when I had longlisted, shortlisted and eventually settled on a final 140 images for publication, an equally challenging job was to then somehow arrange this selection into themes and chapters. It was a difficult process, particularly as I didn't want to simply create a geographical romp around the world. Nor did I want to just order the images chronologically; I've already written a number of travel books which fulfil that role.

After much deliberation I settled on the four themes that I felt most encapsulated my travels. Of course, these themes are all intertwined, and in fact many of the photographs could easily be placed in any one of the categories I chose. Indeed, I have spread out some groups of images across the themes where the story behind them needs to be expanded. In doing so, I hope to demonstrate a certain connectedness I've observed in people all over the world.

In this book, I examine the following:

Frontiers: representing the isolated, remote and wild places where people and nature coexist and collide.
Conflict: exploring areas scarred by war and mired in desperation.
Heritage: discovering how different cultures and ancient ways of life go on in spite of modernity.
Community: understanding how society is bonded together and how humanity thrives.

I see my photography as part of a wider method of storytelling, one facet of a bigger process that includes film-making, writing and seeking to understand a place through immersion – yet always with people at its heart. My style of reportage, if one can call it that, has always been raw, unfiltered and often chaotic. I try to express a whole story within the image by framing the subject – a human being – against a backdrop of either their own making, or the environment in which they are inextricably embedded. I rely less on technicality than a strong and powerful setting. I admit that there are many places I have been to where it would have been difficult not to take a great photograph.

The majority of the images in this book were taken on long expeditions in remote places. They were often captured under difficult circumstances: at high altitudes, in inaccessible valleys, in jungles, deserts and war zones. More often than not it was very hot, very cold, very wet or very dangerous. Usually it was a combination of the above.

The trick, of course, is getting to these locations in the first place. A photograph is not simply a button pressed. It is the sum total of months of planning and

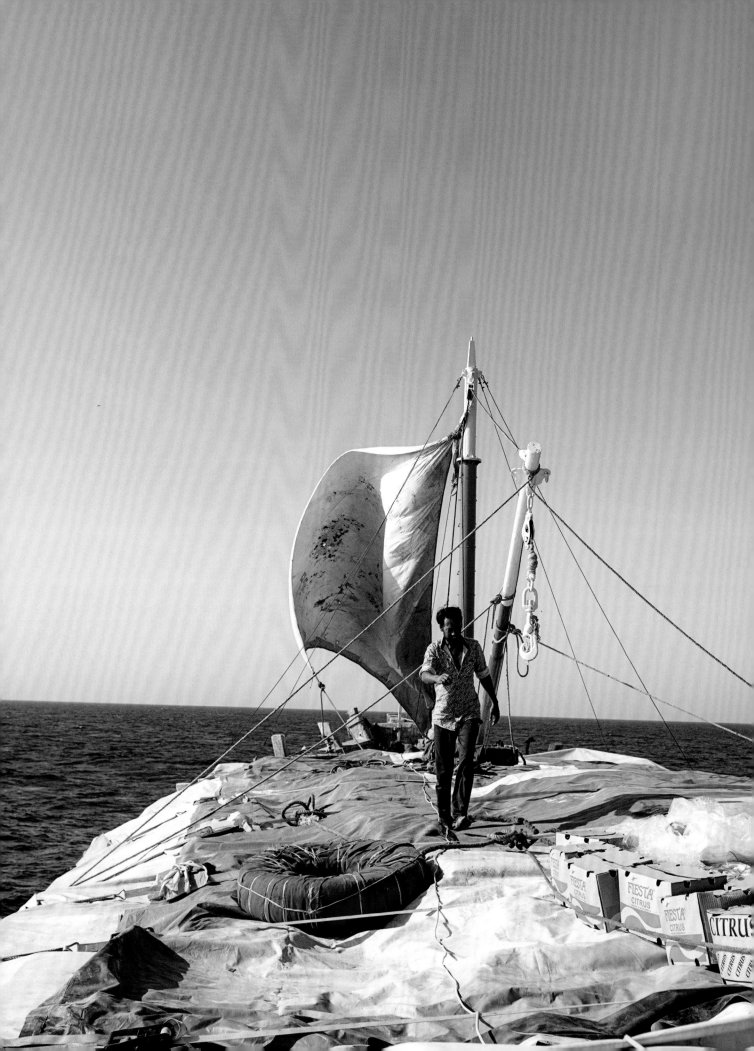

'Photography should be a mode of storytelling. It should highlight some unknown or unseen truth about the world.'

preparation: money spent on visas and permits, local fixers and guides, and vehicles – be they camels, dugout canoes or, in some cases, hitched lifts on battle tanks on the front line. The images I have captured in places like Syria and Iraq, were, in effect, the result of many years' experience living and working in war zones. For me, photography is about living your work: it's about pouring your heart, soul (and usually wallet) into a project. It's about taking risks and living a life that defies the norm, not for the praise or the glory (and certainly not for the money), but instead for the deep joy of what it is to experience true freedom, and the ability to share that in some way with those for whom these places remain inaccessible.

This book is, necessarily, personal to me and my experiences. I have not attempted to cover the whole world, or even any significant portion of it. Instead, I have simply examined the places and encounters that I have found most fascinating on my travels. This means that some countries are featured more heavily than others, and also, inevitably, that what I share here comes very much from my perspective – a Western perspective, with all the baggage that that entails. Just as an Afghan or Brazilian photographer might see London or Paris on a drizzly November day as exotic and different, I seek the sublime in places that I consider to be far away, distinctive and remote, because that is what travel is all about: seeking wonder in the unknown, the strange, the unfamiliar and the colourful.

There is no political agenda in this book, nor does it attempt to right the world's wrongs. As a photographer, I try to show both sides of the story where possible, and where I do not, it is not because of my own views. Ultimately, my images are a reflection of my voyages and the people I have met. That is what my experiences have always been about: people. I never set out to break world records or make TV shows. Of course, I am delighted that others take joy from seeing my photographs and reading my books, but for me, my journeys – and the resulting images – centre around the people I have met, and so that is what this book is about.

We live in turbulent times, and it seems that news reports are full of despair. We are constantly subjected to an information overload, attached to our phones and forever online. The digital revolution, and the ease with which we can now travel, means that the world

A Cargo Dhow on the Gulf of Aden, Arabian Sea, 2017
These traditional wooden sailing boats carry goods across the Arabian Sea from Oman and Yemen to Somalia. The links between the Arabian Peninsula and the Horn of Africa date back thousands of years. I travelled by dhow from the coastal city of Salalah, Oman, famed for its frankincense, to Bosaso in Puntland, Somalia, across the most pirated waters in the world with a crew of Gujarati sailors. This ship carried a surprising cargo of condensed milk, but often a seemingly innocuous shipment is used as a cover for smuggling illicit goods and weapons.

seems to be shrinking at rapid speed, and is changing beyond all recognition. With the outbreak of the global coronavirus pandemic earlier this year, the fragility of our existence has been exposed. We appear to be more vulnerable than ever to social disruption and economic meltdown. We are in the grip of a climate emergency, where our planet's resources are being plundered at a rate never experienced before. More and more people are abandoning the old ways to live in cities that threaten to eat away at the last remaining wilderness areas. Traditions are forgotten and cultures homogenized. Humans have destroyed vast swathes of the rainforests and polluted the seas, wiping out entire species in the process. Wars continue to rage, and tribalism has taken over both politics and conflict, as ever-increasing polarization divides communities. There is a wealth disparity whereby the wealthiest one percent of the world's population earns more than the combined earnings of the sixty percent of people at the other end of the scale. Again and again, we are failing to learn lessons from the past, and humankind continues to make the same old mistakes. It would be easy to think that we are staring over the abyss.

And yet, in spite of the negative coverage and omnipresent fear, there are reasons to be positive. Statistically speaking, humanity has never had it so good. Technological advancements in healthcare, food and infrastructure mean that people live longer, eat better and have access to new and ever-improving medicines. Child mortality across the world has been reduced. Poverty, although still widespread, is nowhere near as rampant as it was only a generation ago. Education is improving everywhere around the world. There is less violent death, more international cooperation than ever before, and more people, especially young people, recognize the need for urgent action: particularly when it comes to environmental issues and social justice.

But, as the saying goes, good news doesn't sell, and so we tend to overlook the advances we have made in the first quarter of the 21st century. That's not to say that we should ever be complacent: the world is full of challenges that need addressing. But I believe that the human story, the human spirit, and the human capacity to fix these problems has never been greater. Now, more than ever, it's important to retain perspective, to seek out a balanced viewpoint and try to understand the 'ground truth' without sensationalism, without agenda and without self-absorption. That's what the following images aspire to do: to show the truth of change, in all its complexity.

Shepherd Girl, Ethiopia, 2010
Children as young as five are employed in the Semien highlands of Ethiopia to guard their family flock against wild animals and thieves. It is an uncompromising tradition, but in these highland communities, where the people rely on their livestock to survive, it seems there is no other choice. Despite the tough living conditions, this young girl had nothing but innocent happiness on her face.

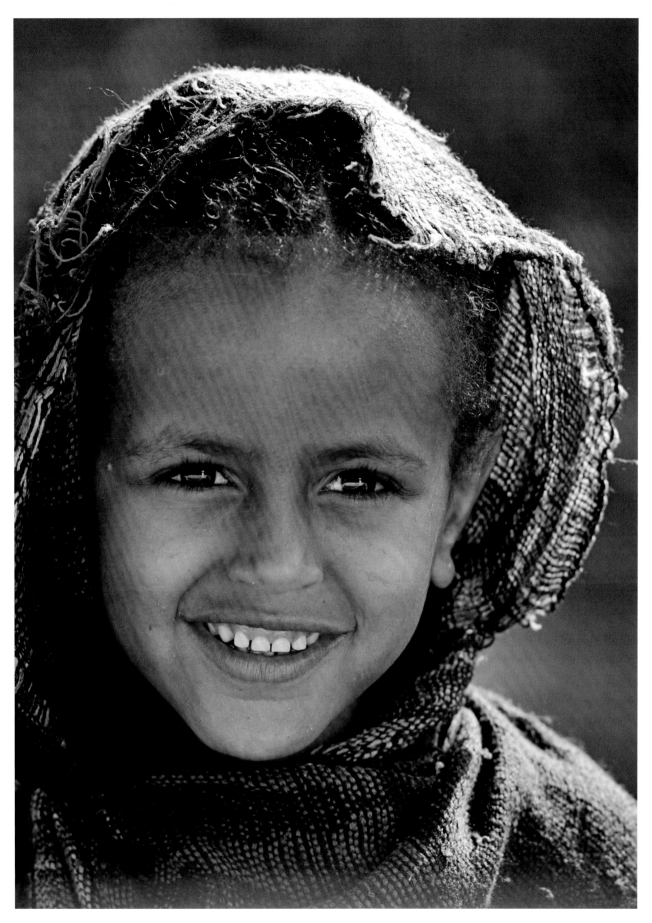

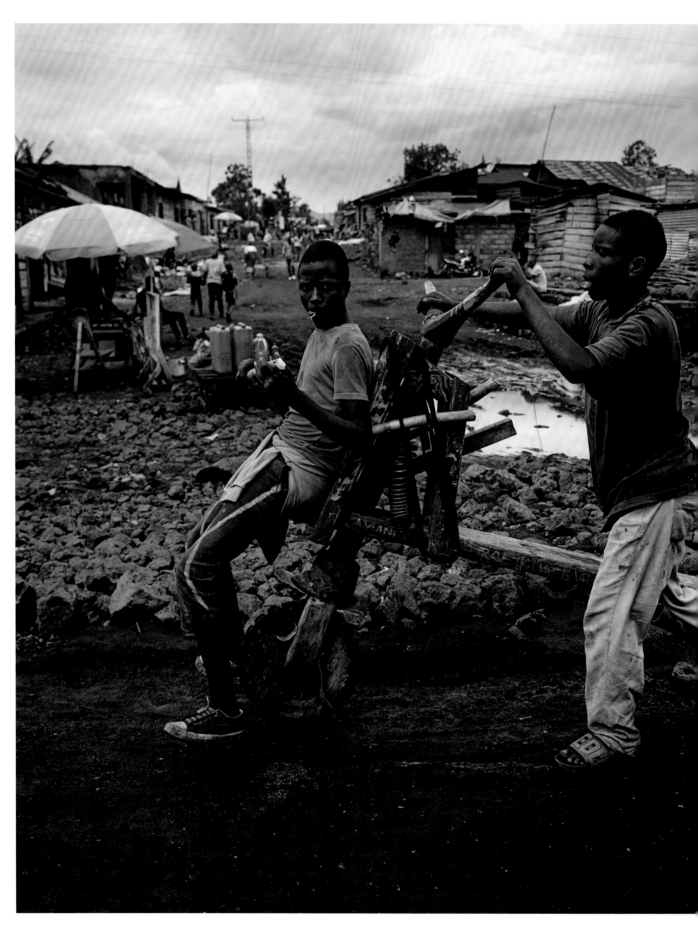

When travelling, I meet individuals and try to document their lives, hopes and aspirations. One story comes to mind: I was in the Syrian capital of Damascus in 2018 and the civil war was in its seventh year. The Assad regime was on the verge of defeating ISIS, and I was filming a documentary about the Middle East. The ancient city was plastered in images of the dictator Bashar al-Assad, his face looking down from flags, posters and billboards wherever you went. Every evening I could hear the roar of gunfire, artillery and mortars, as the war seethed on beyond the city walls. But inside the old city, life was bravely carrying on. People were still getting married, restaurants played music and shops were open for business, even if nobody was buying very much. One afternoon, as the sun filtered through the medieval alleyways, I met a local shopkeeper sipping sweet tea from a chipped mug. We fell into conversation about war and peace and hopes and dreams. I confessed how surprised I was to see Damascus so bustling and alive despite the ongoing conflict.

'We can't put our lives on hold forever. War is just an interlude,' he said, with a shrug. 'One day, when it's over, my family will return, we'll all be friends and live together.'

I was silenced by his stoicism and sense of hope; even in the most brutal of circumstances, he, and most like him, looked beyond the propaganda and beyond the negativity, towards a positive future.

Wherever possible, I have sought to offer a true reflection of what I experienced, seeing beauty in humanity. The world is full of interesting people, and I have found that most of them are good, kind and hospitable. Everywhere I travelled, people took me in, fed me and looked after me, often in the most unlikely of places and in the most unusual of circumstances. This book is a celebration of exactly that: encounters with strangers. It's my way of saying thank you.

Boys with a *Chukudu*, Democratic Republic of the Congo, 2019
These wooden bicycles form the mainstay of Congolese transport in the hectic streets of Goma, the capital city of DRC's eastern North Kivu province, near the Rwandan border. Despite rampant poverty, the local teenagers demonstrate remarkable resourcefulness. These unusual contraptions usually take three days to build and can last for two to three years. I was told *Chukudus* can carry up to 800kg (1,750 lb) of cargo.

FRONTIERS

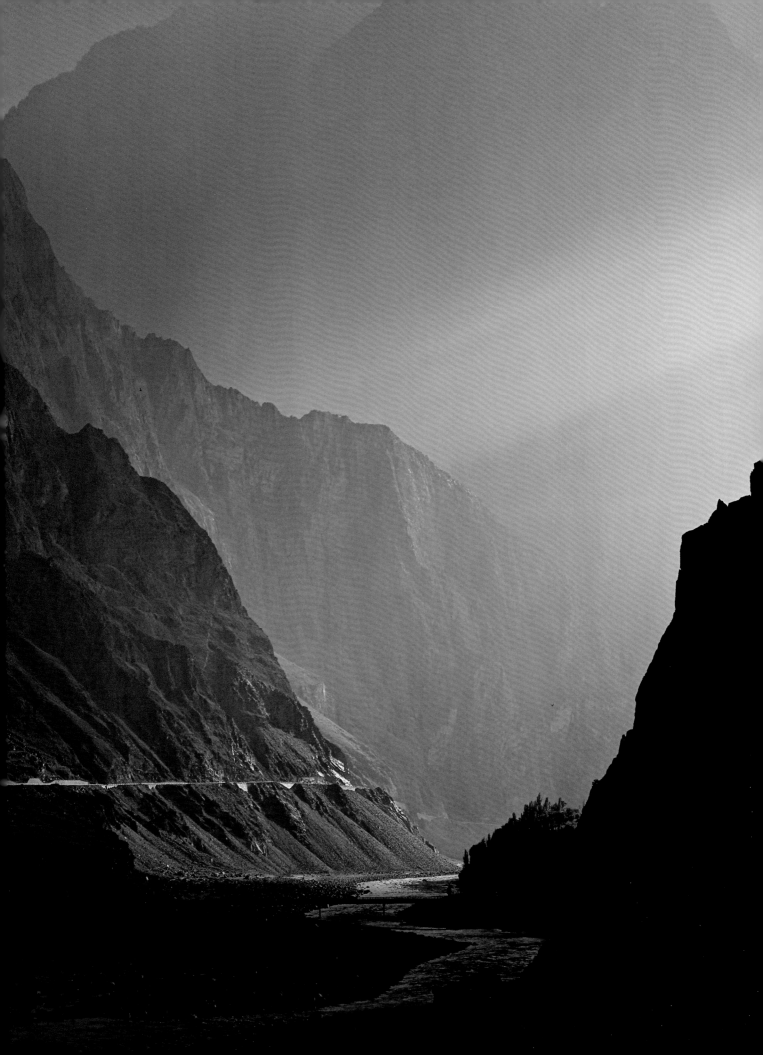

FRONTIERS

Frontiers are real or imaginary lines: border zones, and areas where human civilization meets the rich mysteries of the wilderness, nature and isolation. These are the places to which an explorer must travel to seek the unknown. Over the past ten years, my journeys have taken me to some of the least accessible places on our planet. These regions are often hostile and unwelcoming to the traveller, whether because of difficult terrain or political turmoil. I've been fortunate enough to travel across some of the wildest borders on earth, boundaries not just between countries but between the known and the unknown. In these borderlands, some of the world's most remote communities are found, their people living in some of the most inhospitable environments on Earth and fighting tooth and nail to survive. But there is often a remarkable symbiosis between these people and the nature around them. My photography aims to capture both the majesty of these spectacular corners of the globe, and the daily struggle of their often misunderstood inhabitants.

What is a frontier to one person may, of course, be a home to another, which outlines the subjective and personal nature of my quest. But, for me, looking in from the outside, borders hold such an attraction precisely because they are so difficult to grasp. It's only relatively recently that we as humans have drawn lines on a map and created countries and international boundaries. In many parts of the world, these lines have existed for a hundred years or less, and for those that live there they may mean very little, if anything at all. For the vast majority of human existence and understanding, borders were just the edges of our physical wanderings. They were mountain ranges, rivers or deserts: natural obstacles that represented the limit of our knowledge and control. Beyond the border lay other tribes, hostile foreigners and dangerous forces, and only the most curious of wanderers would venture there.

Frontiers are also the places where magic happens. Here, nature still has the upper hand and so people, forced to innovate, have the opportunity to push their limits and pit themselves against the unknown. Frontiers attract pioneers, voyagers and adventurers: people who relish unpredictability and embrace risk. These are the people who drive progress in the world.

Hunza River, Pakistan, 2015

As the world becomes more globalized, frontiers move; the natural wildernesses are shrinking due to human expansion and development. Advances in technology mean that today, anyone with an internet connection can explore a wilderness or remote region without even setting foot there. Once-great forests have disappeared, deserts have been exploited and people have conquered and settled in almost every landscape. It seems, at first glance, that there is nowhere left to explore. What does this mean for the natural human urge to discover new places that is a powerful drive for so many of us?

I think it's a curiosity that is ingrained in our DNA: an almost primeval need to know what is over the next hill or across a distant sea. Even in the modern age, that desire remains, and for me, it's always been important to see with my own eyes what a place is really like. I hope to share that real and lived experience through my photography. I have been fortunate enough to make it my life's work to try and redefine exploration in the modern age. My belief is that discovery is a never-ending process. The world is still a big place. Borders open and close, and people continue to move, migrate and wander. With each new frontier, we not only have an opportunity to learn about others but also about ourselves and where we came from.

Each place has its own unique story, and every frontier has its challenges, be they environmental, physical or political. I have had the pleasure of being guided across frontiers by the people who know them best. I've travelled with Bedouin nomads across the Sahara Desert and with reindeer herders in Siberia. I've been lucky enough to meet the indigenous communities of the Amazon and the Congo, to spend time with the tribes of the Caucasus and Central Asia. In Afghanistan, I met the Kyrgyz people, cut off from their homeland by newly created borders in the aftermath of the Cold War. In Kashmir, I met nomads who used to roam freely over the Himalayas, but now, due to political upheaval, are stranded in these hinterlands. Frontiers exemplify human hardiness, ingenuity and capacity for adaptation, but they also demonstrate the fragility and complexity of the modern world.

When approached with respect, understanding and preparation, frontiers can provide a photographer with exceptional opportunities for images, while at the same time offering the explorer the chance to discover their own potential. Places such as the Wakhan Corridor on the border between Afghanistan, China and Tajikistan took months of planning to get access to. Similarly, to meet the Emberá tribe in Panama's Darién province required time, energy, resources, contacts and money. Tracking rebel tribes in Yemen was hardly a doddle either.

'Frontiers can be inhospitable, but they can also provide magical scenes for photographers. The boundaries of human civilization can often hold some of the best stories of resilience, ingenuity and strife.'

Once you have made the journey, photography in these areas presents its own problems. Extreme temperatures, monsoon rains and flooded rivers can stop even the most determined photographer in his or her tracks. There are often few opportunities to charge batteries, back up your images or maintain your equipment. Keeping on top of your image archive becomes a high priority and failure to do so can mean a wasted fortnight. Frontiers can sometimes be lawless places, too, and drawing unnecessary attention to yourself and your expensive photography gear is not always advisable.

When I walked the Nile, I came across many frontiers, some physical, others more abstract. Heading downstream through South Sudan with my companion, Boston, we reached the town of Juba, the only real 'civilization' for hundreds of miles. It's known as the 'Wild West of Africa'; everyone is armed and there is a constant sense of unpredictability and nervous excitement. As a visitor, you never feel settled or comfortable. While crossing the only bridge in the entire country, we were arrested by a gang of gun-toting soldiers, put into the back of a truck and taken to a dark compound reserved for torturing prisoners. When I asked on what charges I was being detained, the gruff gunman shouted that I must be a spy, because I had a camera. It was a stark reminder of just how fragile life can be in places on the edge of safety.

Even as the world becomes more connected and we are left with fewer mysteries, frontiers will always exist. As some places open up, others shut down, and borders shift and change. Civilizations have evolved over millennia, each with their own bonds, myths and history. Frontiers, for better or worse, are the places where cultures collide, civilizations clash, and identity is preserved. They are the most enigmatic places on earth.

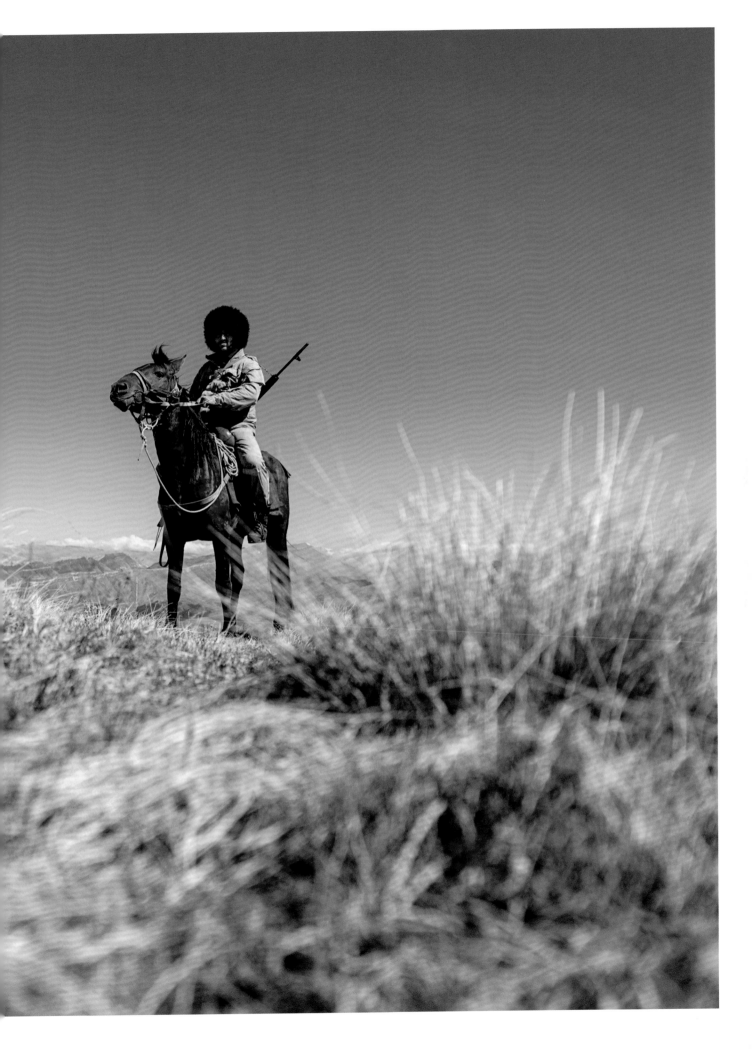

⬉ Zurab Chokh, Dagestan, Russian Federation, 2017

Most Dagestani men are born horsemen and have roamed the plains and mountains of this remote North Caucasus republic for hundreds of years. They have a reputation as fierce warriors. When out riding, all the men bear arms and wear the traditional woollen hat known as a *papakha*. Zurab, my guide, led me over the high passes from his village to the nearest town, always keeping an eye open for bears, bandits … and the Russian military, who frequently raid the mountains in a bid to subjugate the more troublesome Islamic regions. It's a conflict that has raged for centuries, going back to the 1780s.

'Despite increasing globalization and ever greater knowledge, frontiers continue to exist.'

→ Fisherman, Al Mahrah, Yemen, 2017

Along the jagged coastlines of Yemen's Al Mahrah governorate, fishermen eke out a living catching swordfish to survive in a country plagued by civil war. These fish can reach 3m (10ft) in length and weigh half a tonne. Despite being a struggle to catch, just one will feed a family for weeks.

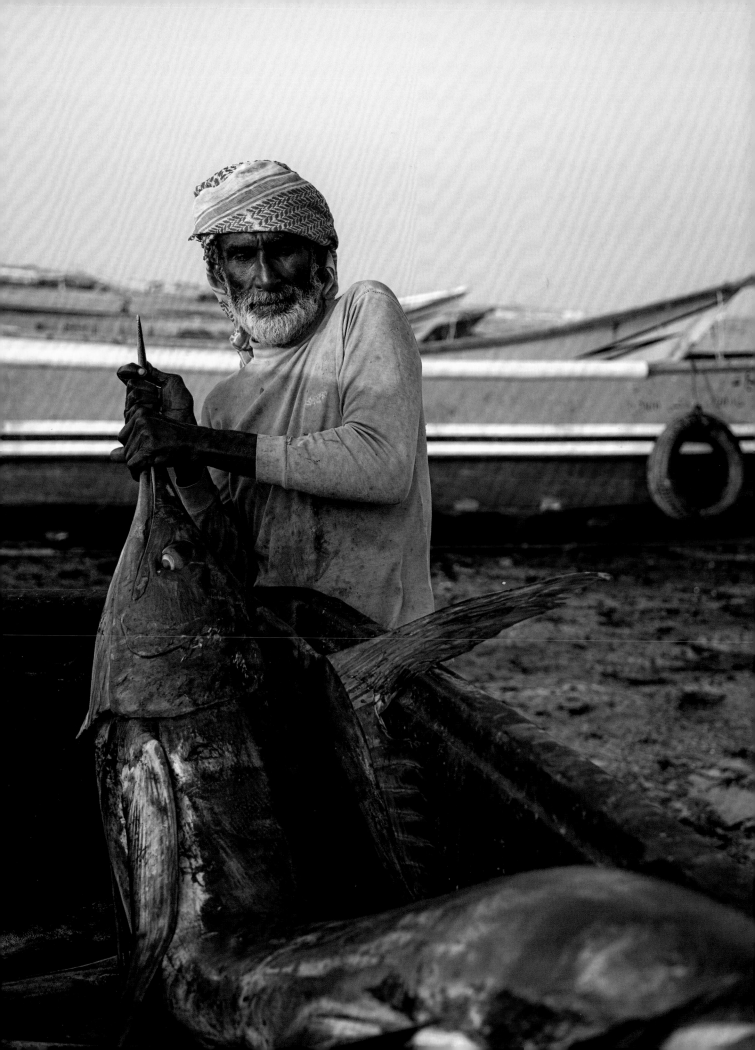

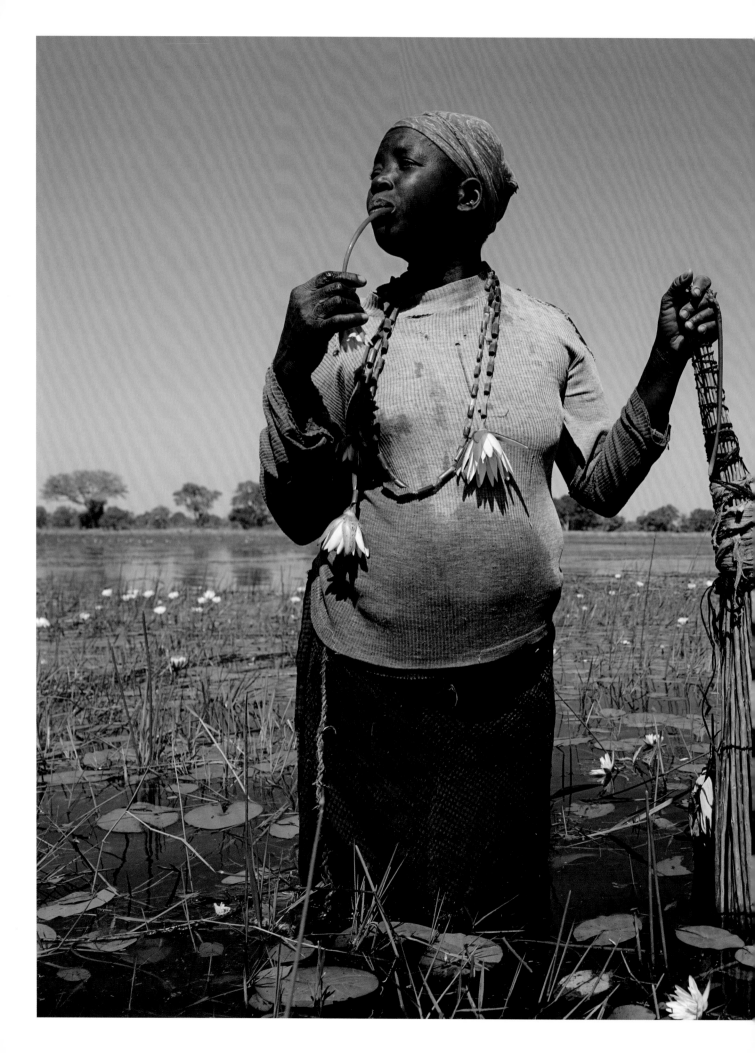

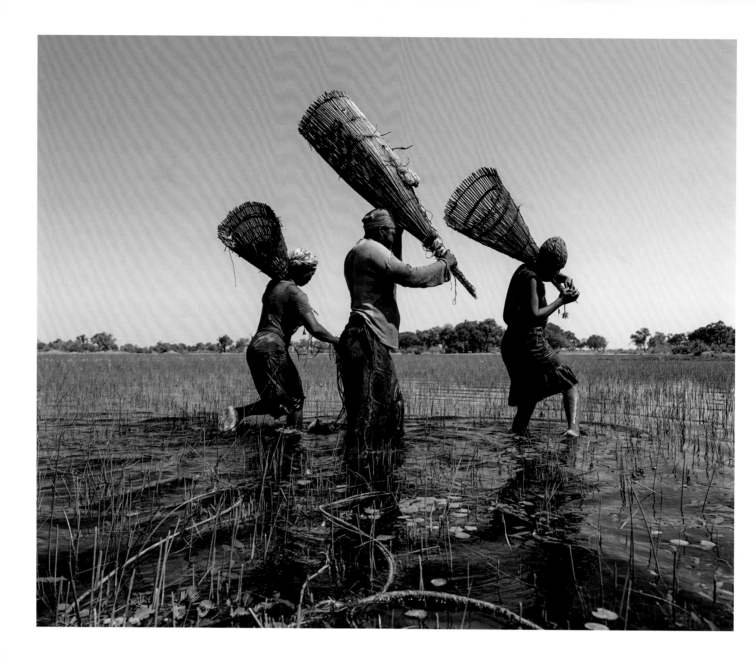

↖↑→ Fisherwomen, Botswana, 2019

Women of the San and Bantu communities fish using traditional handmade baskets on the edge of the Okavango Delta. When they catch nothing, they resort to eating the flowers and stems of water lilies. The stoicism of these women is remarkable. Despite constant danger from attacks by hippos, crocodiles and elephants, the women go out daily to try and provide food for their families. While fishing they sing local songs, which not only provide entertainment but also scare away the wildlife. I spent a month walking across Botswana following a herd of elephants to try to understand more about human–wildlife conflict and how people survive on the frontiers of nature. One of these women told me that she had tragically lost her father to a charging elephant nearby just a few years earlier. Many locals I met said that they should have a right to kill the elephants, but this lady disagreed, believing the elephants have as much right to exist as us, and that humans are just guests in the elephants' ancestral land.

↘ Mundari Cattle Camp, South Sudan, 2014

This captured moment of serenity shows how, even in the midst of a civil war, there can be oases of peace. I visited South Sudan on five occasions over four years and, after many months of trying to capture the essence of this indigenous community, I was very happy with this image, taken near the town of Bor. As war raged all around, the pastoralist Mundari people fled their homelands and sought refuge in the Sudd swamps of the Nile, swimming their cows across crocodile-infested waters to find sanctuary among the floating papyrus islands, where their treasured long-horned cows would be safe.

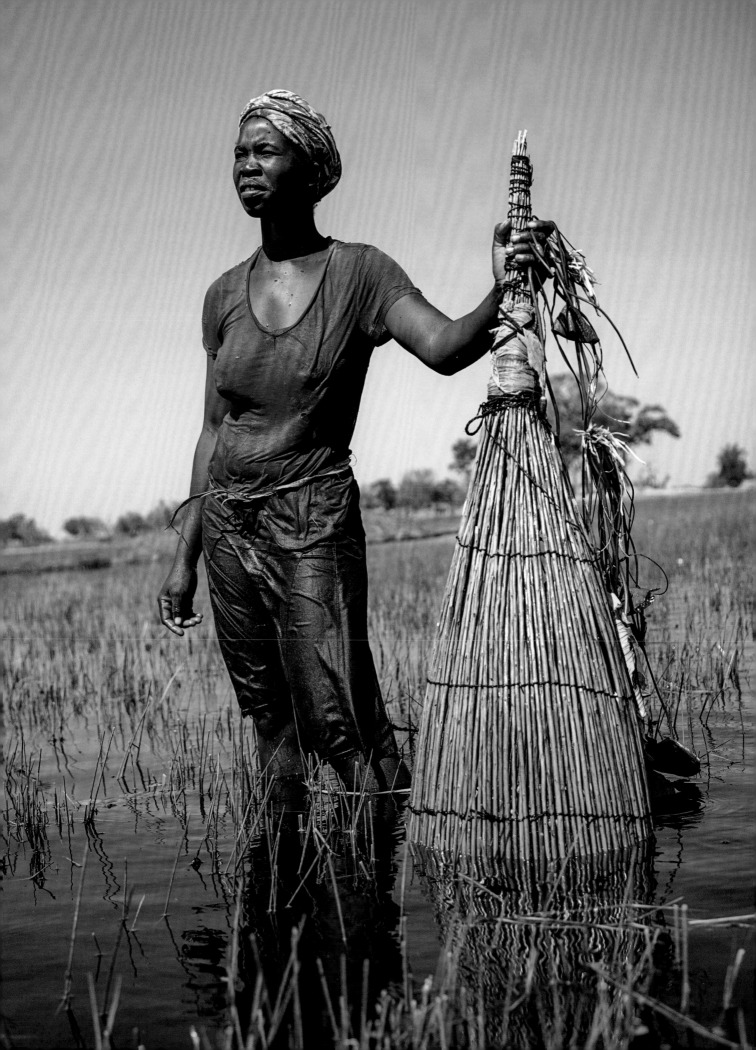

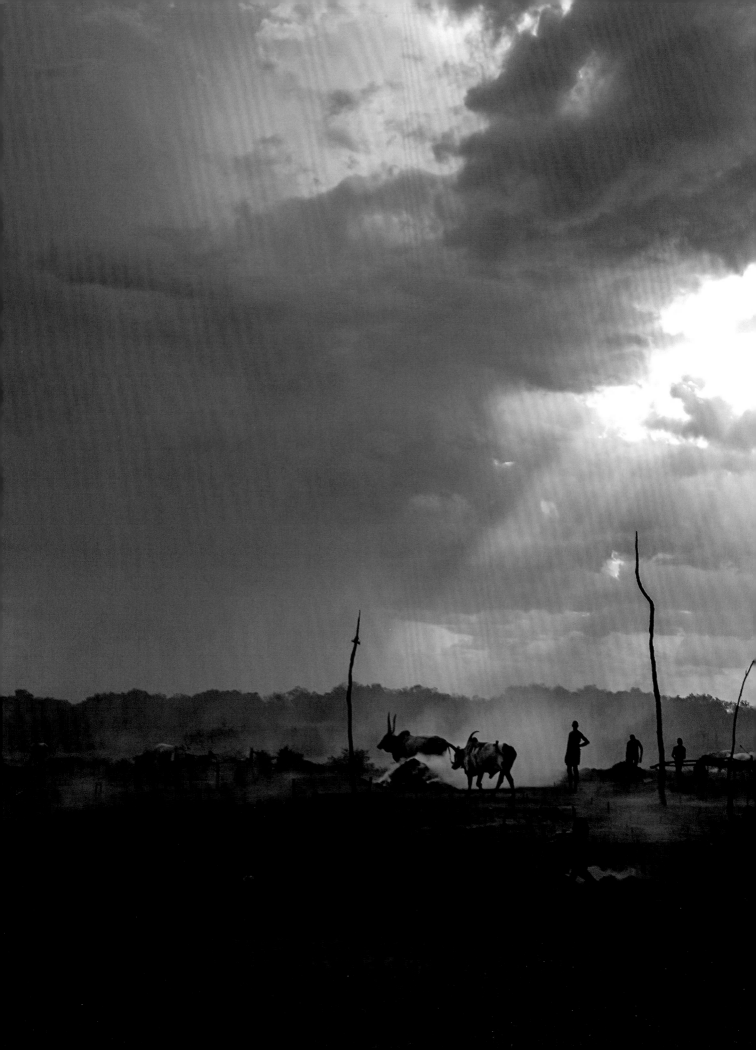

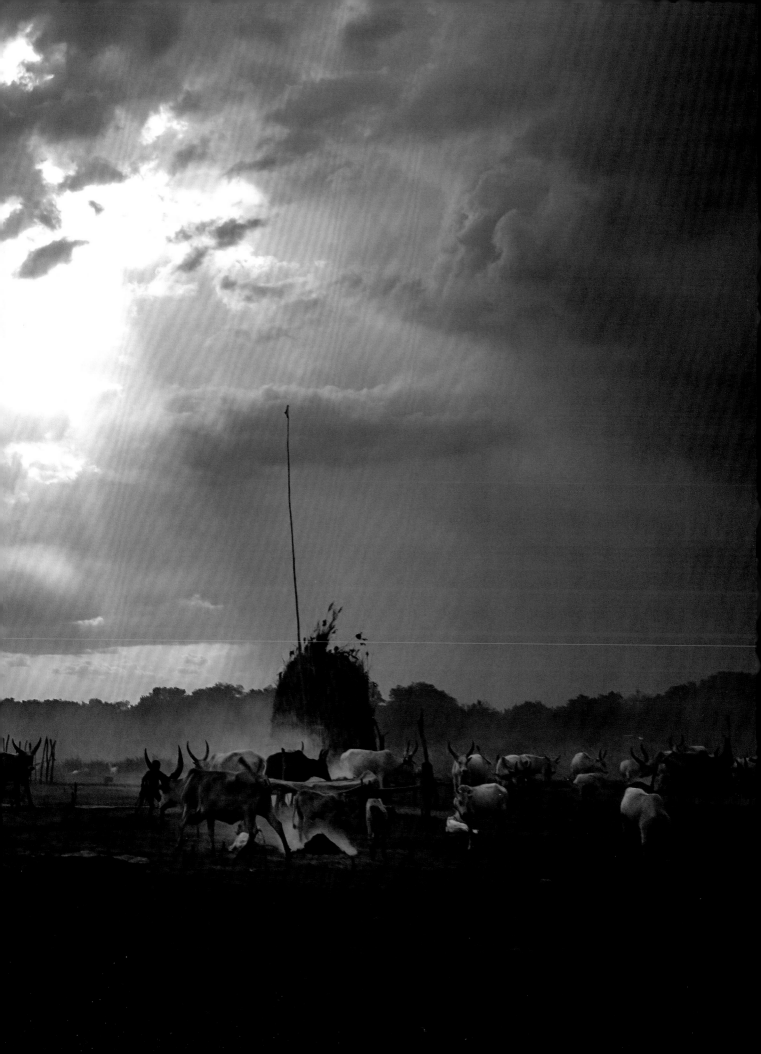

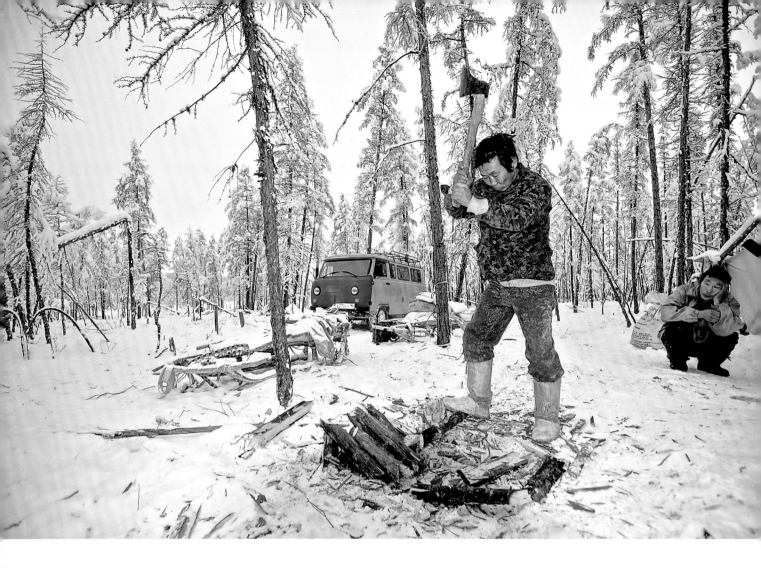

↑→ Yakutian Reindeer Herders, Russian Federation, 2012

In the wilds of Siberia, only the hardiest can survive. I met this family of indigenous Yakuts, who lived with their herds in the taiga forests of the frozen Far East. Living in traditional canvas tents and wearing furs from animals they had killed, these people survived by selling what products they could to the local towns. The Yakuts were persecuted by the Soviet regime and forced ever deeper into the wilderness where they now live, speaking their own language, isolated from the rest of Russia. It has always amazed me how, at the extremes and frontiers of existence, human ingenuity and resilience find a way to succeed despite pressures from mother nature and humankind. The Yakuts' survival skills and knowledge of this harsh environment have been passed down through generations and over years of struggle. Every line on these people's faces is a mark of the human ability to endure.

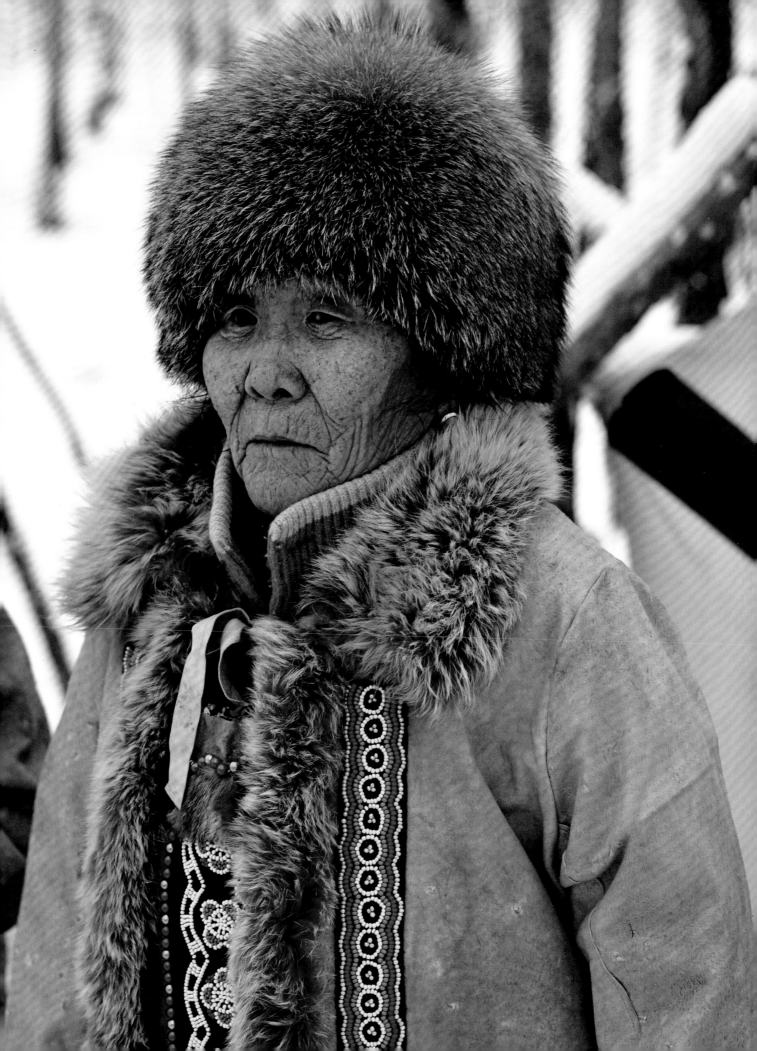

‘My photography
seeks to document
the beauty and
majesty of some
of the most
misunderstood
parts of the world.’

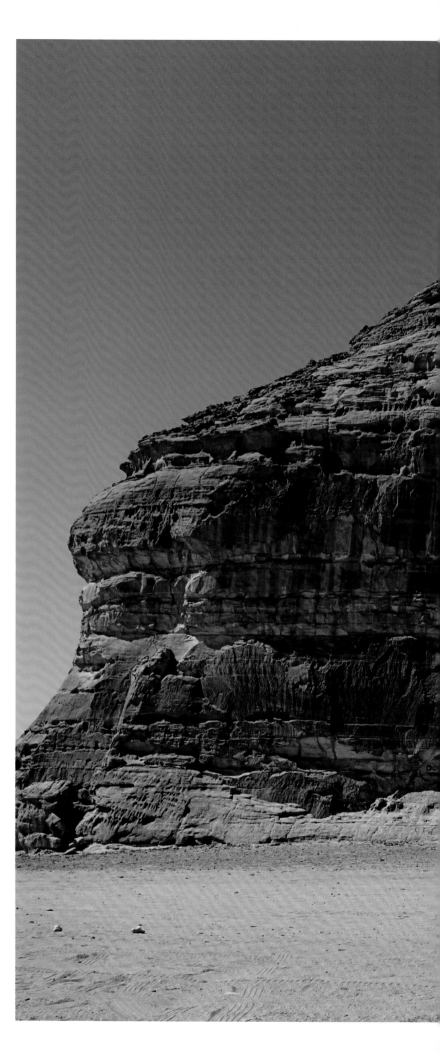

Al-'Ula, Saudi Arabia, 2018
In the sun-baked deserts of the
Hejaz region in Saudi Arabia,
the hidden gem of Al-'Ula
awaits. This frontier town was
once the gateway to the Muslim
holy sites and straddled the
Ottoman railway that linked
Damascus to Medina. Now
the railway is in ruins, but the
surrounding landscape is as it
always was: sublime. Ancient
petroglyphs adorn the striking
rock formations. Here, my guide
Khaled leads the way past
'Elephant Rock'.

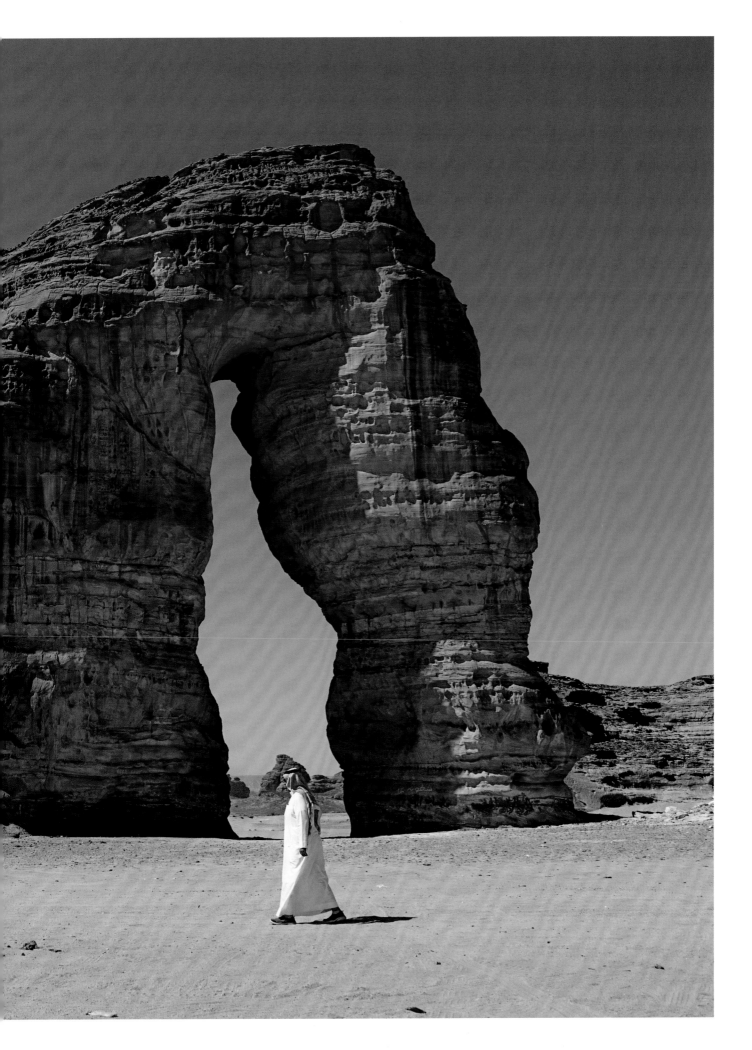

↓ Children in the Rain, Rwanda, 2013

In the town of Gisenyi, close to the border with the Democratic Republic of the Congo, these children were sheltering in a school house, patiently waiting for the rain to stop. A young girl arrived with this colourful umbrella, much to everyone's delight.

For a country like Rwanda, it can be hard to shake off the image of its violent past: nearly a million people, many of them Tutsis, were killed by Hutus in the Rwandan genocide of 1994. Many of the victims were children, and child soldiers were also used. Almost 20 years later, it was a joy to see the children of both Hutu and Tutsi communities living alongside each other in peace.

→ Children of Nyiragongo, Democratic Rebublic of the Congo, 2019

In 2002, a massive eruption of the volcano Mount Nyiragonga destroyed half of Goma town, forcing its residents to flee. But it wasn't long before they returned and simply rebuilt their houses amid, and on top of, the rocky lava field. The active volcano still flares up occasionally, and its red glow lights up the night sky above the beleaguered town. For the younger children it is simply the norm: a part of life.

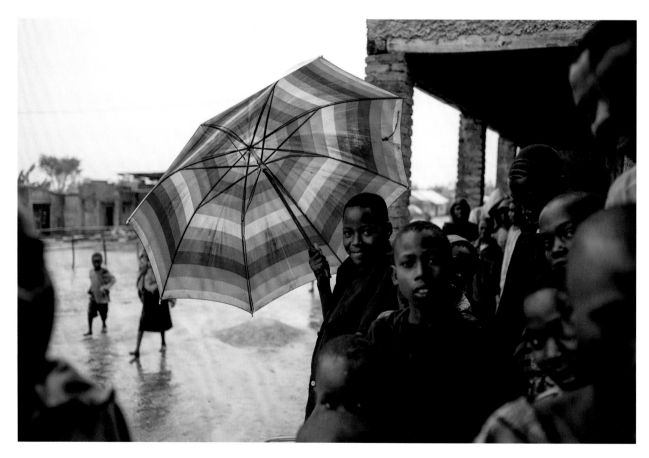

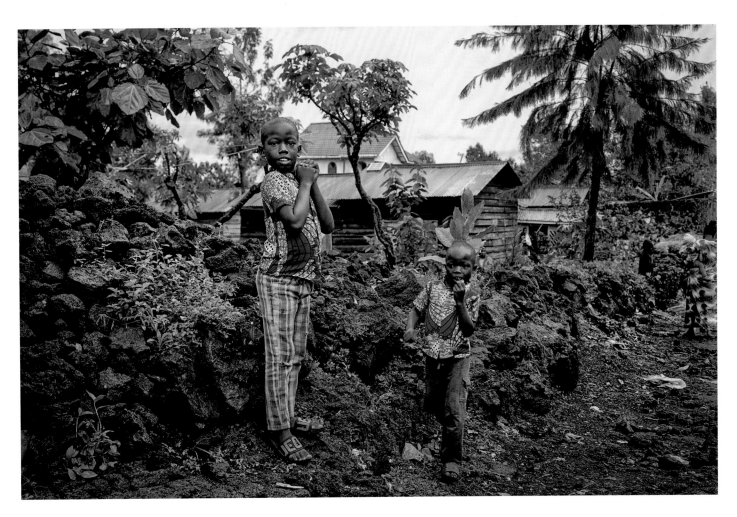
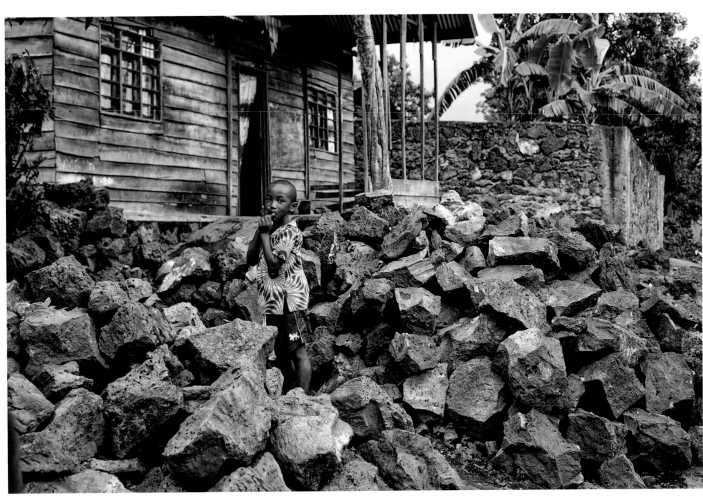

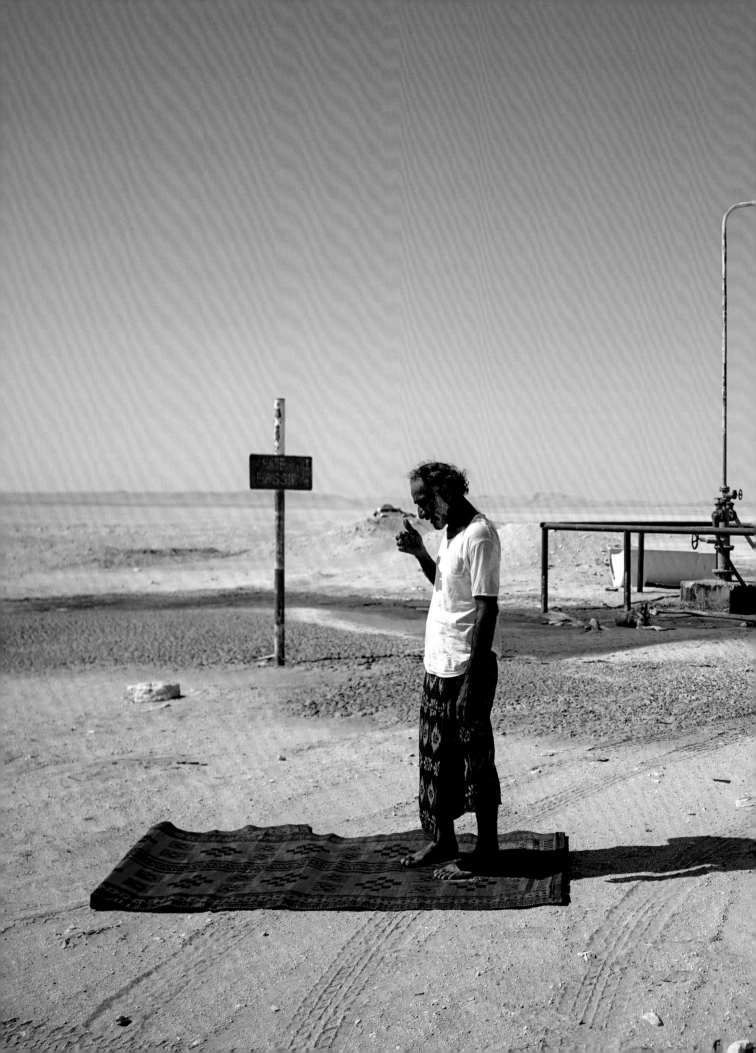

'There are plenty
of rules of
photography, and
it's best to learn
them all – but then,
rules are made to
be broken.'

Mahrouqi, Oman, 2017
On the southern fringes of the Rub' al Khali
('Empty Quarter') desert, my camel guide
Mahrouqi stops to pray by an old water pump.
It was the first sign of water we'd seen in
over a week, and a welcome break from the
arid harshness of the biggest sand desert in
the world. Mahrouqi was a prickly character:
whenever I wanted to photograph him it would
always be on his terms, as he posed for effect.
This image captures him for once relaxed,
having carried out his afternoon ablutions.

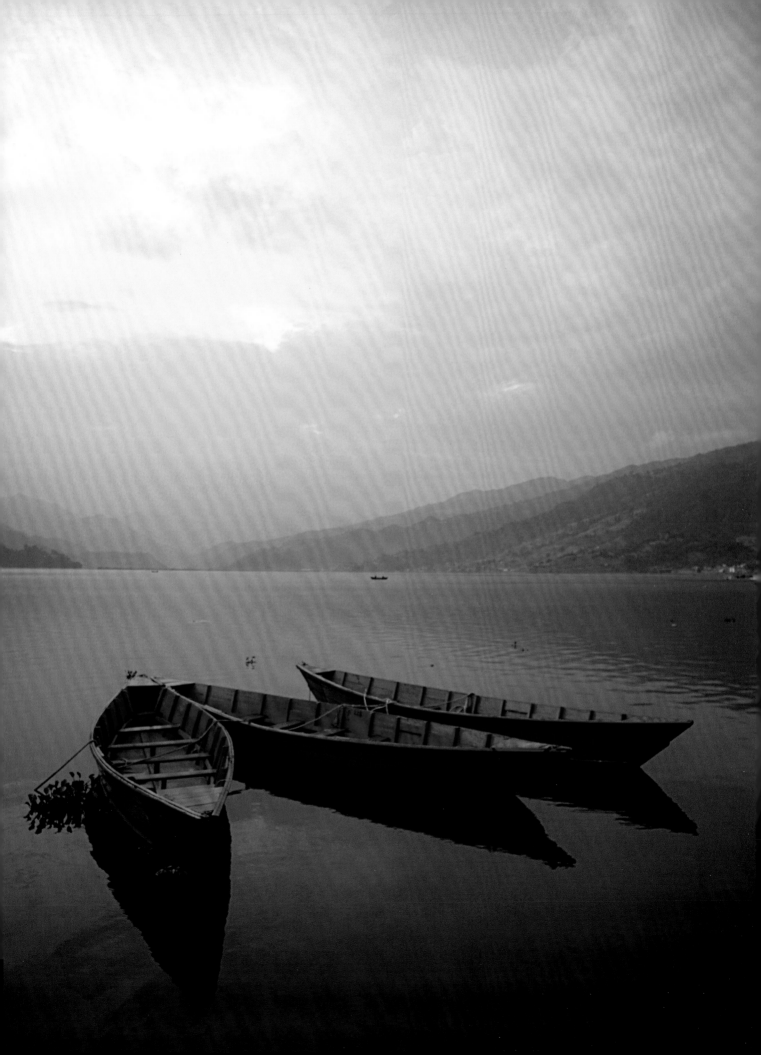

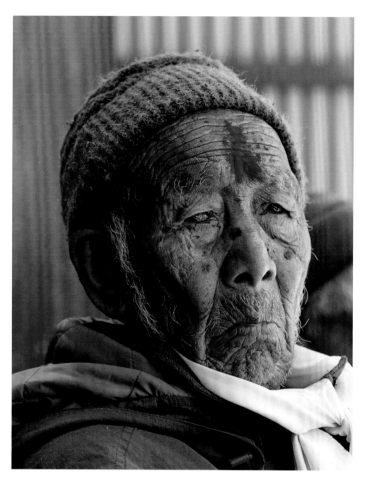

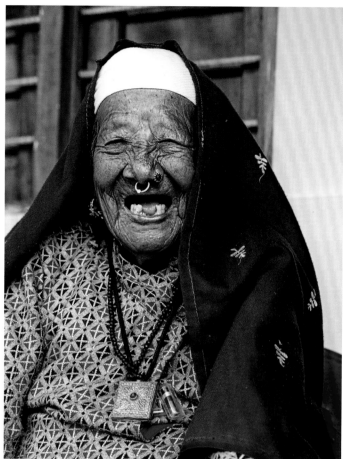

← **Lake Phewa, Nepal, 2015**

I love the stark contrast in colours here as these vibrant boats, used both for tourist trips and fishing, lie still in the early morning quiet of a normally hectic lakeside. Pokhara is one of my favourite places in the world; it was one of the first places I travelled to as a student backpacker and I've been back several times. The city itself was once a small fishing village. In the past 50 years it has seen rapid growth, yet it somehow retains a sense of magic.

Flanked by the rising Himalayas, often obscured by mist, this lake feels like a gateway to the mountains. It's a photographer's dream, like everywhere in Nepal.

↑ **Centenarians of the Hills, Nepal, 2019**

I spent a week as a guest of the Gurkha Welfare Trust (GWT), photographing their projects in and around Pokhara. I met many veterans who had served the British Crown during the Second World War, most of whom had fought in the jungles of Burma. It was humbling to hear their stories and see the joy on their faces when the GWT would come and issue them with their pensions and other assistance. Many of them were well over 100 years old and put their longevity down to simple food and good friends.

There is something innately warm in the souls of these mountain people. Perhaps because they live in such a challenging environment, they seem grateful for every moment of joy. They never fail to laugh, joke and share amusement at the slightest thing.

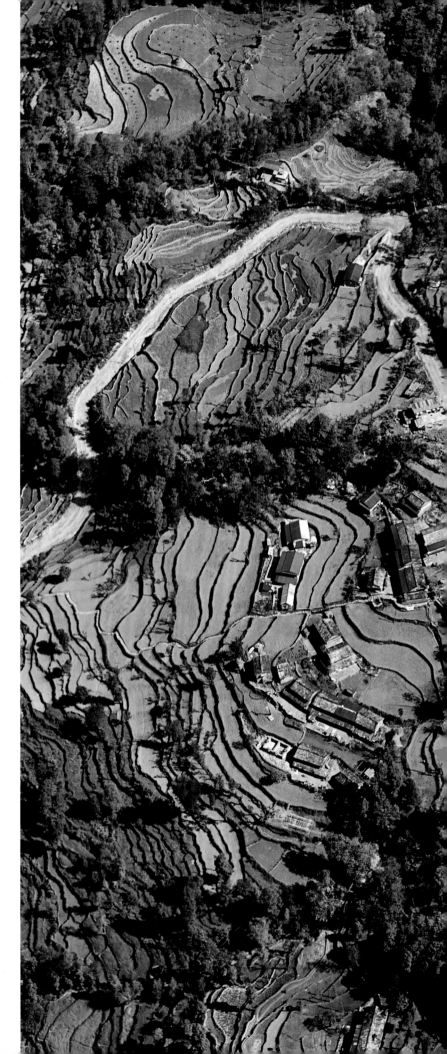

The Road to Rukum, Nepal, 2019
Taken from the comfort of a helicopter, this aerial photograph shows what appear to be contour lines carved into the hills. These farming terraces show how humankind has sculpted the landscape in even the most challenging of terrains – the foothills of the Himalayas. The road seen here is one I had travelled some years earlier on an expedition. The car I hitched a lift in had a brake malfunction and flew off the edge of a cliff, plummeting into the forest below. I was very lucky to survive. On my return to the area, I opted to travel by helicopter rather than attempt the two-day drive.

Helicopter travel in the Himalayas offers remarkable photography opportunities, as you fly between steep cliffs and jagged peaks, zipping over forests and looking down on this truly remarkable landscape.

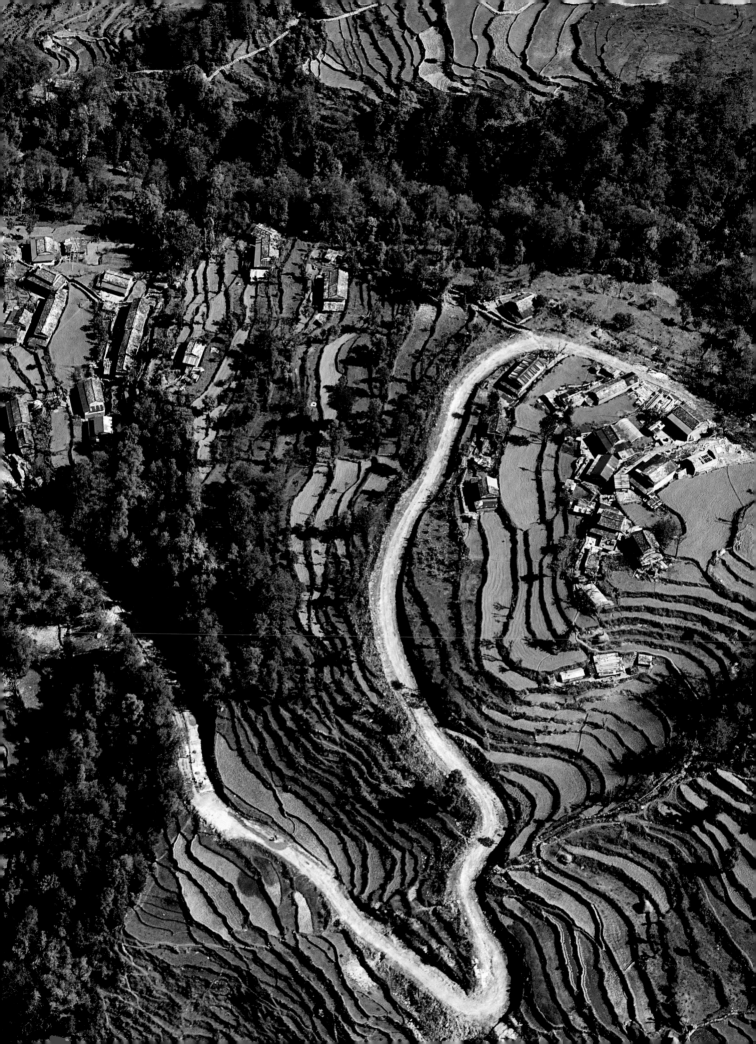

↓ The Lost Village of Gorelovka, Georgia, 2017

The Georgians have a reputation for life-loving hospitality, and I was welcomed everywhere I went. In Gorelovka, near the Armenian border, I met this community of Russian speakers. They demonstrated great resourcefulness in the face of their impoverished living conditions, often topping their roofs with grass for insulation.

The Caucasus region is complicated: a crossroads of cultures and religion. Many Georgians think of themselves as European and look West in their outlook as Christians.

→ Fisherman on Lake Sevan, Armenia, 2017

Armenia sits at the heart of the Caucasus. Like Georgia to its north, it is a predominantly Christian country, but it is surrounded on all other sides by Muslim countries, including some hostile neighbours. The Armenians were persecuted by the Turks for generations and, even now, the country is engaged in a seemingly endless war with Azerbaijan.

Grigor was a fisherman on the beautiful Lake Sevan in the middle of the country. As he navigated its choppy waters, he was philosophical about the conflict and said that all he wanted was to fish and pray in peace.

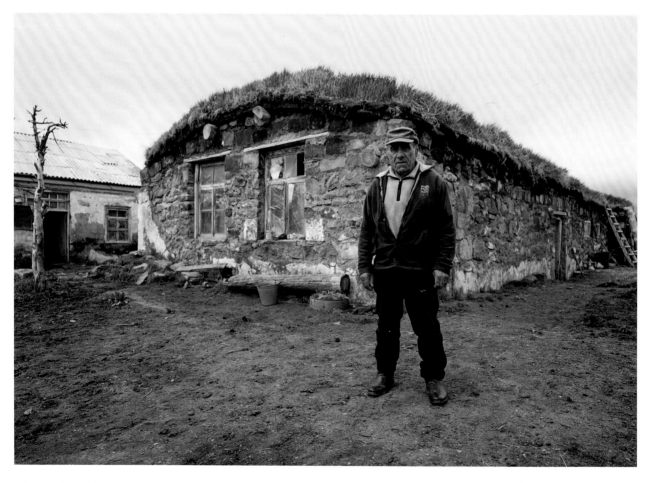

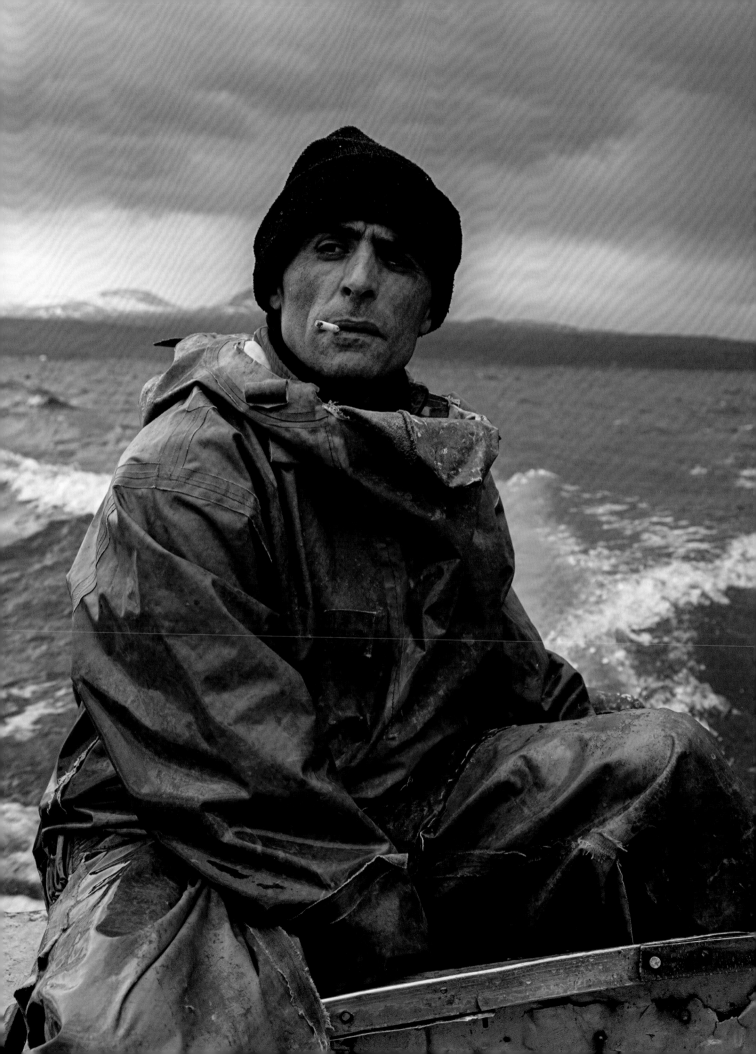

→ Kane Motswana, Botswana, 2019
Here, my safari guide Kane is wearing the
traditional clothing of his tribe, the River San.
The San people are thought to be the oldest
race of humans alive. Kane described himself
as a bushman and every day prayed to his
ancestors that we would not be eaten by
lions or trampled by elephants. In the wilds
of Botswana, both were a very real possibility.
We spent 27 days trekking across the country
following herds of elephants towards the
Okavango Delta.

↘ Attabad Lake, Pakistan, 2015
In the stark valleys of the Karakoram mountains,
the Hunza River cuts a jagged gorge. In 2010,
its flow was temporarily stalled as a massive
landslide blocked its path, creating a 20km
(12-mile) natural reservoir. The nearby road
was completely destroyed, forcing local
mountain dwellers to improvise and build
boats large enough to transport cars and
even lorries downstream so that trade with
China could continue.

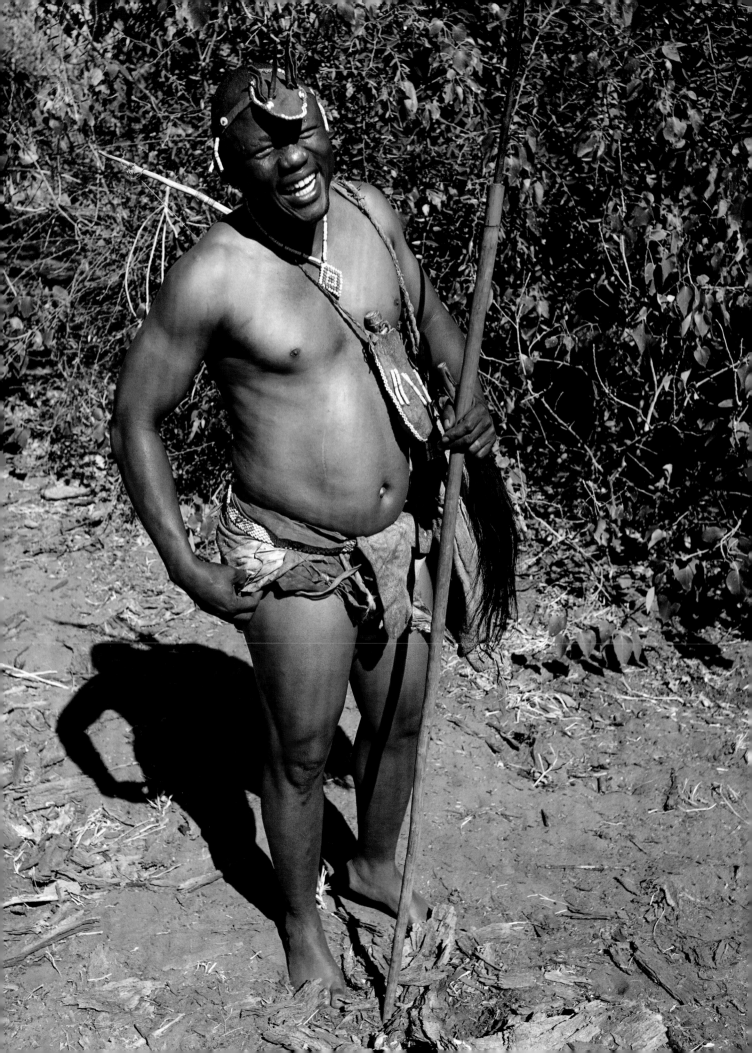

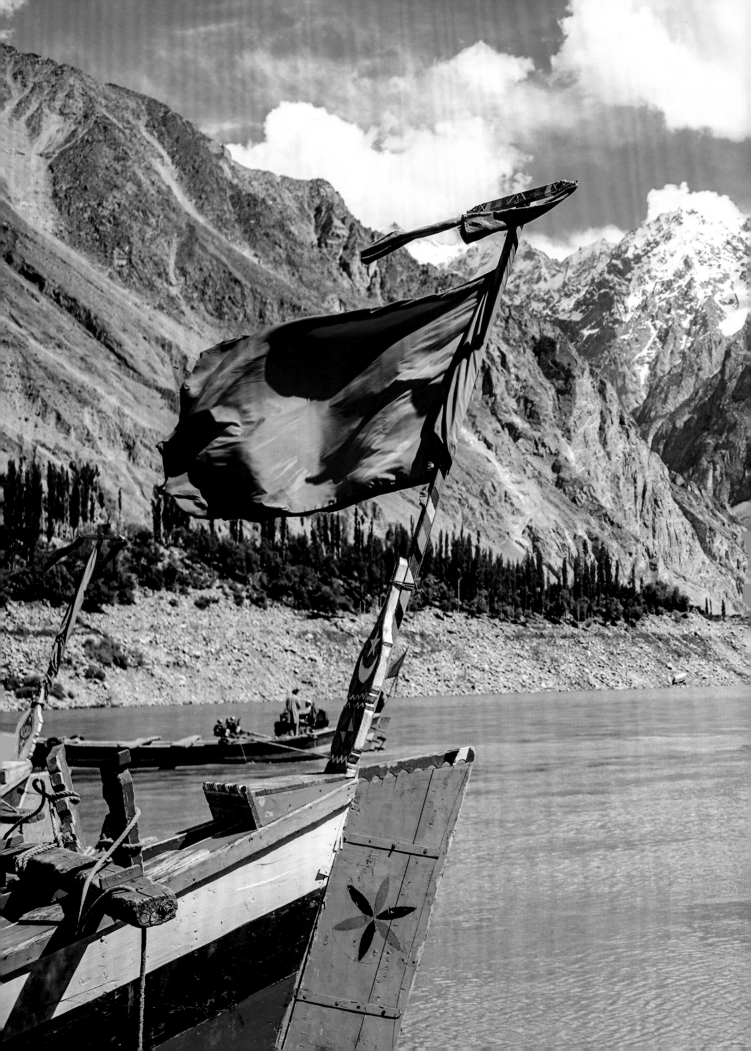

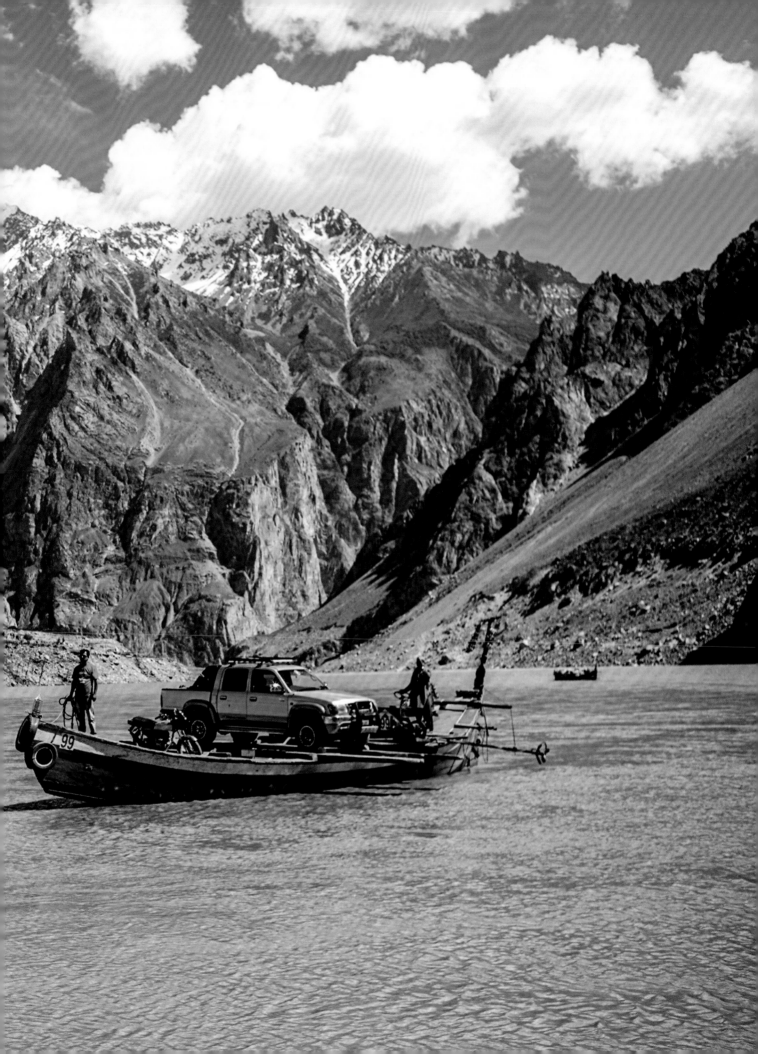

↑ Dinka Boy, South Sudan, 2012

On the fringes of the Sudd Swamp, young boys gather on the riverbanks trying to sell the day's catch. Usually it is Nile perch or tilapia, but sometimes river eels and even pythons are caught and eaten.

→ Excavator, South Sudan, 2013

This is one of the world's biggest digging machines, now left to rot in the bushlands of Jonglei State. In the 1980s, the French attempted to create a canal to reroute the river Nile and avoid the perilous Sudd Swamp, but the project was abandoned due to tribal fighting and civil war. Now the machinery rusts in isolation, miles away from even the nearest village. It took me many days to reach this spot from the capital, Juba, and I had to ask for special permission from the tribal chiefs to visit. The whole area is covered in land mines and only a handful of people know how to access it safely. When I found the apocalyptic-looking machine, there was a leopard living in the driver's cabin and the most enormous beehive had formed amongst the girders.

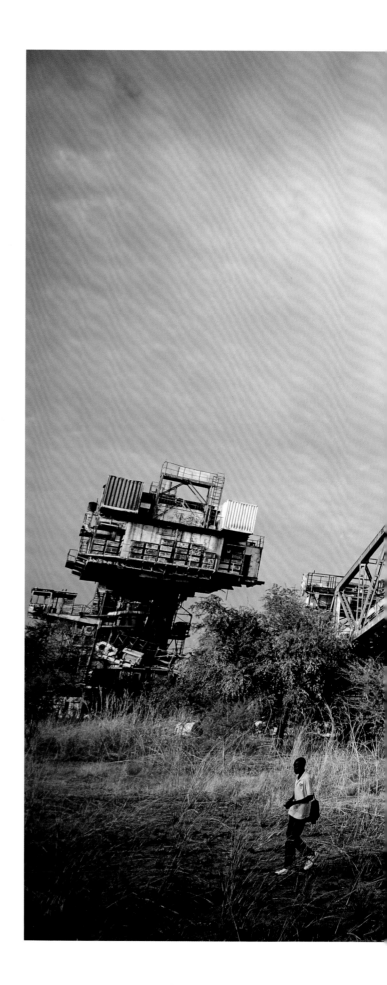

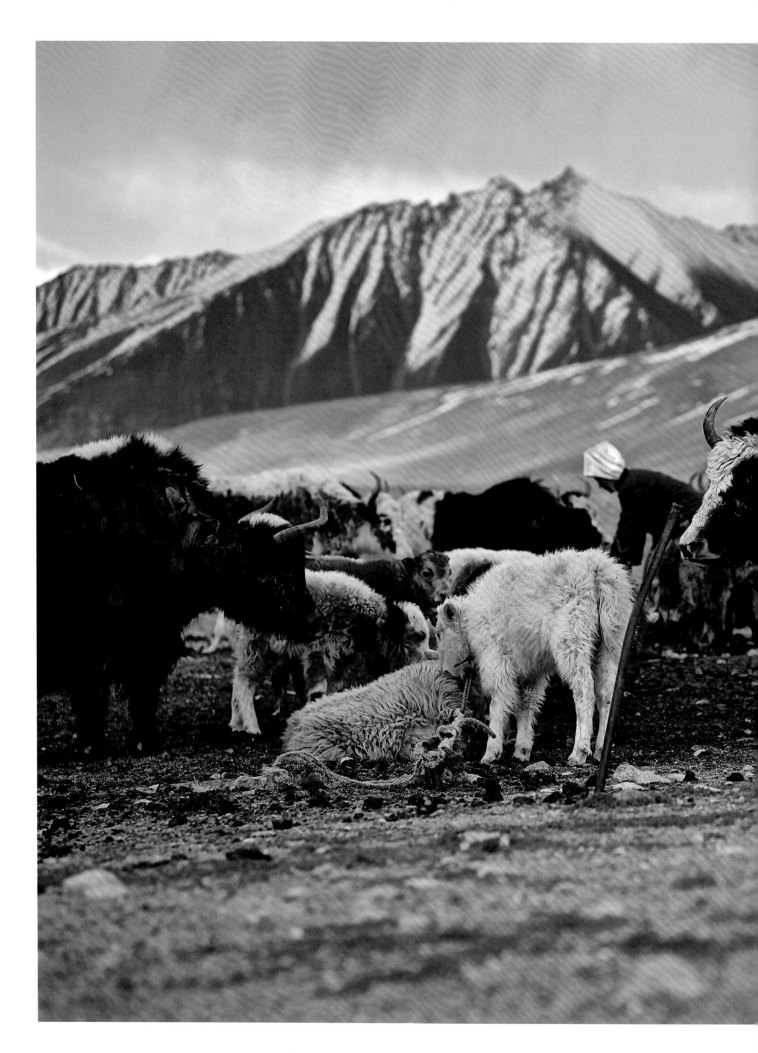

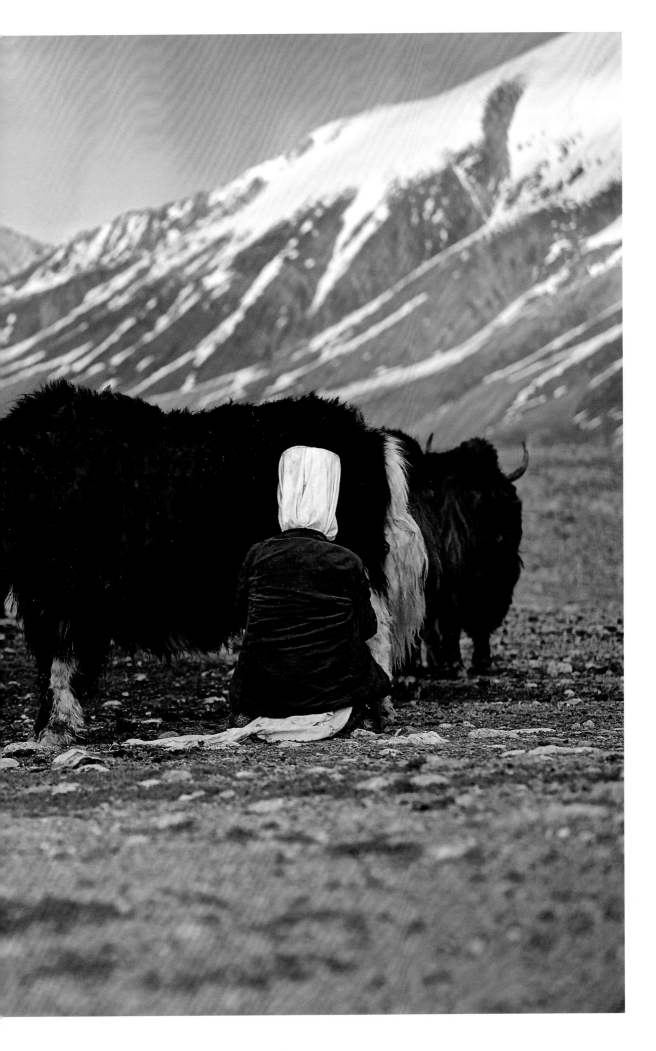

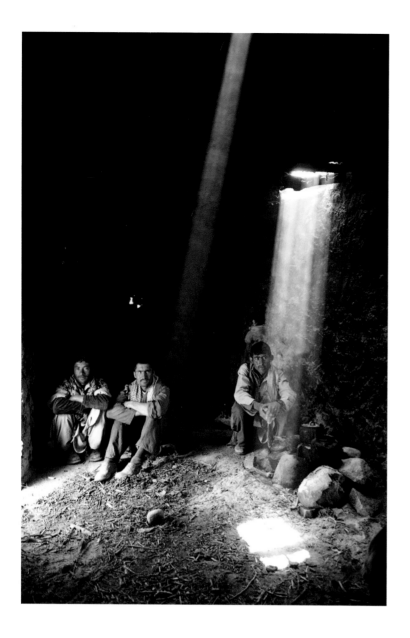

↖ **Kyrgyz Women, Afghanistan, 2011**
High in the Pamir Mountains, a nomadic tribe of people inhabits the so-called Wakhan Corridor: one of the most remote and spectacular valleys on Earth. These nomads live in yurts and roam the pastures with their yaks and goats. It's a way of life barely changed in centuries. Here, I found the women and girls milking their yaks. They often ferment the milk to create an indescribable beverage that I'm afraid I found truly disgusting.

← **Wakhi Men, Afghanistan, 2011**
In the western end of the Wakhan valley live the pastoralist Wakhi people. They live in permanent villages but often roam for weeks at a time with their herds. These men were taking refuge from the freezing cold in a stone hut.

The Wakhi people used to wander across the mountains into China and Tajikistan. When borders were drawn up between the British and Russian empires, these communities, and many like them, became stranded. None of them have passports, and even the journey to Kabul was virtually impossible because of the danger of violence from the Taliban to the south.

'Travel is all about trying to discover what unites us even when things appear strange or unfamiliar.'

→ **Sergei, Russian Federation, 2013**
A modern nomad, Sergei lives in the frozen wastes of Yakutia, travelling the 'Road of Bones' with his herds of reindeer to sell skins at the local market. The road was so-named because of the thousands of prisoners who perished building it under the brutal rule of Stalin in the Soviet era. Temperatures in this part of Siberia can plummet to -60 degrees Celsius.

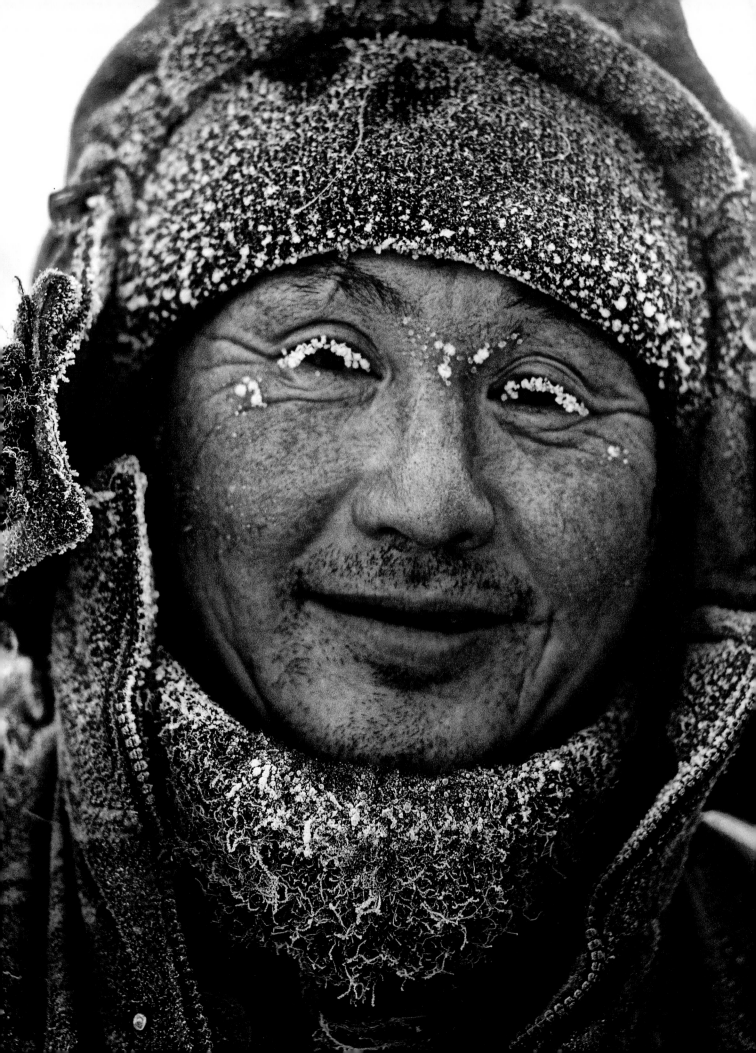

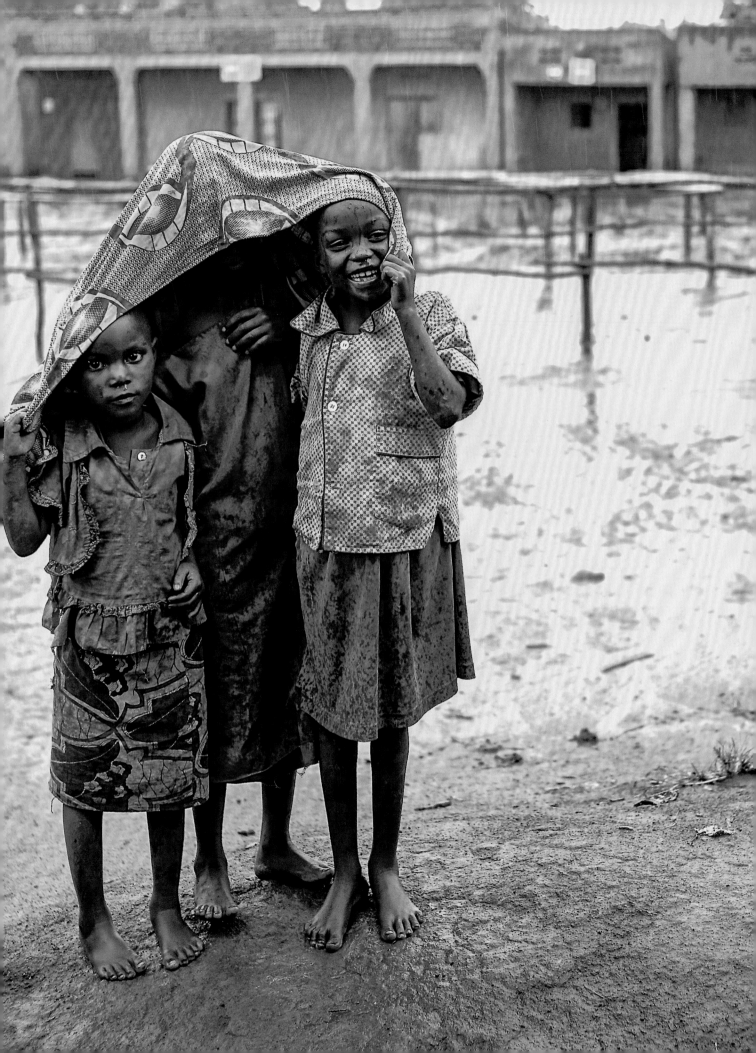

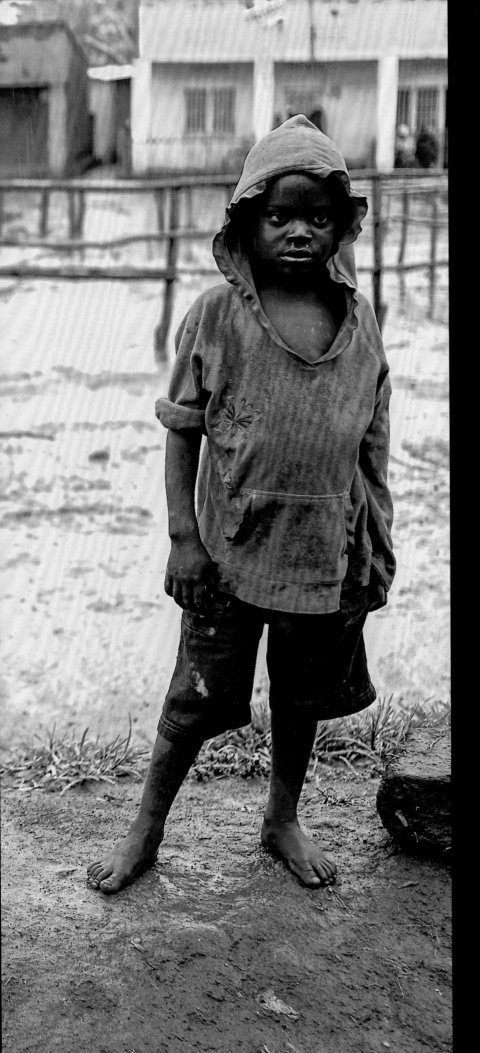

Children of Gisenyi, Rwanda, 2013

Rwanda is known as the land of a thousand hills for good reason, as I discovered when I walked across it, following the longest tributary of the River Nile and documenting the people who call it home.

The villages that are found in the valleys are always filled with bare-footed children. Despite the obvious poverty, they were invariably smiling and curious, and loved to have their photograph taken.

Dinka Man, South Sudan, 2014
Wearing unusual gold earrings as a unique form of decoration, this man was one of life's real characters. I spent all day with him as he milked his cows and drank gallons of the milk from a bucket, still warm.

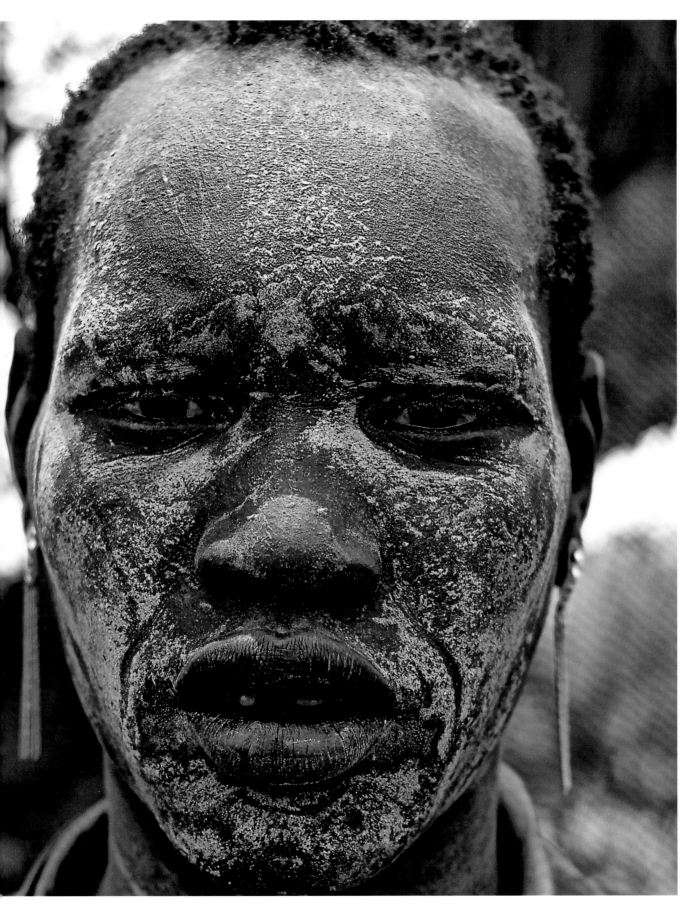

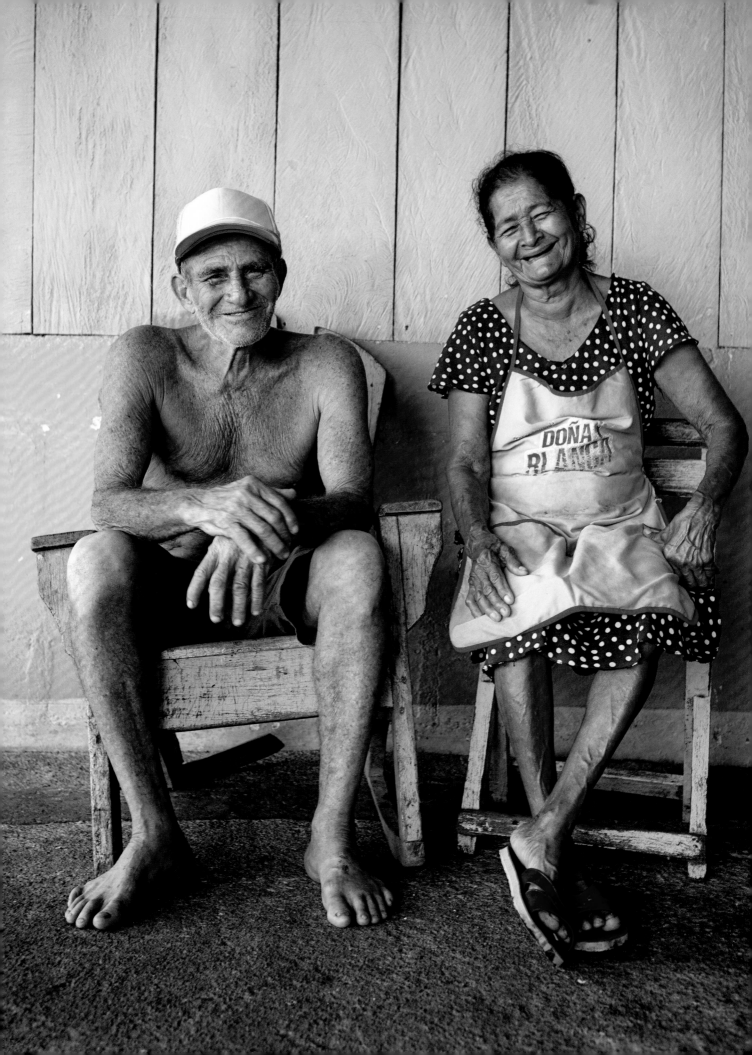

← Couple on the Lake, Nicaragua, 2016

Simon and Maria giggled like children as I took their photograph. They lived with their children and grandchildren on a small island in the middle of Lake Nicaragua, near the island of Ometepe.

The lake is one of the few places in the world where sharks and crocodiles inhabit the same waters. Simon, who claimed to be 96, said that, as a teenager, he saw another youth eaten by a shark. He also said he himself had been bitten by a crocodile and had the scars to prove it. Despite the dangers, Simon had a dark sense of humour and described the encounters in grizzly detail, laughing the whole time.

→ Kyrgyz Girl, Afghanistan, 2012

This shy youngster was a tricky subject in the darkness of the family yurt, only occasionally raising the courage to come close enough for me to photograph her. The Kyrgyz live a hard existence, where the average life expectancy is under 40 years old. Men have several wives, and girls are expected to marry as soon as they reach puberty.

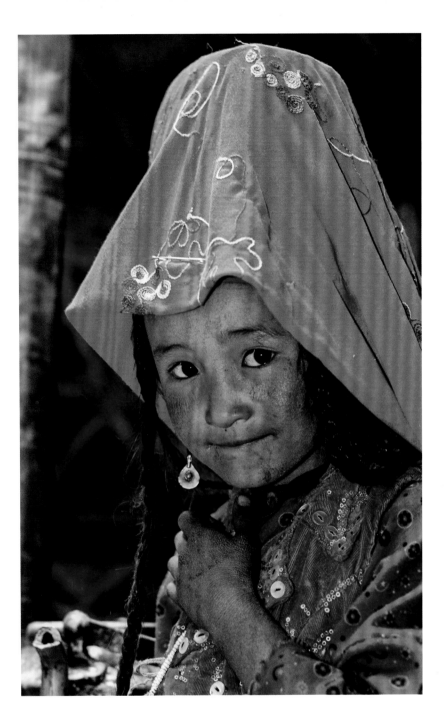

'The impermanence of life is, I think, part of the reason we all love photography so much: the desire to make a moment last forever.'

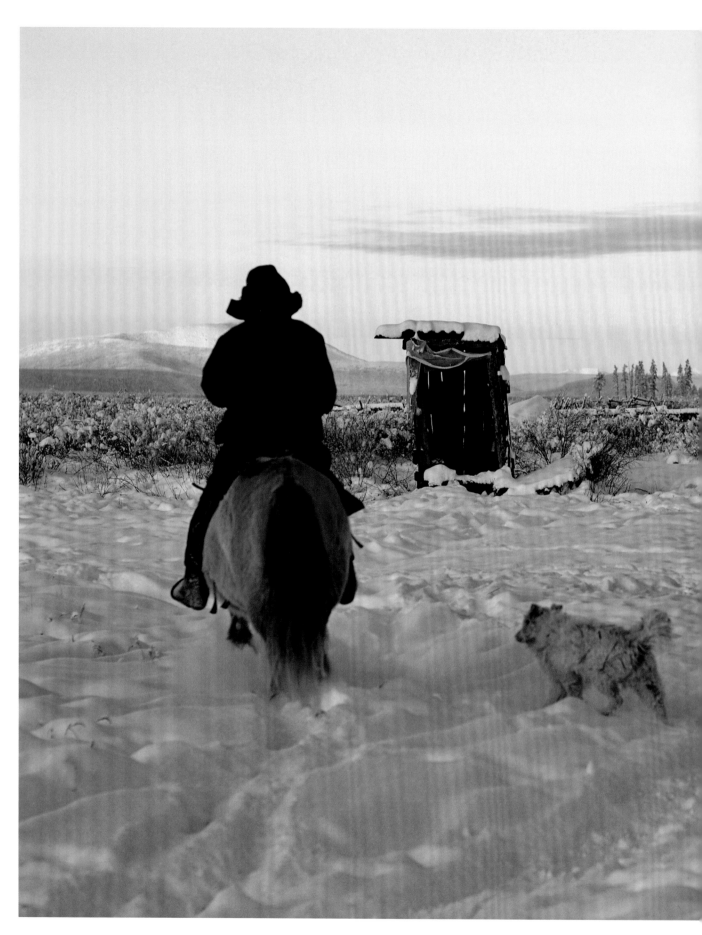

Oymyakon, Russian Federation, 2012
The coldest inhabited place on Earth, Oymyakon lies in the Far East of Siberia, farther east than even Japan. The coldest recorded temperature here was -72 degrees Celsius. And yet, in spite of the harsh conditions, life goes on. Men ride ponies to go fishing on frozen lakes, and pet huskies keep the wolves at bay.

CONFLICT

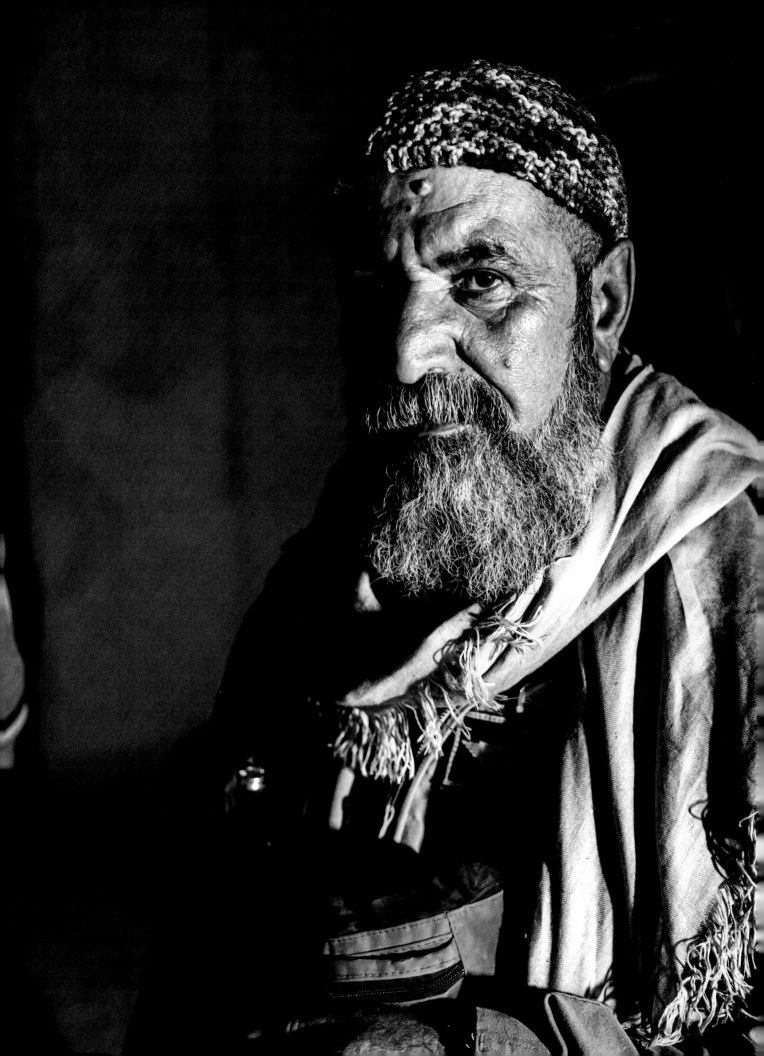

CONFLICT

Conflict is a deeply ingrained part of the human condition and experience. Inherent in all society is a seemingly endless struggle for supremacy and survival. Power, as we all know, corrupts and gives rise to the darker side of human nature. Conflict is everywhere: from the internal struggle in our psychological make-up to tribal and societal friction, all the way up to revolutions and civil and international wars. It emerges from a clash of views or ideals that is sadly so often expressed in violent aggression.

On my travels I have witnessed the fallout of conflict in all its guises. I've never considered myself a war reporter or a conflict journalist, nor do my images tell the full story of any particular struggle. There are many great photographers that have set an incredibly high bar in this regard and none more so than Don McCullin, a man who has dedicated his life to documenting the ravages of war in all their horror. I myself have never set out to attempt to understand why people kill each other, and yet, for one reason or another, I have found myself in situations where they do, and on unimaginable scales. Just as frontiers and borders separate and define different cultures and understandings, conflict is, all too often, the inevitable consequence of these differences. Wherever there is a clash of beliefs, conflict will, sooner or later, rear its ugly head. Those who dare to walk the lines of frontiers, therefore, also run the risk of finding themselves caught on the front lines of these struggles.

I have found civil wars, insurrections and battle-scarred ruins in every landscape I've visited, and it's easy to become overwhelmed by the tragedy and sadness of war when one sees so much destruction. And yet, while war certainly demonstrates the very worst of humanity, it often also brings out some of the best of what humans are capable of. We have such an immense capacity for both good and evil, and these tumultuous conflict zones can often be the backdrop against which both sides of the human story play out. This is what makes these places so enthralling for the photographer, whose job it is to document the human condition and witness the extremes of human experience in all its complexity.

I have often found myself on geopolitical fault lines, drawn to places that have been widely regarded as off limits or too dangerous to explore. War zones are the frontiers created by humankind; those places where humans fight over land, resources and ideas. War has been pervasive throughout the 20th century. My grandfather served in the Second World War in Burma and Japan, and my father

Abu Tahsin al-Salhi,
Iraq, 2017

served on exercise in the forests of Germany during the Cold War. I remember as a child hearing about the Falklands and watching the oil fields of Iraq and Kuwait light up, and, in my teens, seeing on television the horror of the Rwandan genocide, civil war in the Congo and fighting on the streets of Europe in Bosnia and Herzegovina and Kosovo. By the time I reached adulthood, the 'war on terror' had been declared. I watched footage of the Twin Towers falling, and knew that my plans to join the army meant that I too would soon be drawn in personally.

I served in the British Parachute Regiment in the mid-2000s and fought in Afghanistan, bearing personal witness to the nature of modern warfare and the psychological impact it can have, both on soldiers and the civilian population in whose country we were operating. I experienced how the constant threat of potential harm, both to you and those around you, is never far from the mind.

War is tragic, sad and brutal. It destroys people, civilizations and the environment. I've seen cities reduced to rubble, families devastated and minds shattered. The horror of war has long-lasting effects on all involved, and I've felt it a part of my duty to capture these effects wherever I've encountered them. Of course, it's always the vulnerable that suffer most in times of war: women, children, the elderly, and those who cannot escape its ravages.

The following photographs aim to convey what life is like in conflict zones for all concerned, because war isn't just about fighting. It's also about the ways in which something resembling normal life manages to continue despite what is happening: it's about buying ice cream surrounded by devastation, enjoying a cup of tea while mortars hit nearby, or sharing a joke as bullets fly overhead or tear gas fills the streets. As surreal as they seem, these moments of normality, even in the most brutal of conflict zones, are just as important a part of the story as the fighting itself. I'll never forget the time in Iraq when my convoy was ambushed by ISIS terrorists. The Iraqi soldiers I was with proceeded to fight back, and it was some of the heaviest combat I've ever seen. But as soon as the catering vehicle came around to dish out the chicken curry, everyone suddenly stopped and enjoyed their meal. Life goes on.

I have travelled to many types of conflict zone over the last decade, which I've tried to represent in the images I've chosen here. I have included the war on poaching in Africa, which spans across the continent. I've included photographs from the ganglands of Central America, where drug trafficking and urban violence go hand in hand. I've covered some of the tribal wars in Africa, where competition over water, cattle and ancestral land has caused bitter division. But, of course, some of the most iconic images come from the places that I have travelled to the most, those regions and countries which have, for the last decade or so, been mired in endless conflict: Afghanistan and the Middle East. I have spent considerable time living closely with fighters on different sides; I have been with the Kurds on the front line in Syria and met rebels in Yemen. I've documented Hezbollah in Lebanon and Assad's troops in Damascus. In Afghanistan, I've met

mercenaries and warlords, and in Iraq, I was embedded with the Iranian-backed militias that were fighting against ISIS. I bore witness to the final battles against that most evil of terror groups and saw what they did to cities like Mosul and Homs. Perhaps most frustrating of all is the endless struggle between the state of Israel and the Palestinian people. I spent much time with people on both sides of this conflict, and it's one that appears to have no solution.

Whatever the conflict, in all my photography I have tried to remain objective, non-judgemental and alert to the fact that, in most fights, there is no black-and-white 'right side' and 'wrong side': people, wherever you go, are still people.

Capturing images in conflict zones is, by its very nature, not easy. To get good shots, you've got to be close to the action, which of course comes at great personal risk, whether that's from incoming bombs, gunfire or kidnap. Being seen as a journalist in some regions can put you in great danger, particularly if there are war crimes to hide, or militias paranoid about intelligence leaking to the outside world.

I've been very lucky in many ways, and I'm still here to tell the tale. It is a sad fact that many war correspondents have lost their blood and lives to the profession. It's worth remembering the sacrifices made by truly incredible people like Tim Hetherington, Marie Colvin and the hundreds of others of every nationality who didn't return. Many reporters and photographers carry mental scars from the things they have witnessed, and these are not to be underestimated.

Despite the risks, I believe that some of the most powerful images are those that emerge from the ashes of war. They are visceral and raw and play an important part in telling stories that would otherwise remain untold. Documenting conflict is one way of trying to prevent the same things happening again.

Many photographers have discussed the morality of capturing images in conflict zones. Some might argue that war photographers are simply propagandists who pick sides and glorify a cause. Others would insist that the observer has a duty to remain objective and document what happens without agenda. I have tried to pursue the latter aim on my travels, but it goes without saying that there are occasions when it is impossible not to become attached and develop strong feelings about those people you are with. It can be heart-wrenching to have an encounter with someone knowing that, at the end of your time with them, you will return to safety, while they have to stay in harm's way. Perhaps, too, it's impossible to completely shake our own prejudices and world views, however hard we try. Despite being behind the lens, we are still human.

If I have learned anything from war, it's this: no matter where I go in the world and no matter what the nature of the conflict, the vast majority of people are just trying to get on with their lives and protect their families. Even in the worst situations, having faith in a better future can give us hope. And it is my hope that, in this chapter, these remarkable stories will provoke some contemplation about what it means to live in places so often defined only by despair.

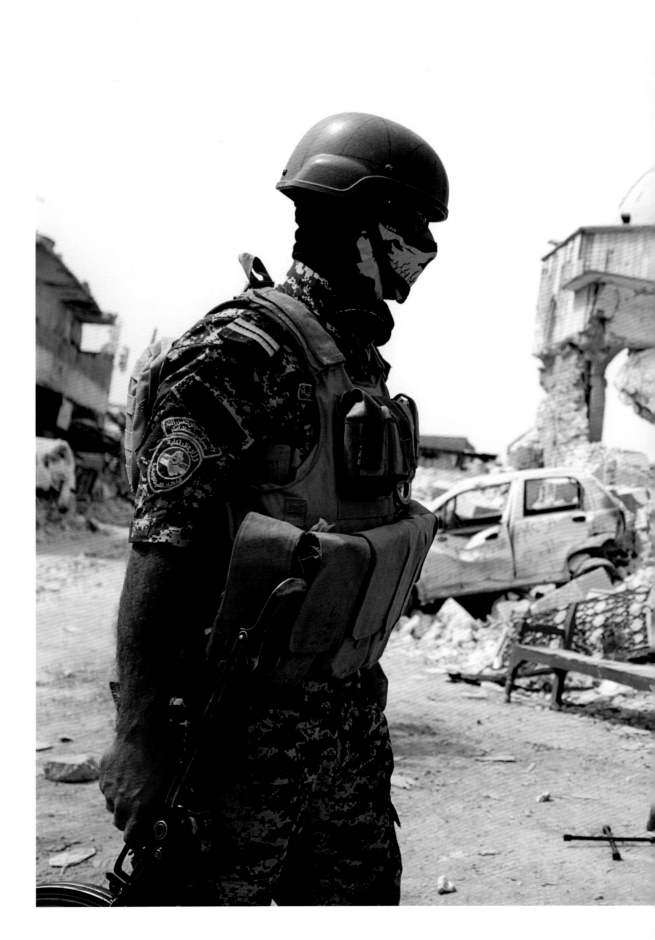

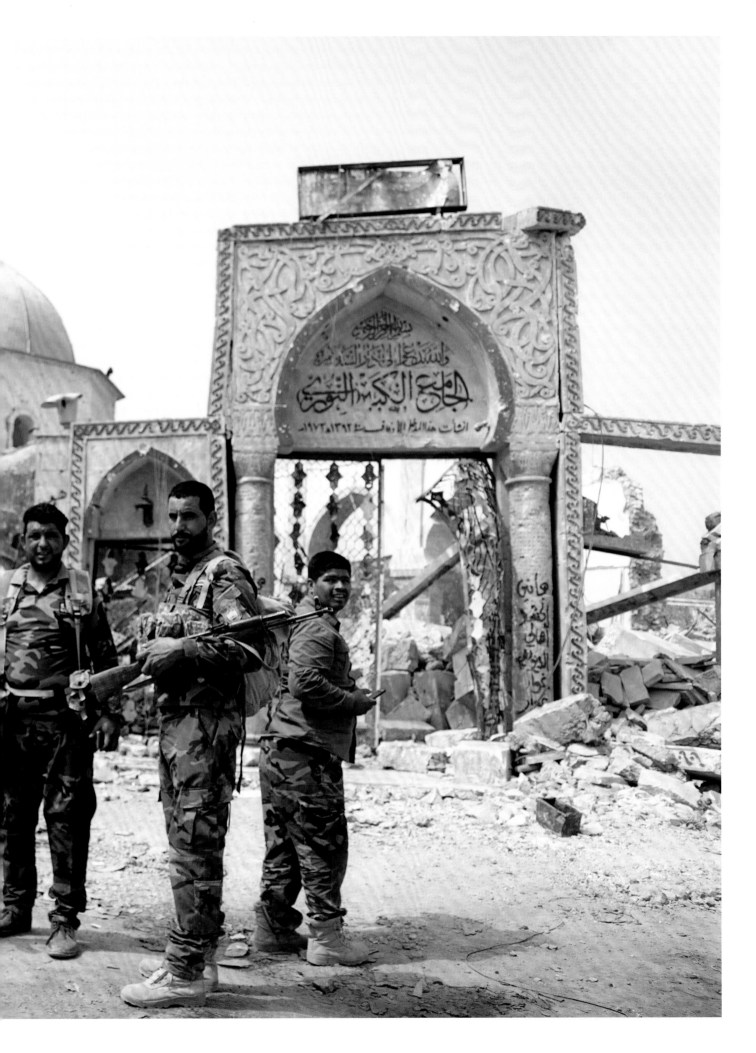

↖ Great Mosque of al-Nuri, Iraq, 2017

Mosul's 12th-century mosque, with its famous leaning minaret, was destroyed in the fight between Iraqi government soldiers and ISIS in the summer of 2017 as the terrorist group fought back against the advancing Iraqi forces. I visited Mosul a few weeks later as soldiers hunted for any remaining terrorists among the ruins. Gunshots could be heard in the background as the troops searched the tunnels and bunkers. We had to be constantly vigilant and on the lookout for booby traps and home-made bombs. There were dead bodies still lying under the rubble and the level of destruction was indescribable. The mosque was seen as an important symbol of control, as it was the place where the ISIS leader Al-Baghdadi declared their new 'caliphate' in 2014.

↓ Ice Cream Van, Yemen, 2017

Amid the humanitarian crisis and civil war that continues to ravage the country, life goes on in the peaceful enclave of Al Mahrah in the east of Yemen, near the border with Oman. The proud region, at once governed by a politician installed by the puppet Saudi government, and yet really led by the Sultan, son of the last king of South Yemen, it has provided sanctuary for displaced people fleeing the war in Aden as well as refugees from Somalia. In the port town of Al Ghayda, I couldn't resist capturing this moment as teenagers came together to enjoy a little treat.

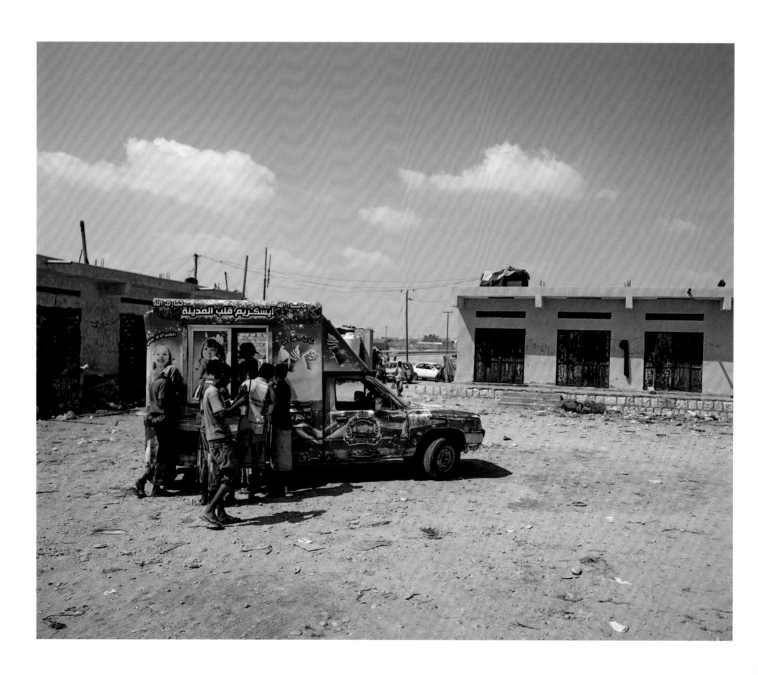

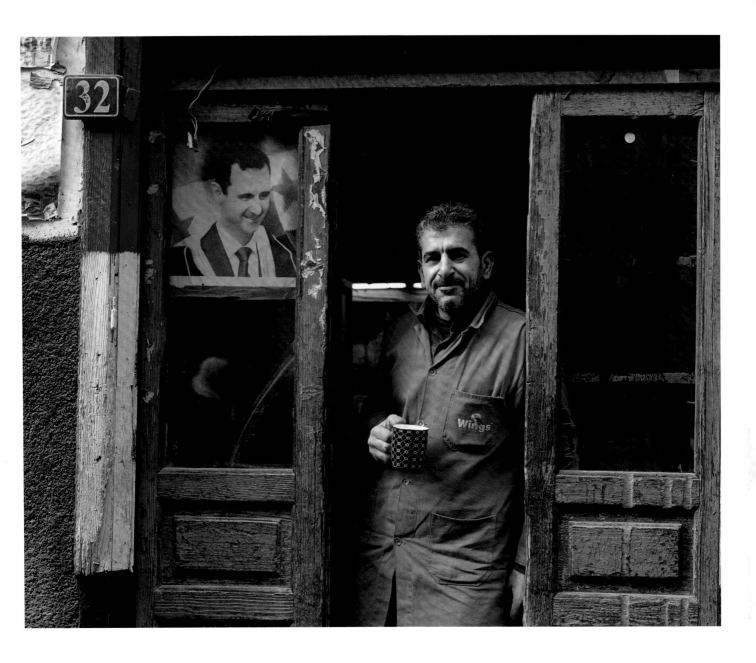

↑ Damascene Mechanic, Syria, 2018
As the Syrian civil war dragged on into its seventh year, it became apparent that the Assad regime was on the verge of victory over ISIS and rebel forces. For most in Damascus this came as a relief, and support for the infamous dictator remained as strong as ever. The war had become a battle for the soul of Syria, and for most that meant the choice between ordered tyranny and barbaric chaos. In the capital, the dictator's image is everywhere: on posters, flags and billboards. Inside the ancient walled city, life carries on despite the almost constant thud of mortars, artillery and gunfire in the nearby suburbs.

→ **Dinka Soldier, South Sudan, 2014**
As I crossed the River Nile from the fishing
village of Terekeka on the west bank to Bor,
the gateway of the Sudd Swamp, I arrived to
a scene of tragic pandemonium. People of
the Nuer tribe were fleeing violence in the
bush and had sought refuge inside the UN
compound here. Members of a Dinka militia
group stormed the compound and slaughtered
dozens of the Nuer. My armed escort across the
river was a Dinka soldier of the Sudan People's
Liberation Army and had little sympathy for the
victims; the Nuer are considered rebels by the
Dinka majority. The conflict, which had broken
out just a few months before, rages on.

'In the age of "fake news", truth has never been more important. A documentary photographer's job is to capture the truth.'

↘ **Dome of the Rock, Jerusalem, 2017**
Perhaps the most iconic symbol of this eternal
city, the glistening dome that stands atop
the Temple Mount is the place where Muslims
believe Muhammad ascended into heaven.
It is also revered by the other monotheistic
religions: for Jews and Christians, it is where
the biblical Abraham was told to sacrifice his
son, and also where God began to create Earth
itself. The Dome of the Rock sits at the heart
of a conflict that has raged for millennia. Now,
the soldiers of the Israeli Defense Forces (IDF)
patrol the surrounding pavements, keeping a
very fragile peace.

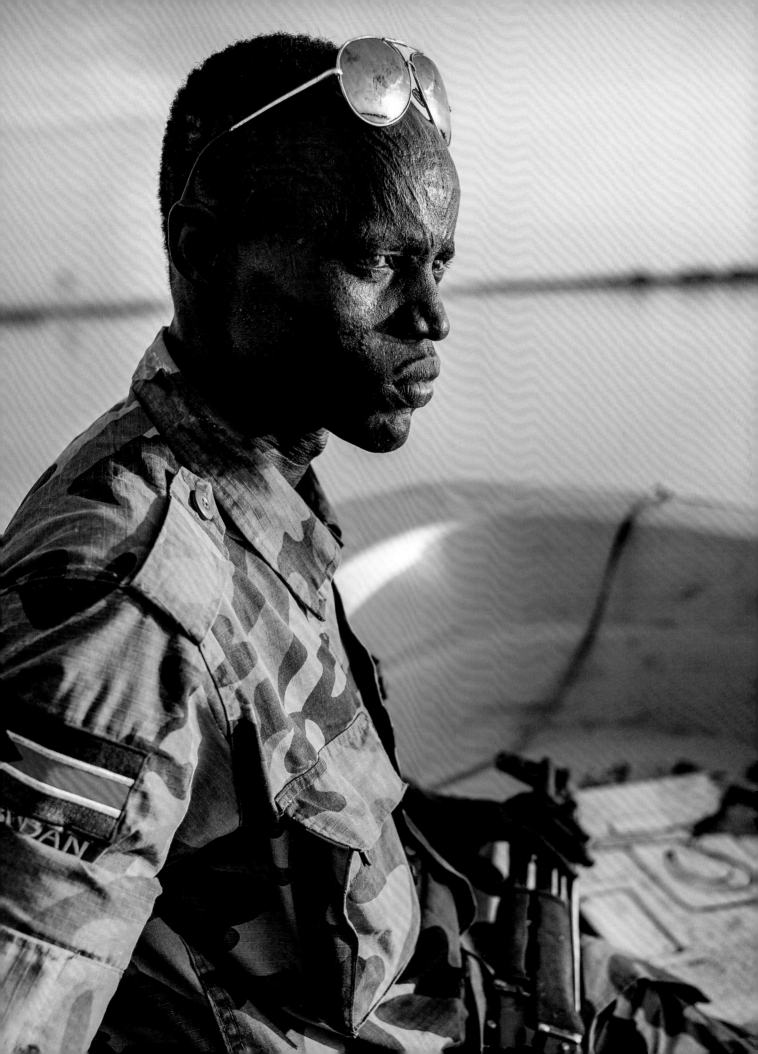

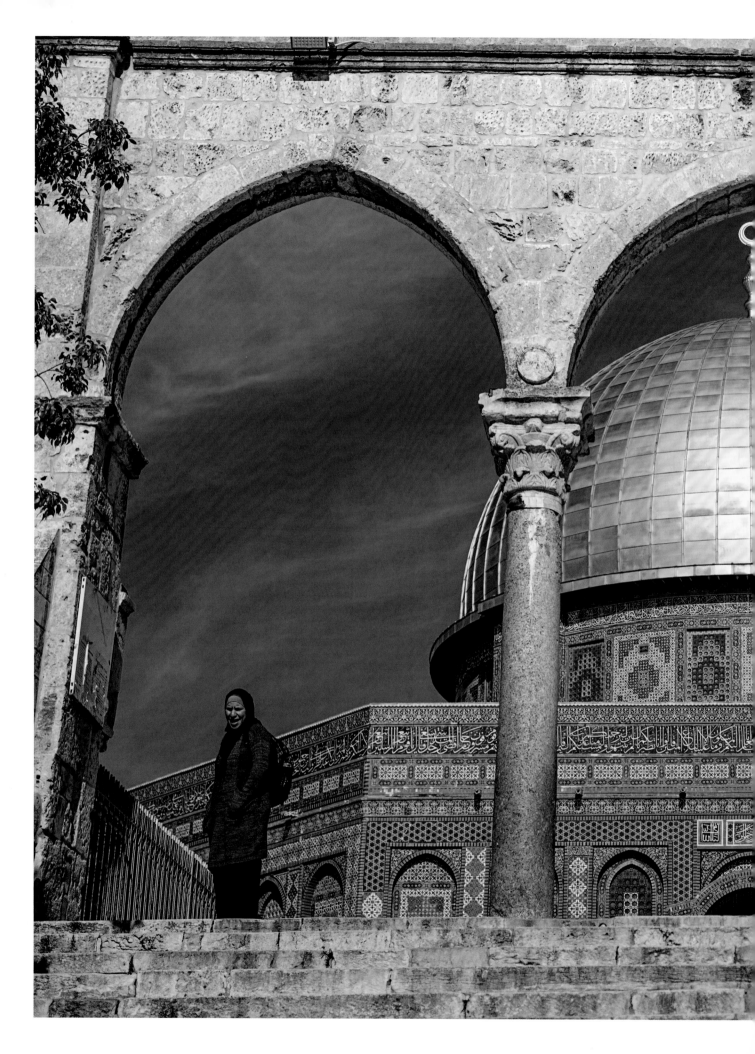

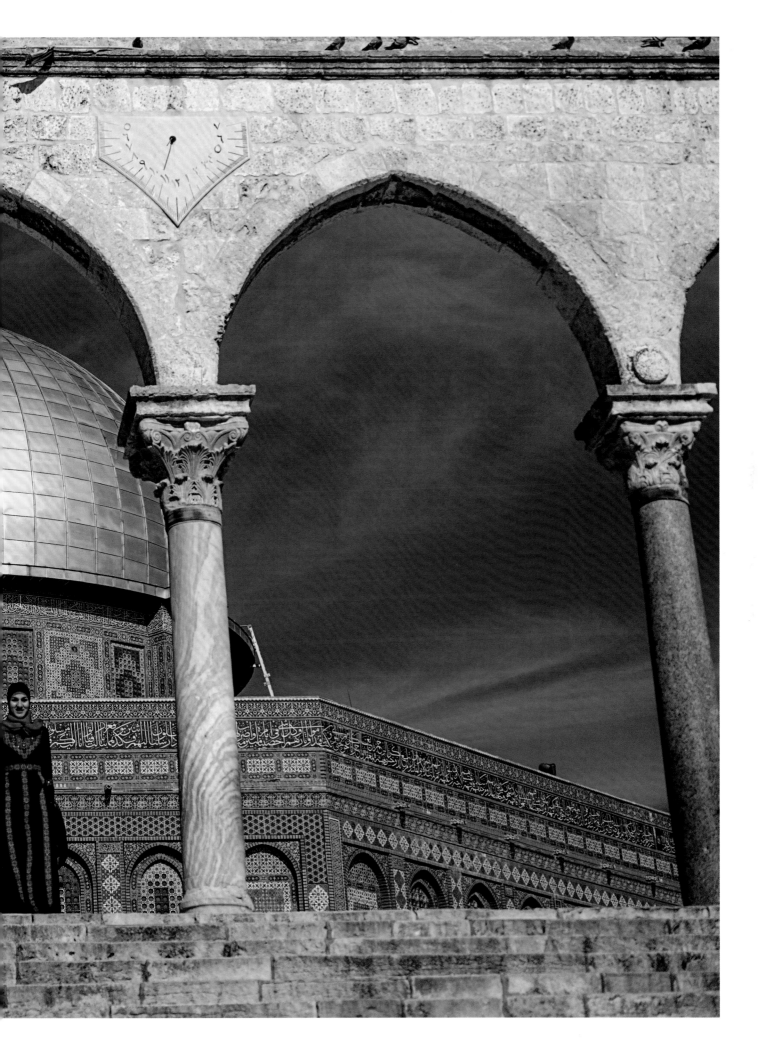

↓→↘ Palestinian Protesters, West Bank, 2017

In December 2017 President Donald Trump announced that he was authorizing the move of the US embassy in Israel from Tel Aviv to Jerusalem, thereby sanctifying the state of Israel's claim of Jerusalem as its capital. Protests flared up around the Muslim world, especially in the occupied areas. From the front line, I witnessed a violent protest in the ancient city of Jericho as young men gathered to destroy the town's infrastructure, burning cars and tyres and throwing rocks at IDF soldiers. The Israelis fired back with tear gas and rubber bullets. In a twist of irony here, the Palestinians (a corruption of the biblical term Philistine) use sling shots to fight against soldiers wearing the Star of David, lined up behind armoured cars.

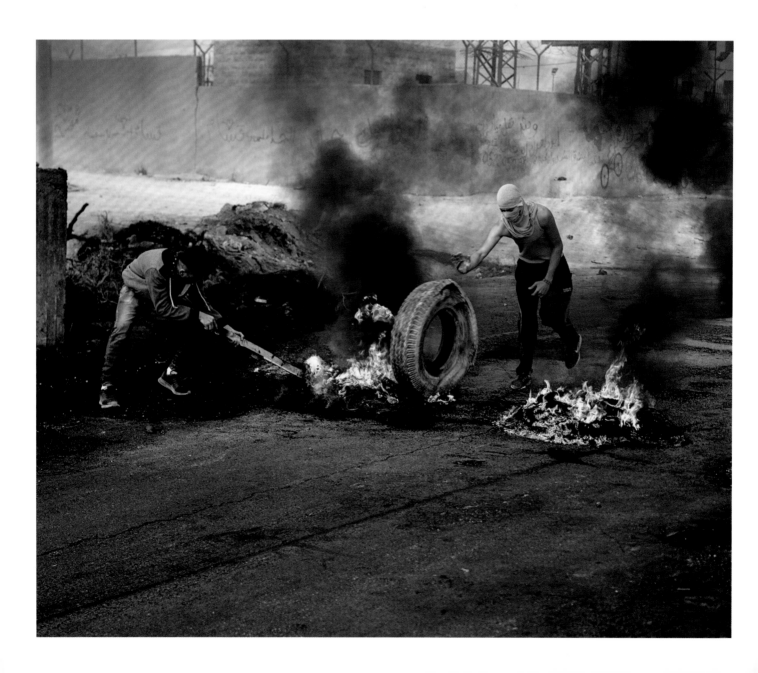

'The purpose of documentary photography is to chronicle moments and environments that are not only significant in terms of historical events and current affairs but also of everyday life in the here and now.'

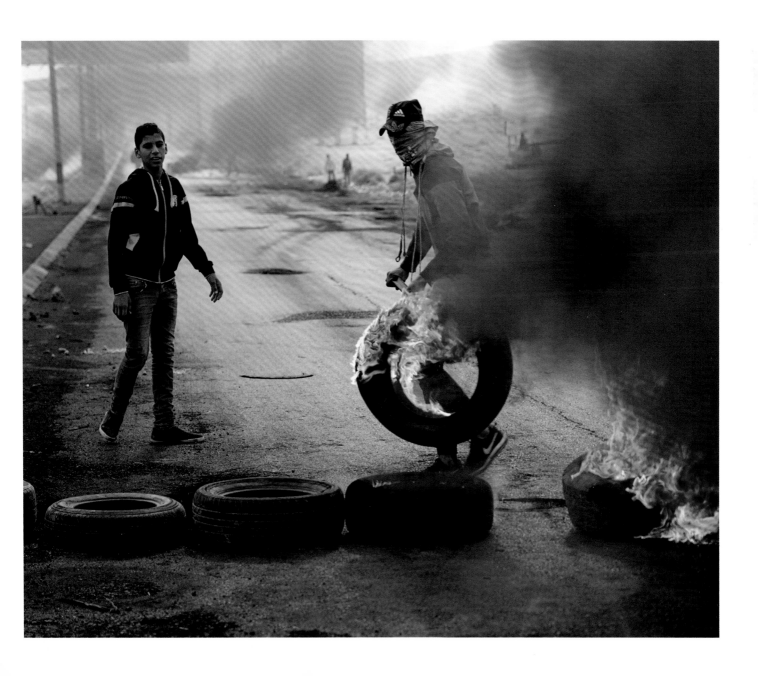

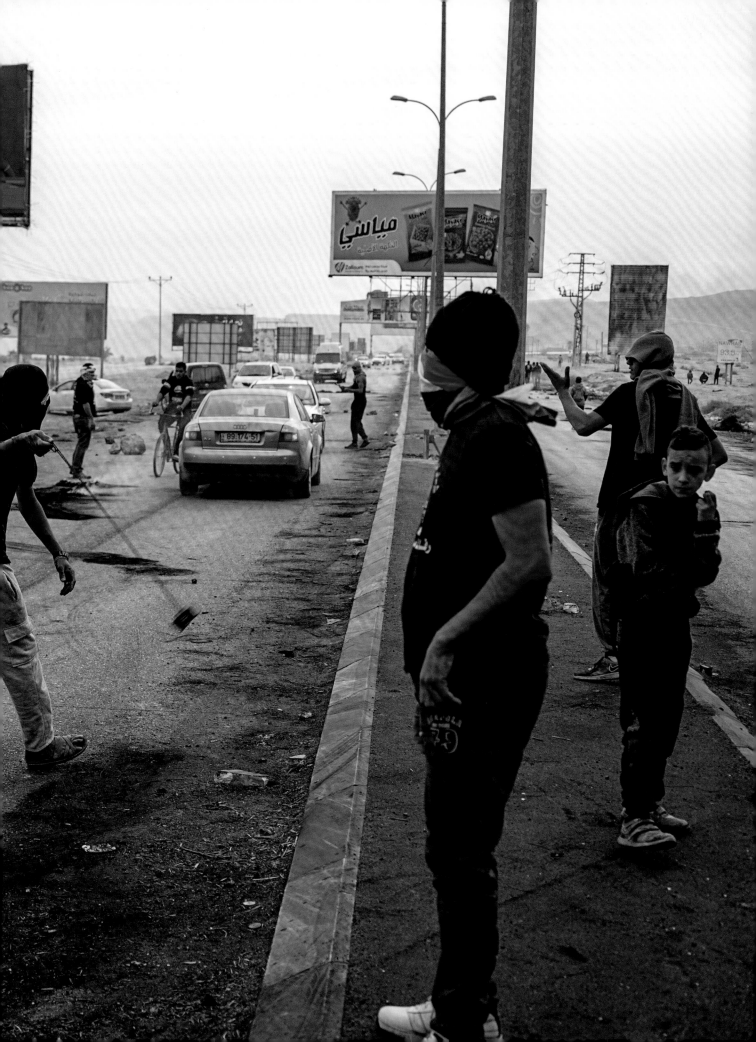

Temple of Baalshamin, Syria, 2018
This temple, dedicated to the Caananite God
Ba'al and dating back to the 2nd century BCE,
was blown up by ISIS terrorists on 23 August
2015 in their attempt to damage Palmyra's
cultural significance and destroy any pre-Islamic
architecture. I met Tarek Al-Assad, the son
of the director of antiquities in Palmyra, who
told me that ISIS were in fact looking for gold,
antiquities and other treasures that they could
sell.on the black market. Tarek's father, 86-year-
old Khaled Al-Assad, was brutally murdered by
ISIS after refusing to tell them where he had
hidden some precious artefacts.

I was escorted around Palmyra under the
watchful eye of Russian mercenaries, who were
tasked with keeping the historical site from
falling back into terrorist hands.

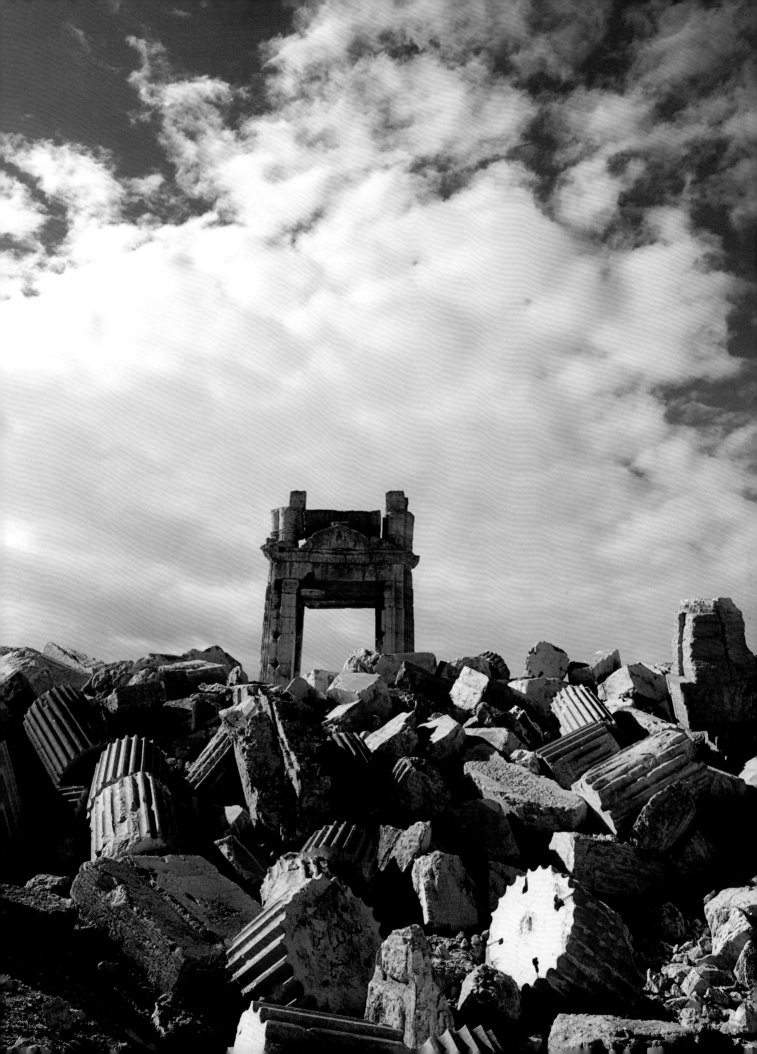

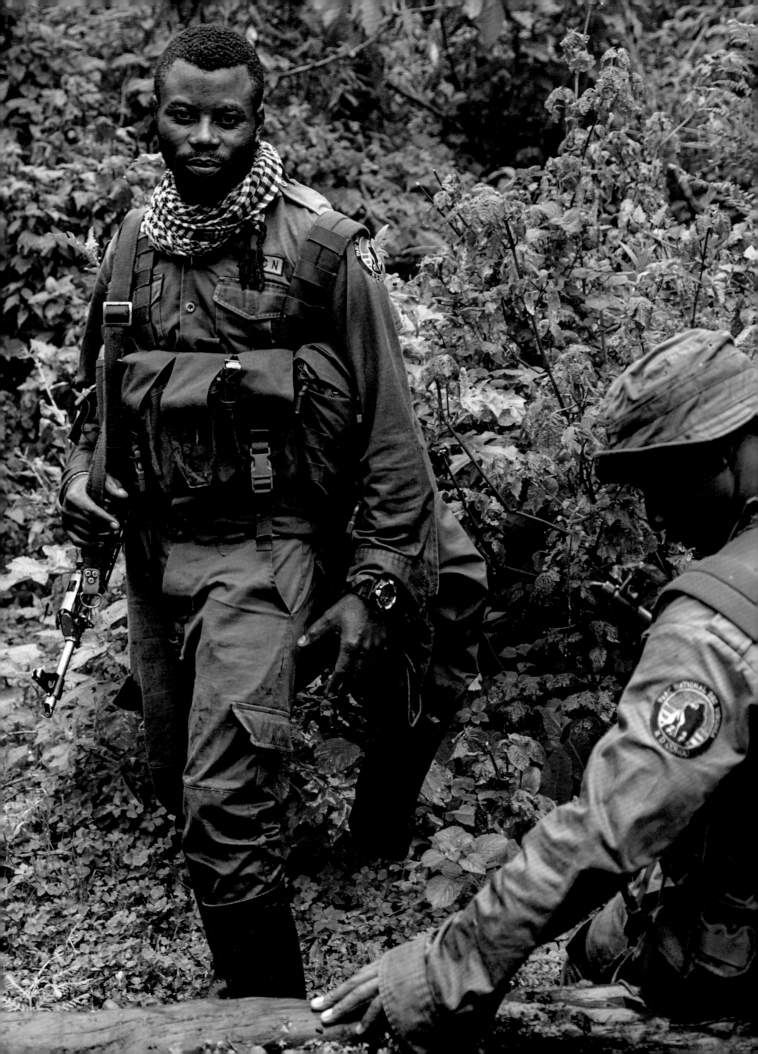

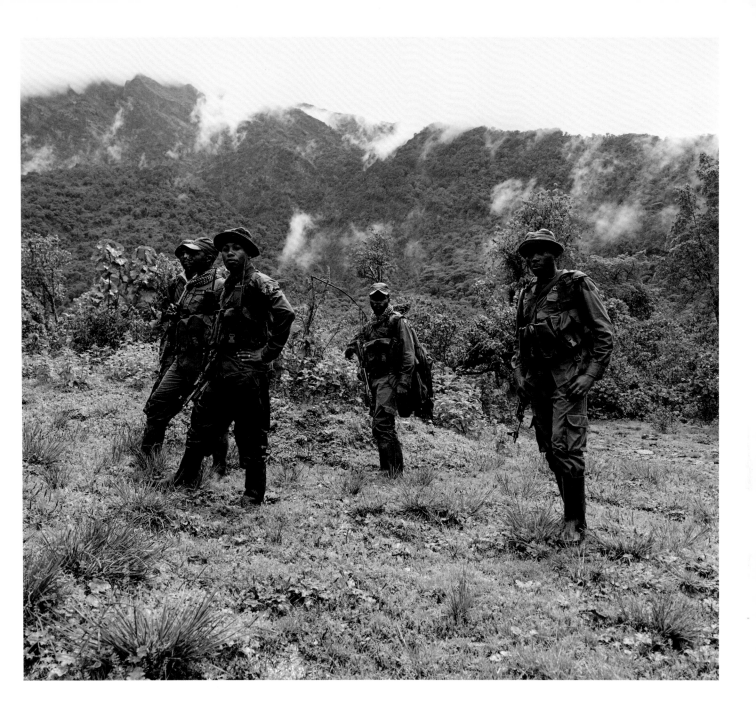

←↑ Virunga Rangers, Democratic Republic of the Congo, 2019

Wildlife rangers from Virunga National Park embark on an anti-poaching patrol in the mountainous forests of North Kivu province in eastern DRC. These volcanic jungles on the borders with Rwanda and Uganda are home to some of the world's last mountain gorillas and forest elephants. Years of tribal conflict and civil war have decimated the wildlife populations and local people frequently poach

animals for bushmeat inside protected areas. The rangers have the unenviable – and dangerous – task of protecting these endangered species. The rangers often go out for days and weeks at a time, camping in the forest under incessant rain. Dozens of them are killed every year by militant poachers and armed gangs.

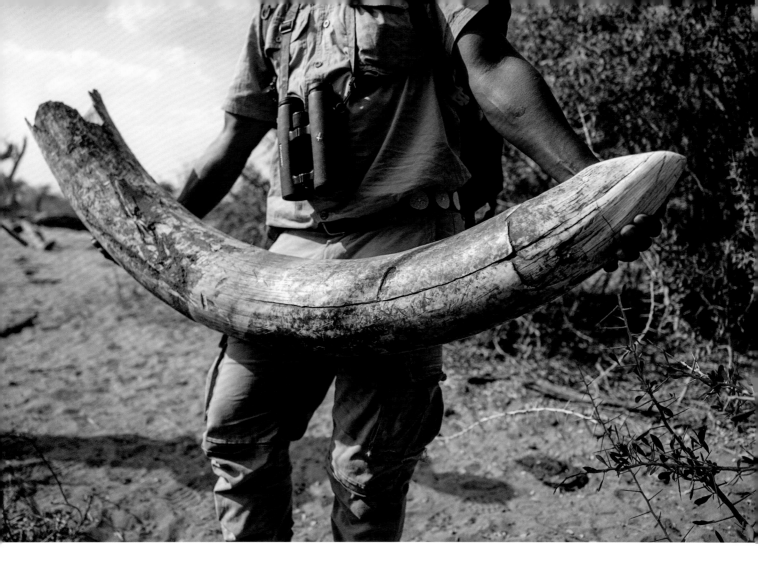

↑→ Ivory, Botswana, 2019

A soldier from the Botswana Defence Force shows me a 40kg (90lb) elephant tusk, found just a few days previously in a cache on the edge of the Okavango Delta. Ivory poaching across Africa is responsible for the deaths of upwards of 20,000 elephants a year and their numbers have plummeted from over a million just 40 years ago to less than 450,000 today. The elephants with the biggest tusks are especially targeted by poachers, meaning fewer and fewer 'big tuskers' are able to breed, resulting in elephants with smaller tusks, or no tusks at all, passing on their genes.

Unless this plundering is stopped, it is likely that elephants will face extinction within our lifetimes.

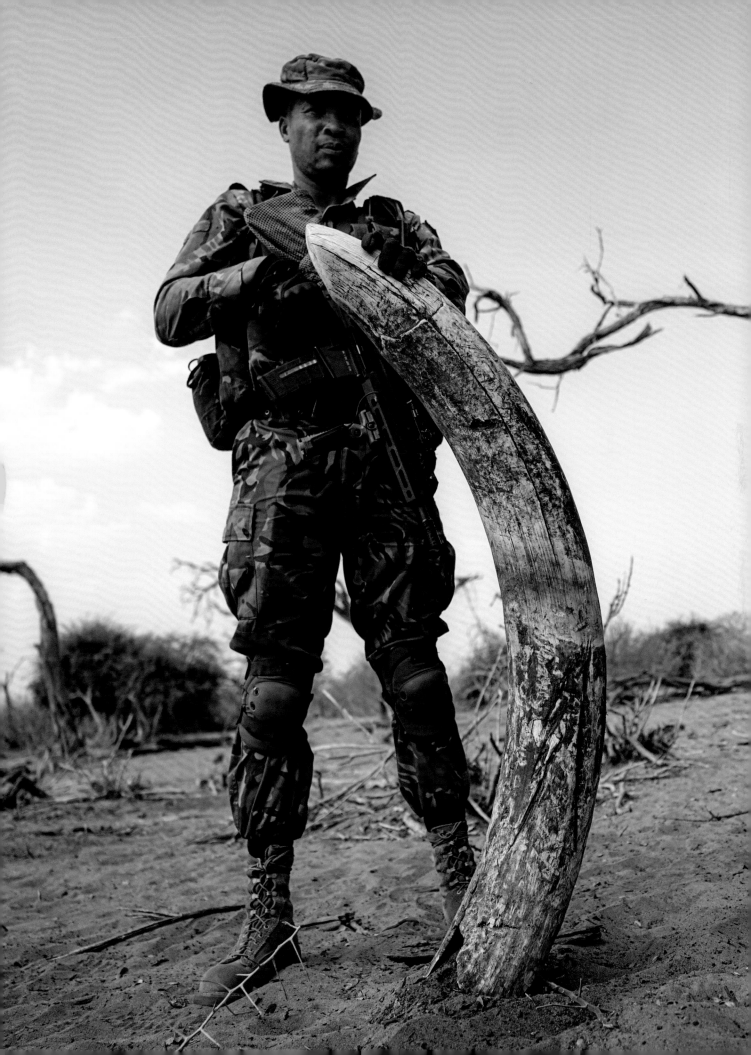

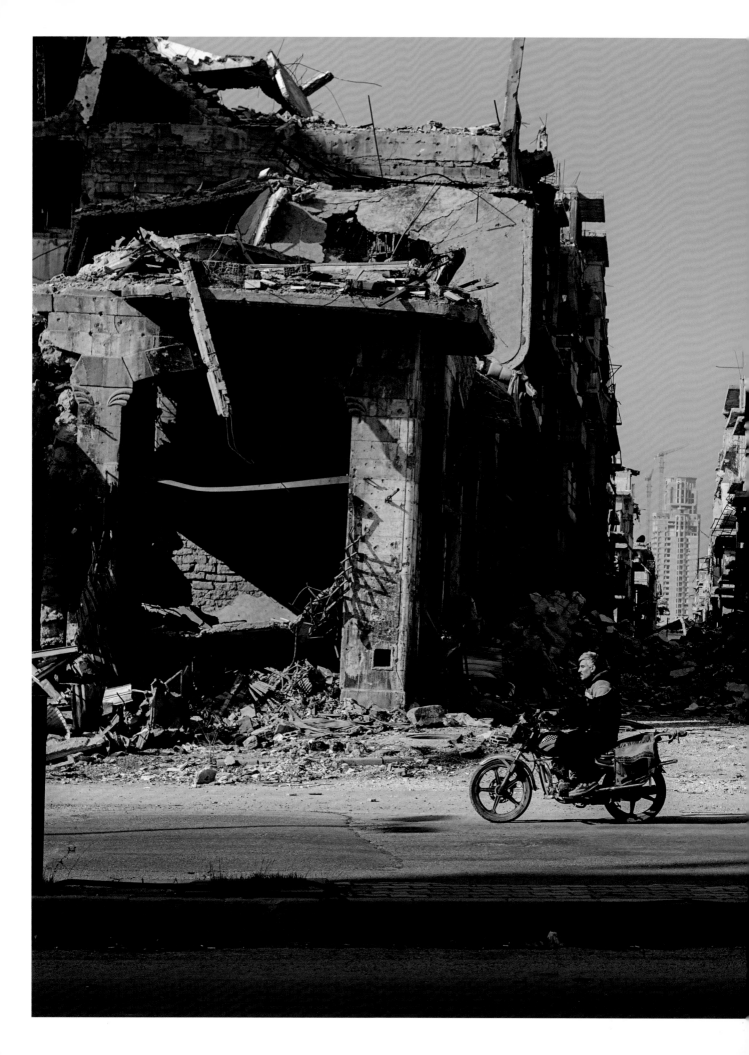

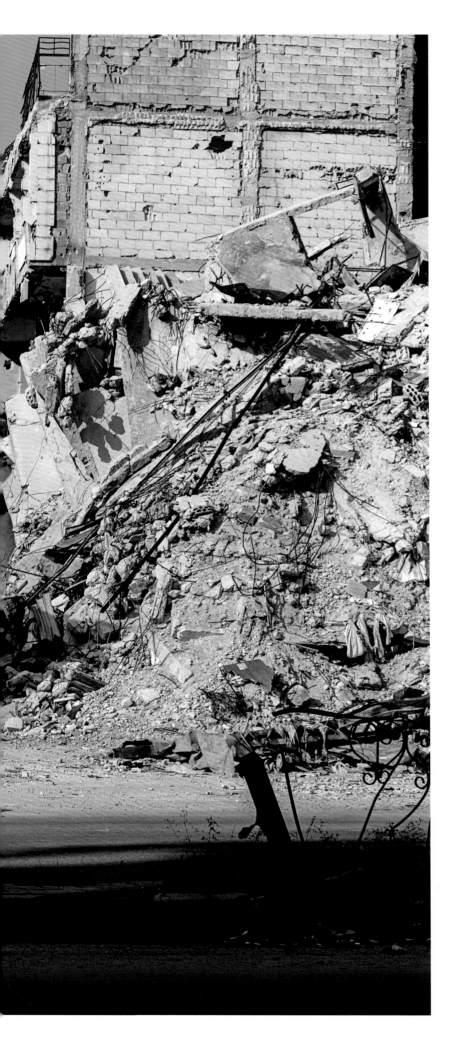

Homs, Syria, 2018
I visited this beleaguered city
during the civil war after the
Syrian regime's forces had
defeated ISIS in the city centre,
although fighting continued in the
northern suburbs. The Siege of
Homs lasted for three years, from
the start of the revolution in May
2011 until May 2014, destroying
most of the city's buildings.

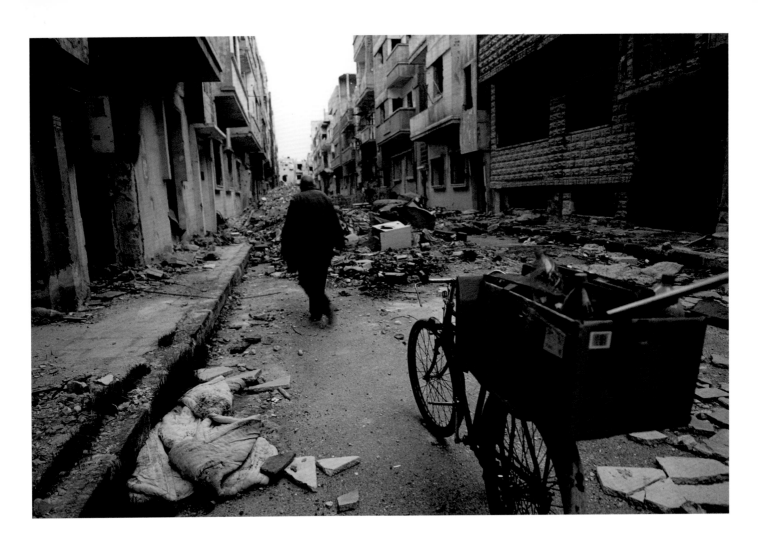

←↑ Returning Home, Homs, Syria, 2018
I met Ali Fayed in the street as he was pushing his bicycle
to the ruins of his former home. He was one of the first
people to try to return to the devastated city after it was
recaptured by government forces. He told me how all his
children had fled the country, but he had remained. Despite
the tragic circumstances, he was hopeful that Homs would
be rebuilt and that one day his family could come back.

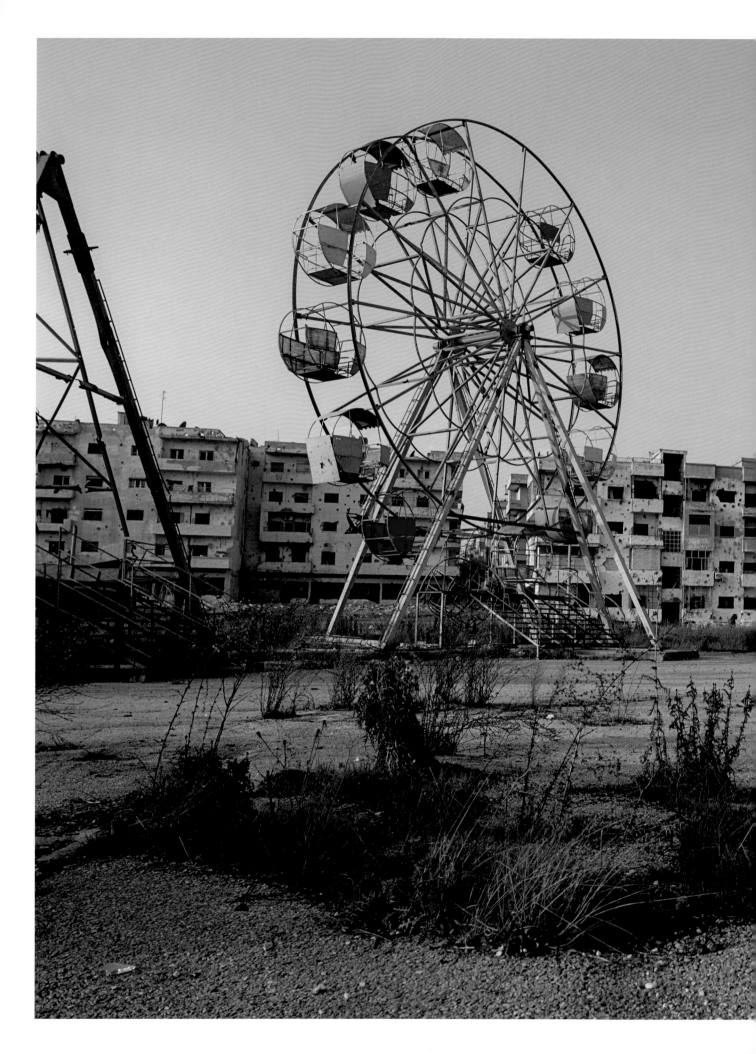

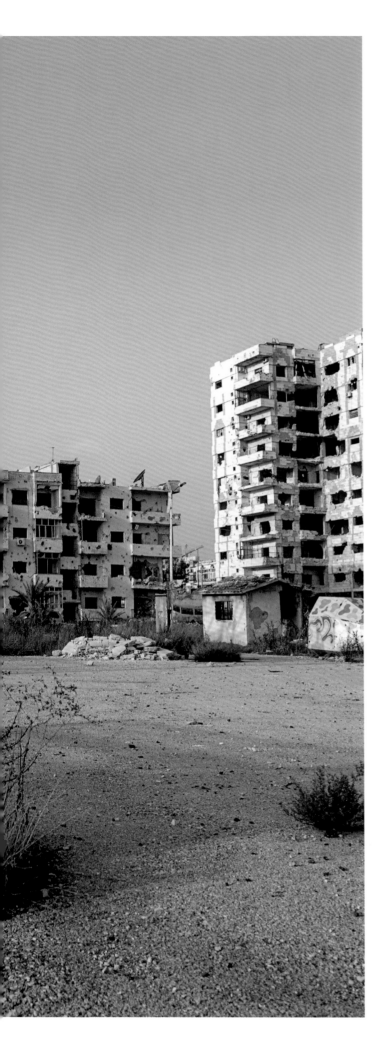

The Front Line, Homs, Syria, 2018
This Ferris wheel makes for a surreal sight standing before the bullet-scarred shells of flats in the Warik district of Homs, which served as the front line between the Syrian Arab Army and rebel fighters. Thousands of people were killed in the battle and hundreds of thousands made homeless. When I visited, the streets were eerily silent. I picked my way through the carnage and couldn't quite believe that it was real. Looking around at the broken toys, torn photographs and children's clothes strewn through the broken houses was a reminder of the terrible human cost of conflict, and that it is always the most vulnerable whose suffering is greatest.

'A camera suggests a role and a purpose, and it's a way of encouraging people to tell their own story.'

→ **City of Shusha, Nagorno-Karabakh, 2017**
The tiny enclave of Nagorno-Karabakh, high in the Caucasus Mountains, is a disputed territory between Armenia and Azerbaijan. Although internationally recognized as part of Azerbaijan, it is occupied by Armenian troops. Razor wire, landmines and trenches line its boundaries, and a thirty-year stalemate sees soldiers from both sides peering at each other, sometimes just metres apart. Occasionally, violence flares up, mortars are dropped and pot shots are fired by snipers. Across these contested highlands, entire towns and cities lie abandoned as a result of previous conflicts and ethnic cleansing.

↑ **Namin Bunyatov, Azerbaijan, 2017**
Namin was my guide through Azerbaijan. He was a former soldier in the Special Forces of Azerbaijan and had served on the front line in Nagorno-Karabakh in Europe's 'forgotten war' against the Armenians. After he retired from the army, he became a 'rope access' technician, dangling off buildings and bridges to assist with engineering works. He was a daredevil at heart and enjoyed nothing more than seeing me squirm as he hung by one arm off a high bridge. Despite being an accomplished climber and mountaineer, he went missing in the Caucasus mountains a few months after I last saw him. A search party was sent out and we hoped that he would be rescued, but it was in vain. The following spring, Namin's body was found, and it was presumed he and his fellow climbers had been killed in an avalanche.

→ **Infantry Soldier, Armenia, 2017**
In the capital city of Yerevan, Armenian troops are trained to be sent to the front line of this forgotten war. Armenia receives some support from its ally, Russia. Armenians call the Azeris 'Turks', and make no distinction between them and their former Ottoman oppressors, who slaughtered hundreds of thousands of Armenians in the Armenian Genocide of 1915. The hatred between the two races is tragic, and I saw little hope on either side that it would be reconciled any time soon.

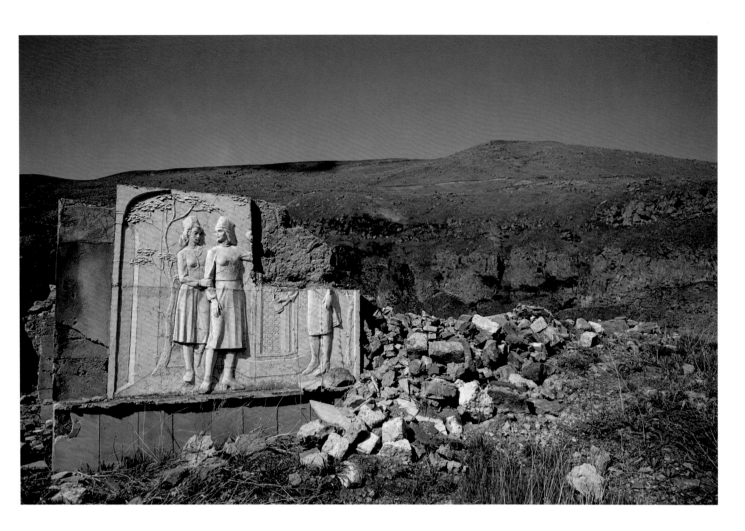

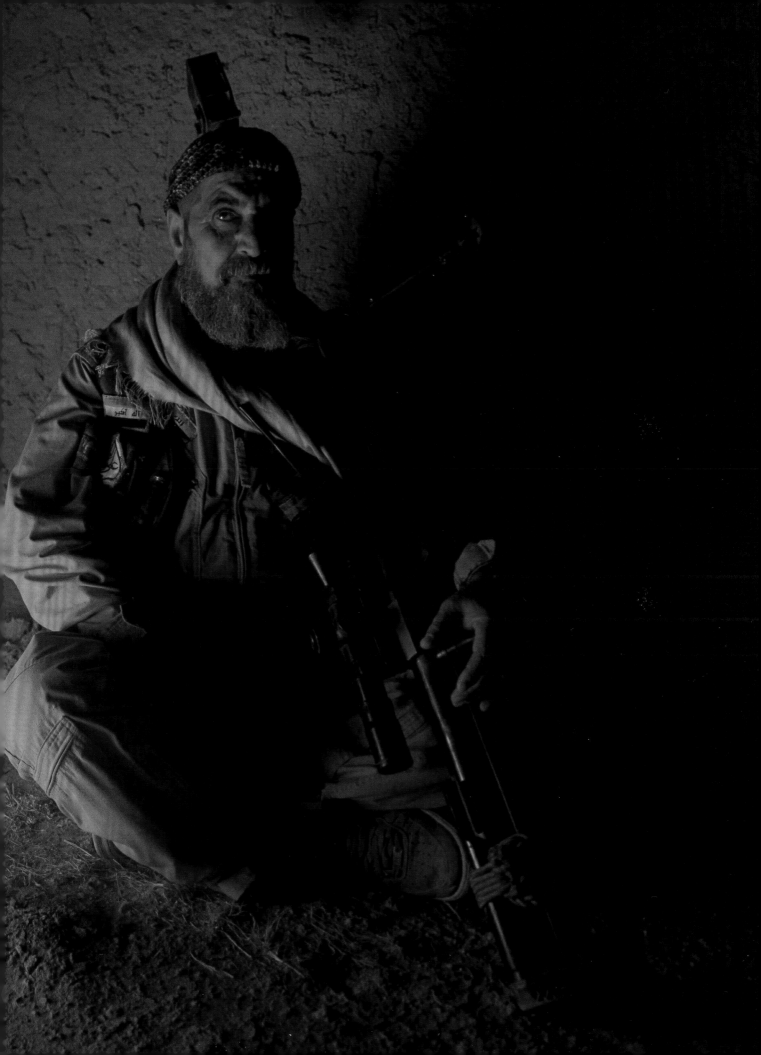

↖ Abu Tahsin al-Salhi, Iraq, 2017

Perhaps the most feared warrior in Iraq, Abu Tahsin al-Salhi, nicknamed 'Hawk Eye', was a sniper in the infamous Hashd, or Popular Mobilization Forces: Shi'ite militia who rallied to fight against ISIS in 2014. Aged 65, he had been involved in several wars and conflicts, including the Yom Kippur War in 1973, where he fought against Israel, and the Iran–Iraq War of the 1980s. He was trained by the Russians in Chechnya and had fought against both British and American soldiers in Basra and Fallujah. He preferred a .50-calibre, long-range, Czech-made sniper rifle and usually operated alone. He claimed to have killed over 340 people. I interviewed him as his unit moved forward against ISIS in the Hawija offensive in late September 2017. He was killed by ISIS a week later.

↓→ The Road to War, Iraq, 2017

As part of the Hawija offensive in September 2017, volunteers from the Popular Mobilization Forces, alongside Iraqi government soldiers, Iranian militia and US advisors, advance deep into ISIS territory to flush out the last vestiges of terror organization. It is strange, although not entirely surprising, given the complex nature of hybrid warfare, to think that the Iranian-backed fighters I was travelling with at this time were pitted against the US just three years later.

The militia groups were greeted as heroes by most of the villagers they liberated from ISIS. I saw dozens of women tear off their burkhas and stamp on the ISIS flags after three years of oppression. The Hashd soldiers handed out food and water to the locals, who complained that, under ISIS, they had not been allowed to visit the local markets or have access to electricity.

Many of the children being liberated were born under ISIS rule and had been fathered by ISIS fighters.

'Conflict photography can capture moments of hope and humanity against a background of despair.'

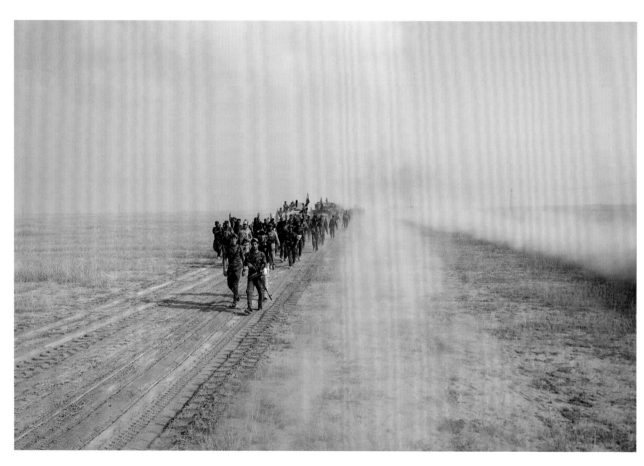

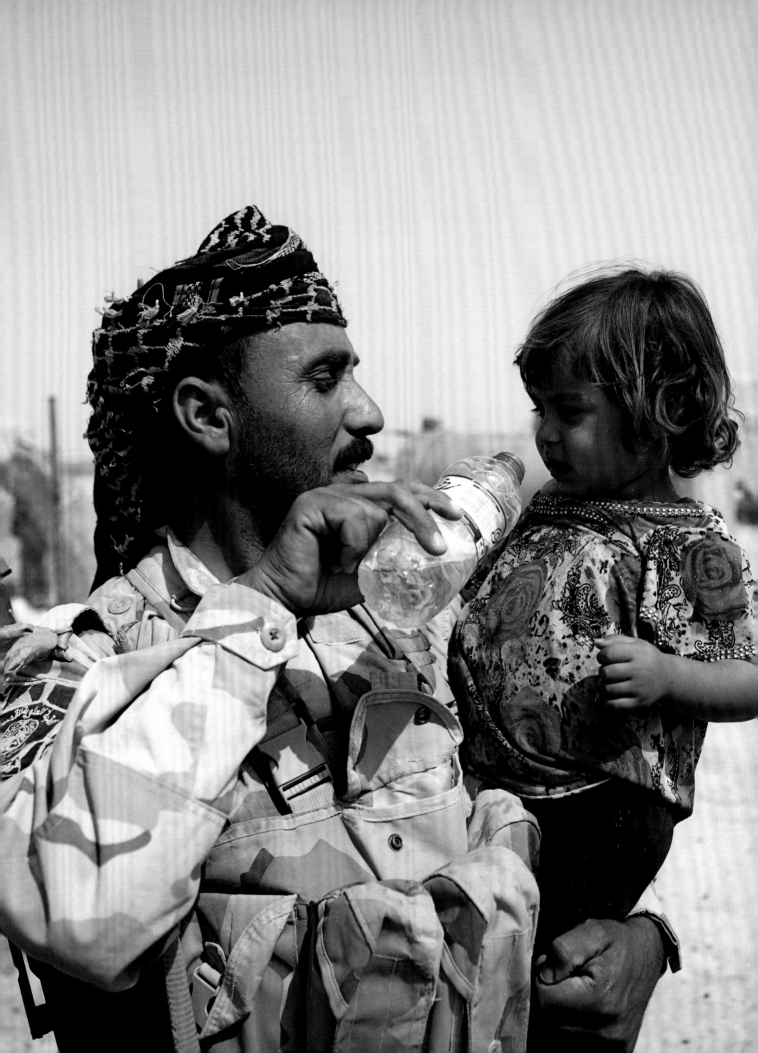

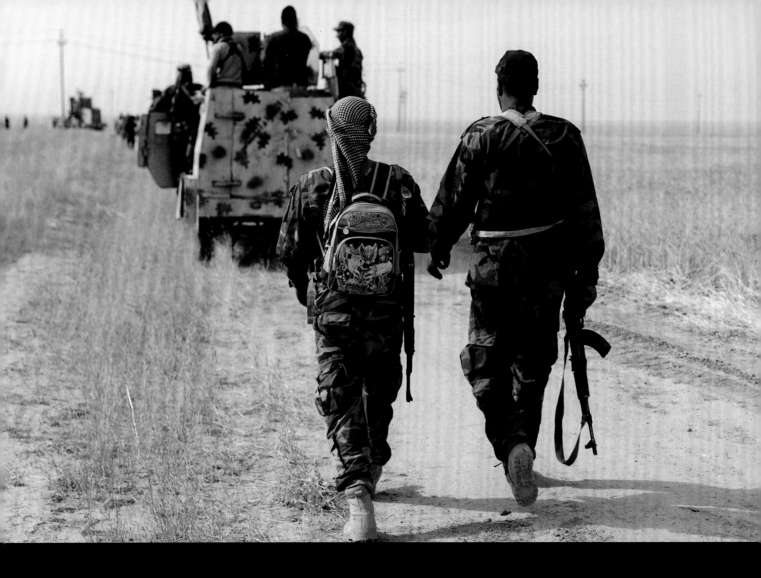

'I try to capture moments of surreal normality in the midst of conflict, which are just as important as the fighting itself.'

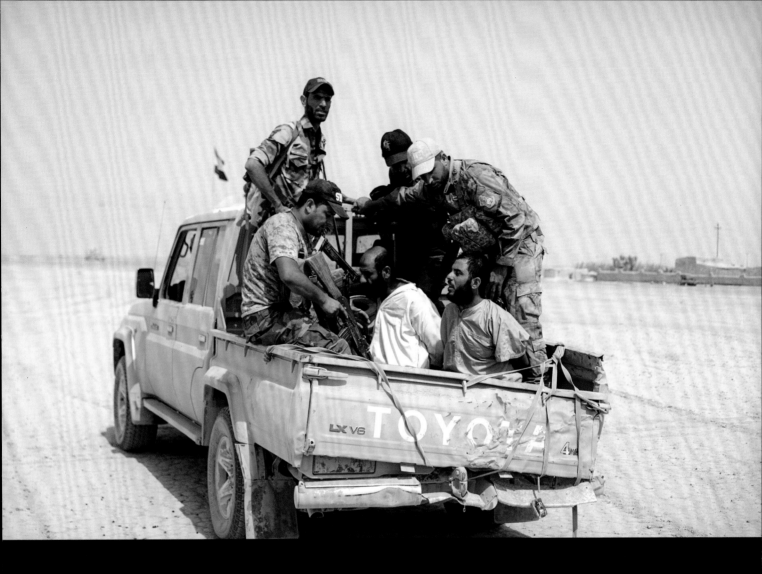

←↑ Hashd Troops Moving Out and Suspected ISIS Fighters, Iraq, 2017

After days of heavy fighting, the Iraqi forces progressed through the plains of Hawija, liberating villages and towns. I was embedded with the Hashd troops as they assaulted ISIS positions. It was one of the most intense battles I have witnessed: helicopter gunships pummelled the enemy positions before a column of two hundred vehicles, including thirty tanks, attacked. ISIS tried to escape but were picked off one by one. After the village was taken and searched, the civilians came out to celebrate their liberation and informed the commander of the whereabouts of two ISIS fighters who had dropped their weapons and tried to blend in. The fighters were captured and bundled into a pickup truck to be taken away for interrogation. Their fate

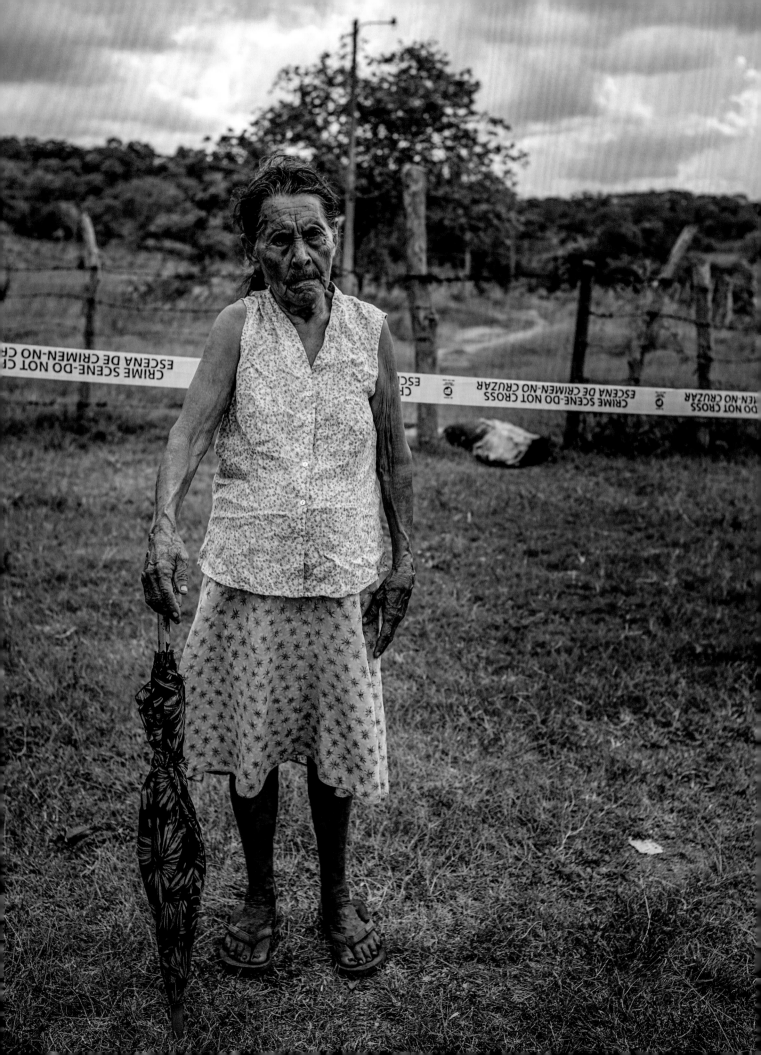

Maria and Alfonso Pavón, Honduras, 2016
After visiting the town of San Pedro Sula in northern Honduras, I came across a commotion in a nearby village. As I approached, I saw the gruesome corpse of a man who had been shot in the head. Locals had gathered around to see what had happened and I met this lady, Maria Teodora Pavón. She explained that the dead body was that of her own son, Alfonso. Normally, I wouldn't photograph such a grisly scene, but she insisted I capture the moment and stood in tragic stillness. She wanted to tell the world her story. Alfonso was a serial thief, known locally as a burglar with a history of domestic violence. He'd even tried to kill her once. In Honduras, such disrespect doesn't go unpunished. He'd been killed the night before by an unknown assailant.

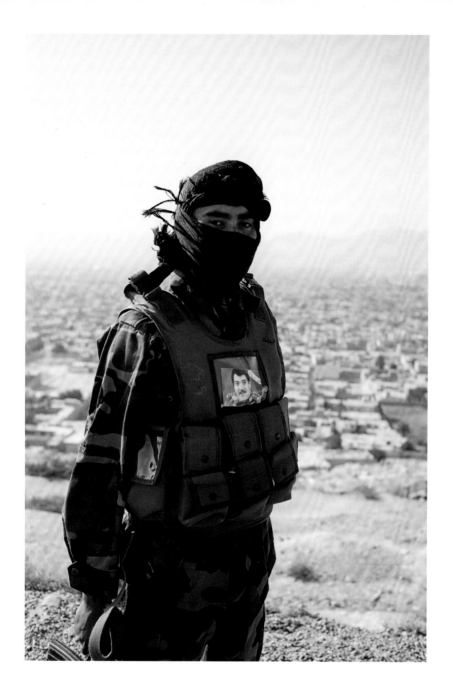

← Soldier of Dostum, Afghanistan, 2015
This fighter stands guard in Kabul's Wazir Akbar Khan district. It is under the protection of General Abdul Rashid Dostum, one of Afghanistan's most powerful and feared warlords, notorious for changing sides in the decades-long civil war. Afghanistan has dozens of ethnic minorities and tribal conflict is rife. The leaders often switch allegiances and own private armies. This man was happy to be photographed with a picture of his master clearly displayed on his body armour, but he didn't want his own identity revealed.

→ Yasser, Egypt, 2014
Yasser is a Coptic Christian living in Cairo's Zabbaleen district. In March 2011 he was savagely tortured and left for dead by a mob of fanatics from the Muslim Brotherhood, who tried to decapitate him. He invited me to take his picture in his house and showed me the scars all over his body. Inter-religious violence spiked in the aftermath of the Arab Spring, and communities across Egypt live in fear of sectarian violence. The Copts, one of the oldest Christian denominations, frequently see their churches burned down.

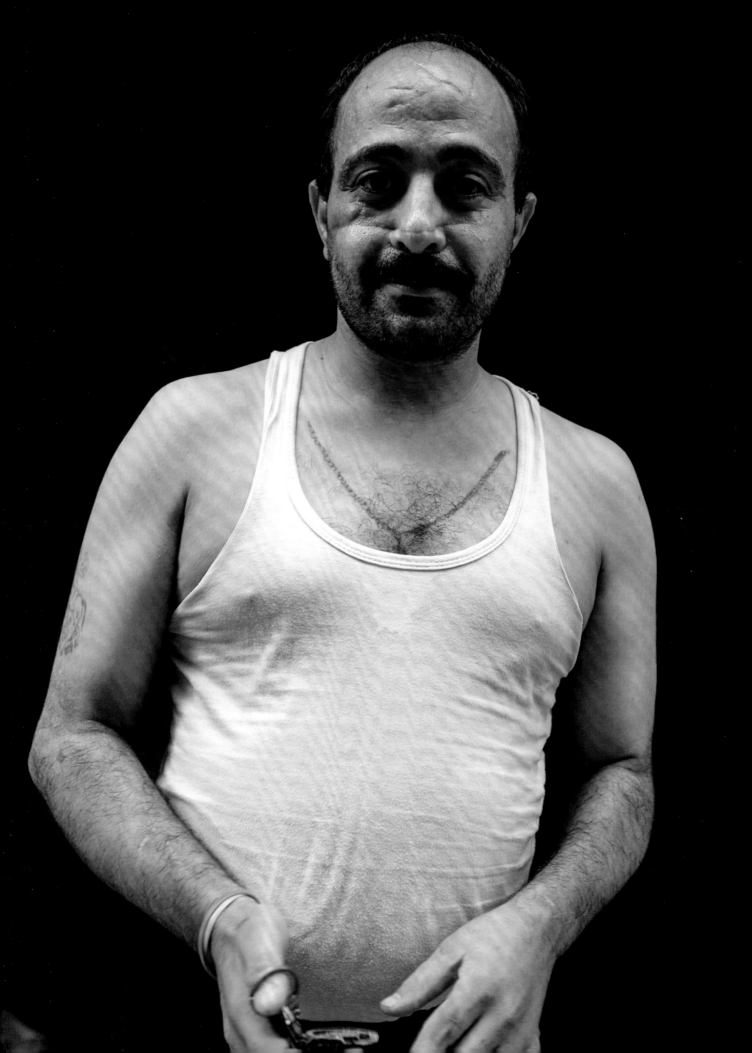

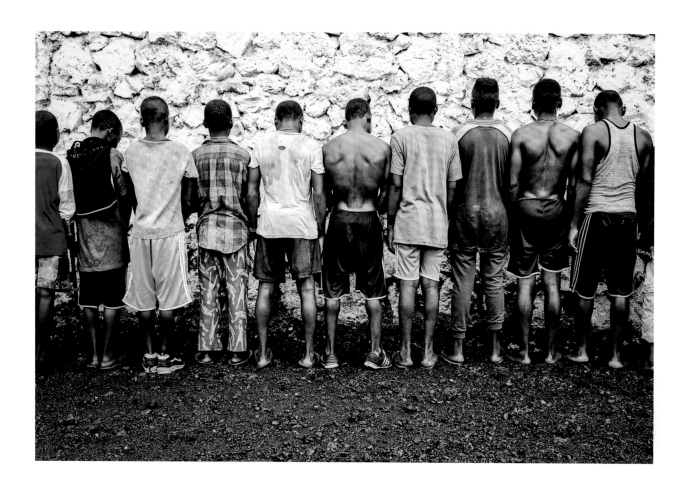

'I would like to believe that good photography is a pathway to empathy and understanding, shedding light on the incredible possibility and potential of humanity.'

← ↑ ↘ **Child Soldiers, Democratic Republic of the Congo, 2019**

I spent a week as a guest of UNICEF visiting a project to rehabilitate former child soldiers back into society. It was one of the most harrowing – and humbling – experiences of my career. These children, some as young as ten, had been perpetrators of the most terrible crimes. They had killed, raped and plundered during the vicious civil war. And yet they were all victims themselves. Most had been kidnapped from their homes and forced into slavery. Boys were forced to kill their own family, and girls given the choice of becoming sex slaves or front-line fighters. Now, after their escape or capture by government forces, many had served lengthy prison sentences. In this rehabilitation centre outside the city of Goma, dozens of youngsters were helped to cope with their trauma through normalization activities like sport, art and music. They were encouraged to be open about their past and given hope for the future. They didn't mind being photographed, but for their own safety it is the organization's policy not to show the identities of under 18s.

Haaa! Ne me tuez pas, J'ai droit de Vivre.

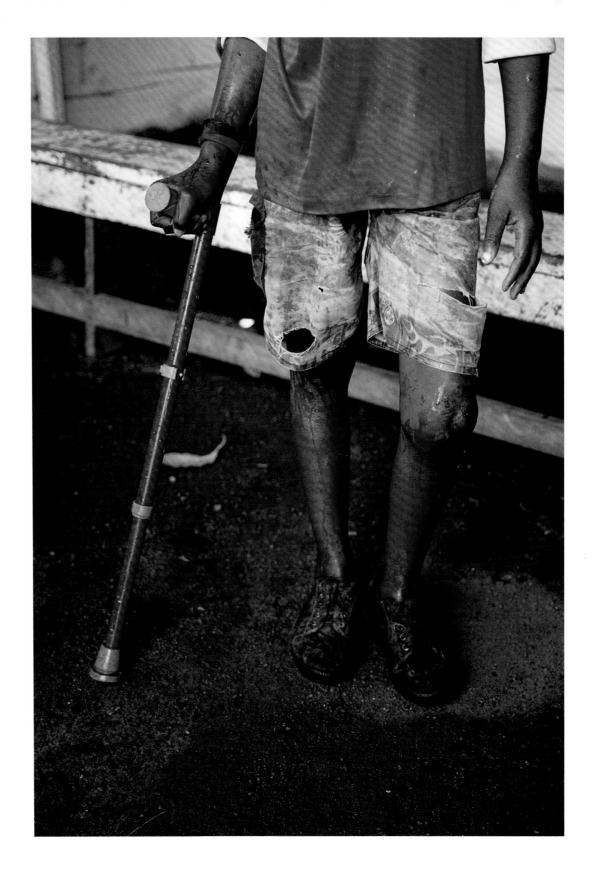

**←↑ Child Soldiers, Democratic Republic
of the Congo, 2019**

I wanted to capture the tragedy of what these children had gone through. Some had injuries from being shot or mutilated during battles. They had all seen things no child should ever see. It was hard to remain composed myself while photographing these kids, and yet they all managed to smile and seemed to retain an element of their former innocence.

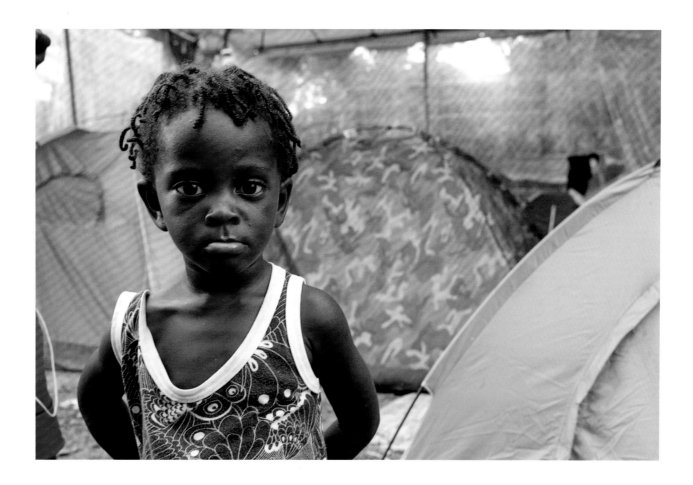

↑ Refugee Girl, Costa Rica, 2016

This little girl from Haiti was trapped in a makeshift refugee camp on the border with Costa Rica and Nicaragua as part of the 'migrant caravan' trying to travel through Central America in a bid to reach the USA. No one knew where her parents were and she had latched on to a man who was temporarily looking after her.

I have met people from all over the world who are willing to take untold risks in the search for a better life. Migration is going to be one of the biggest challenges of the 21st century, as the human population explodes past eight billion people and competition for land and resources becomes more and more problematic. Ultimately, it is the most vulnerable who will suffer.

↓ San Pedro Sula, Honduras, 2016

The ganglands of San Pedro Sula became infamous in the early 2000s as they earned the city the undesirable title of murder capital of the world. At its peak violence there were three or four killings every day. The violence is mainly between two rival gangs: Barrio 18 and MS-13. I travelled through the neighbourhoods as a guest of the rival gangs, with each group eager to show me that they were the 'good guys'. In a bizarre twist, although they didn't seem to mind showing me their torture chambers, they politely asked if I would avoid photographing the litter or graffiti as they felt it gave the wrong impression.

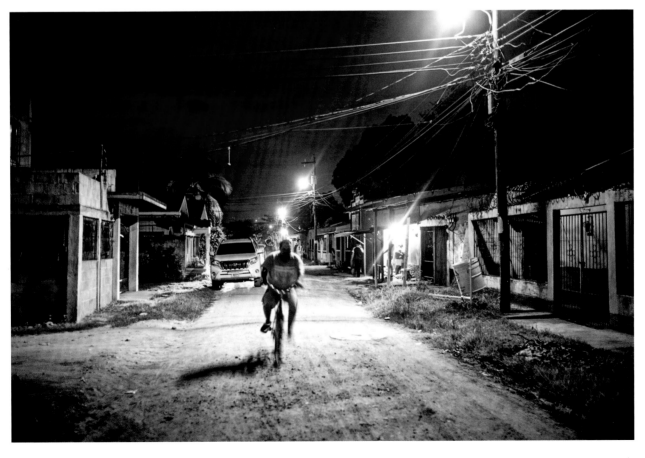

HERITAGE

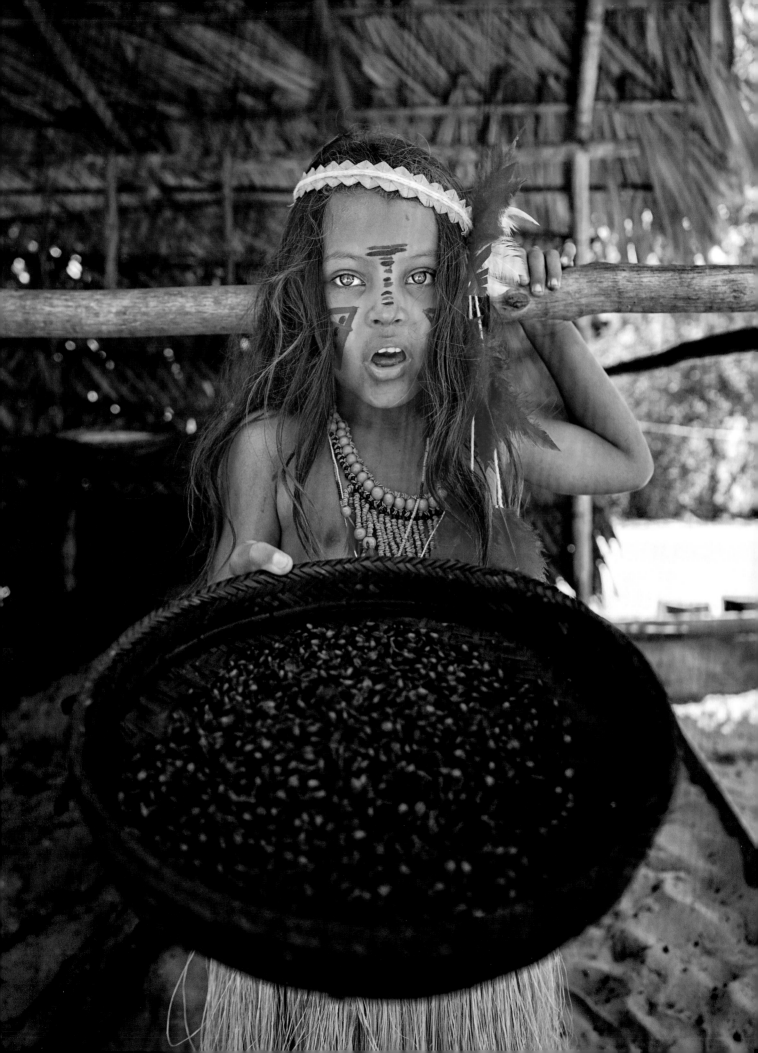

HERITAGE

Heritage is expressed in the myths, stories, rituals and customs of a place. It can be represented in the way a society dresses, migrates, speaks, dances or fights. It is something organic that we inherit from our ancestors and that develops over generations. It is affected by geography, by language, by neighbouring cultures. By this same token, heritage is always under threat, as communities increasingly come into contact with each other. This, of course, can lead to conflict, as I discussed in the previous chapter.

It is this mixture of isolated opinions and exposure to new ideas that makes travel so interesting and transformational: the opportunity to visit faraway lands and discover what their communities have decided to safeguard over the generations, past, present and future. As T.S. Eliot famously wrote:

We shall not cease from exploration
and the end of all our exploring
will be to arrive where we started
and know the place for the first time.

I have always been deeply fascinated by the legacy of culture and how cultural identity defines people around the world, from tangible assets such as a national costume or a style of architecture to more abstract ideas, religions and languages. History defines all communities, whether we like it or not, and in this chapter, I explore why our past should be understood and valued, if only to enable us to progress towards a more hopeful future.

Heritage and culture are made up of ways of life that have become sanctified and revered. Often these traditions and practices are to be protected, encouraged and held dear, but culture can manifest itself in both benign and dangerous ways. Many are difficult for an outsider to understand.

It is often hard to understand yourself and your own identity in isolation. What is exotic to one community might be mundane and prosaic to another, and I've always sought to question my own viewpoints by exposing myself to different opinions and ways of life. The ability to travel beyond the borders of my own society and to experience such a diverse mix of world views is, of course, a privilege, but I also see it as essential. It has enabled me to return home with fresh eyes and a better understanding of myself and the world in which I live. In these days of globalization, social media and information overload, I believe that it's more important than ever to see, hear and feel how other people live. I try to remain hopeful

Elouisa, Brazil, 2019

that cultures can coexist peacefully, while also retaining the positive aspects of our various heritages. However, the world is changing rapidly and no culture lasts forever. I have tried to document ways of life around the globe before traditions disappear forever, buried in an onslaught of smartphones, chain stores and Western materialism.

To witness other cultures around the globe requires you to be able to connect with other people, to be able to set aside your own notions of how things are or should be done. Essentially, there is a need to try to put yourself in the shoes of another and attempt to understand their way of being, no matter how strange or unusual it may seem. As a photographer, you need to capture images and moments that portray something different but not do so in an exploitative manner. There is a fine balance in showing empathy and understanding, yet still taking the aesthetic opportunity to capture something meaningful, truthful or beautiful.

I have been fortunate enough to have witnessed many marvels in the world, and I've made it my life's work to learn as much as I can about different ways of life on my travels. I've seen the ancient cities of the Middle East, including Jerusalem, Damascus and Palmyra. I've explored places where old meets new in Asia, Africa and Latin America. I have wandered with geishas in Kyoto, observed how connectivity has brought the hill tribes of the Caucasus into the modern world and witnessed the ever-changing growth of India as it blossoms into a superpower. I've seen the Iraqi marshes repopulated after a generation was expelled into a desert wilderness; by coming back, the Marsh Arabs re-established a way of life that has existed since the beginnings of civilization itself. I have met with Sufi shamans in Pakistan, with their unique rituals and perception of Islam. In Nepal, I've visited great temples that serve as looming artefacts to the ancient Hindu ways of life. I've met cannibal monks on the banks of the Ganges and wandered through the ruins of cities devastated by natural disaster and civil war. I have photographed those who take pride in wearing the traditional dress of their ancestors, which in itself is becoming increasingly rare. And I have witnessed fathers tell their children the same myths and stories that were told to them in times past, to keep their cultural thread unbroken. My photographs of these experiences are solely a moment in time and, of course, can never fully encapsulate what heritage means, but my hope is that they can act as a literal snapshot of culture as a traveller might perceive it right now.

One of the biggest challenges in photographing unique cultures is reaching them in the first place – both physically and emotionally. Often, what makes a place culturally unique is its remoteness and isolation from the communities around it. Even when you have made the journey to these special places, that's just the start of the challenge. Photographing people who aren't used to meeting outsiders means hours of initial conversations, breaking bread and gaining trust before the camera even comes out. It's important to earn the respect and confidence of your subject, particularly when you want to photograph their most treasured possession, whether that is their home, temple or clothing.

'Heritage is a sense of identity, formulated over many generations, and it comes in many forms.'

This chapter is a celebration of diversity: of the many thousands of traditions that make up a culture and the ways of life that have evolved to represent a community's heritage. I aim to show what life is like in places where people do not fit the mould, or where there has been a resistance to modernity. At the same time, I try not to romanticize indigenous cultures or hide how they really live. I want to show the world as it is. Many communities are being amalgamated or homogenized, which results in their people being forced to adapt and some of their traditions being watered down. Of course, many photographers lament these changes: the loss of traditional dress or dialects, for instance. As a student of history, I myself find it regrettable in many cases. But 'progress', in all its forms, means that change is inevitable, and the modern world is full of juxtapositions and surreal blends of old and new, tradition and innovation.

Technology and communication have helped millions of people out of poverty, so it should come as no surprise to see tribesmen in the deserts of Arabia or the jungles of South America wearing feathers in their headdresses while also peering at their smartphones. Most of the planet is now connected to the internet, and many a time I have been added on Facebook or followed on Instagram by a shepherd or a Bedouin nomad. Such is the way of the 21st-century world, and it is these very changes that I hope to capture as a way of recording our own moment in time, our own part in our heritage.

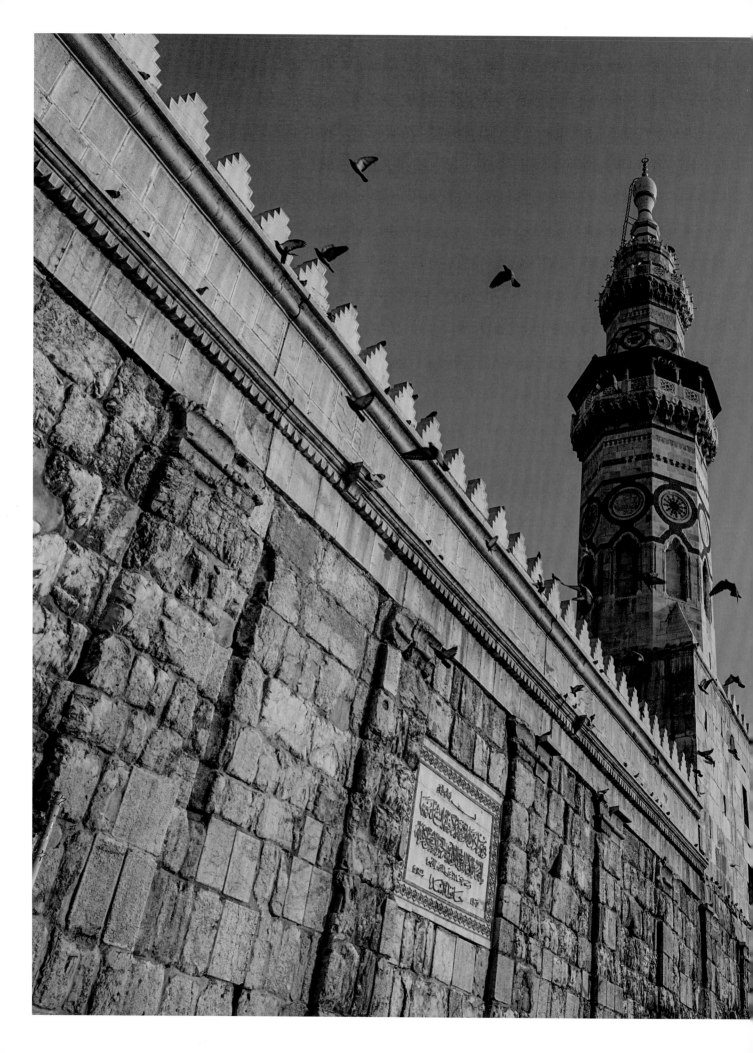

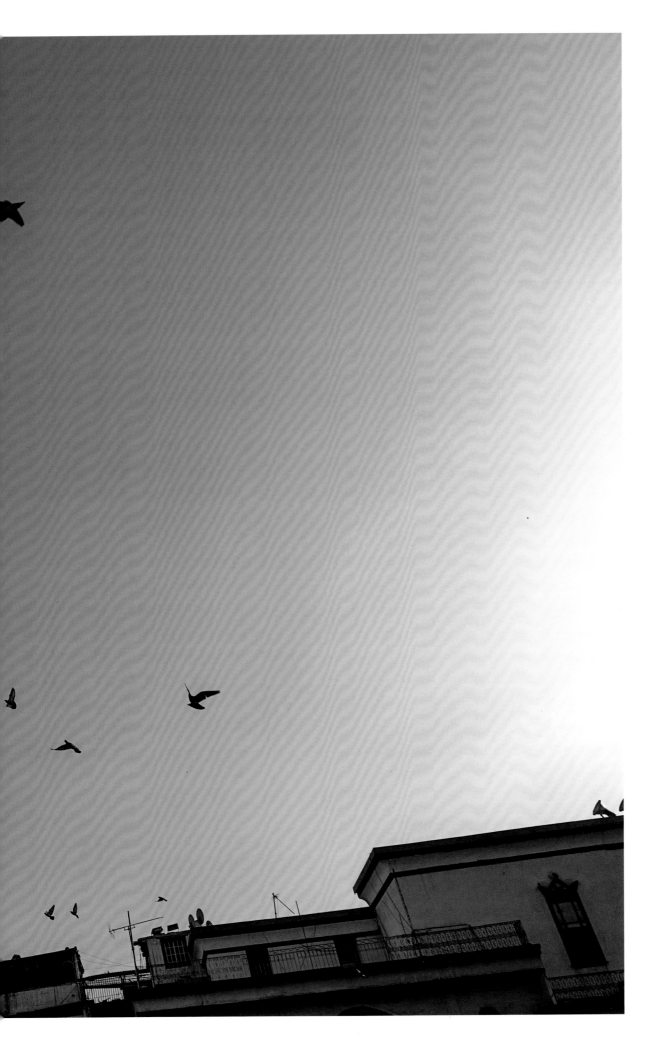

↖ Damascus Mosque, Syria, 2018
At the centre of the old walled city of
Damascus is the Umayyad Mosque. It's one of
the largest and oldest mosques in the world.
Built in 634 CE, it sits on the ancient Roman
Temple of Jupiter and a Christian basilica. It
is the spiritual heart of Islamic learning and
thousands of worshippers visit daily. Legend
says that it contains the head of Saint John
the Baptist, and it also houses the mausoleum
of the medieval Muslim warrior Saladin. It has
survived the current conflict in Syria unscathed,
even though when I was there, the sound of
bombs and gunfire could be heard in the
suburbs just a couple of miles away.

→ Abu Haider, Iraq, 2017
Near the town of Chibayish lies the gateway to
the marshlands of southern Iraq. For thousands
of years, these marshes were home to the
ancient Sumerian people, famed for their
thatched houses and peaceful civilization,
until the dictator Saddam Hussein tried to
ethnically cleanse the region by draining the
swamps. Throughout the 1980s and '90s,
thousands of these tribes fled their way of life.
One of the positive outcomes of the 2003 Iraq
War was that the marshes were reflooded.
Over the last fifteen years, they have been
gradually regaining their previous appearance
and the Marsh Arabs are returning. I spent a
few days with boatman Abu Haider and his
family, who make a living raising buffalo in the
channels and cutting grass. The sound of him
reciting ancient poetry amid this transformed
landscape remains a haunting memory.

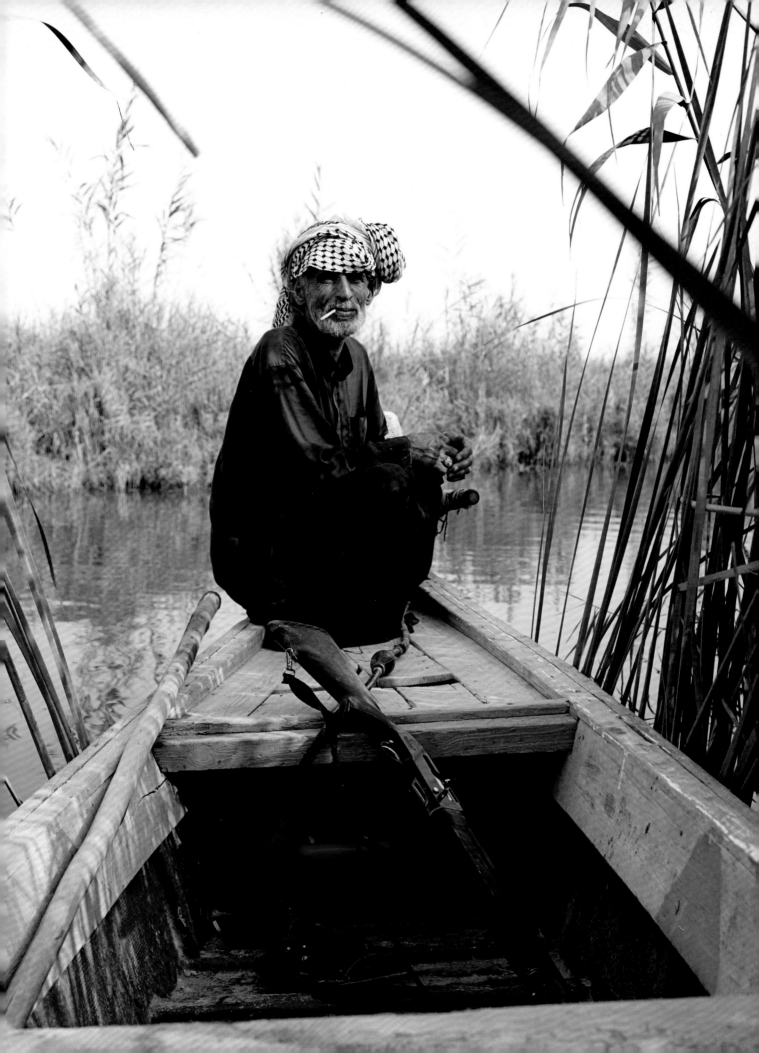

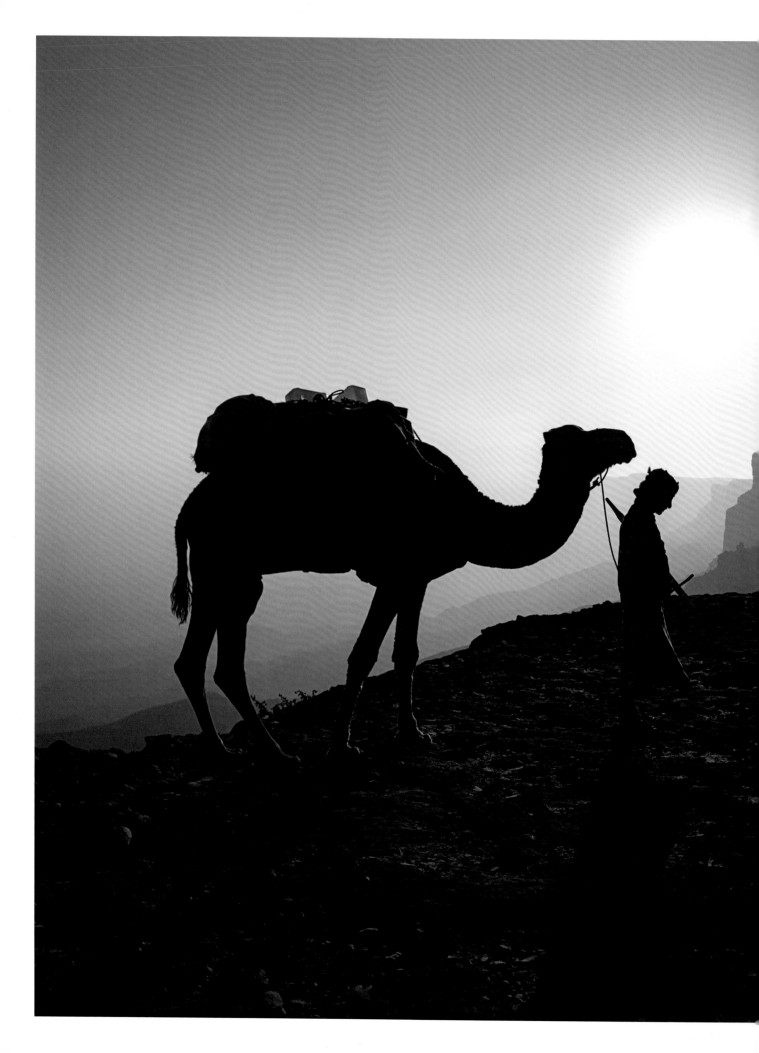

← Dhofar Ridge, Oman, 2017
The Jibbali people have lived in the crags and caves of this isolated escarpment for hundreds of years, evading the rule of the Arab sultans in both Oman and Yemen. They are legendary camel handlers and rulers over a remote highland that is transformed each year as monsoon rains – called the *khareef* – turn a brown, barren mountain into a lush green landscape for a few weeks, with hidden forests and glades known only to the tribe.

Nowadays the area is a military training area for the Oman army, to protect against Yemeni bandits and Somali smugglers, who hide out in the hills. Most of the locals now live in the towns, but a few hardy camel herders remain committed to following the ancient trails in the footsteps of their forefathers. To this day, they can be found camping out in the caves, tending their goats and collecting precious frankincense, which is then sold in the city of Salalah and burned in places of worship around the world.

↘ Palmyra, Syria, 2018
This ancient Nabataean city was once an important trading centre in the Roman Empire, forming part of the great spice route that linked East and West. During the civil war in Syria, the heritage site changed hands twice between government forces and ISIS. The terror group tried to destroy much of the architecture and succeeded in blowing up the Monumental Arch and the Temple of Baalshamin. They also used the Roman theatre to stage vile executions and mass beheadings. Some of the people murdered during this conflict had been trying to protect the city's ancient artefacts.

Now, the site is under government control and, for the time being, protected. Only time will tell if the historic city will be restored.

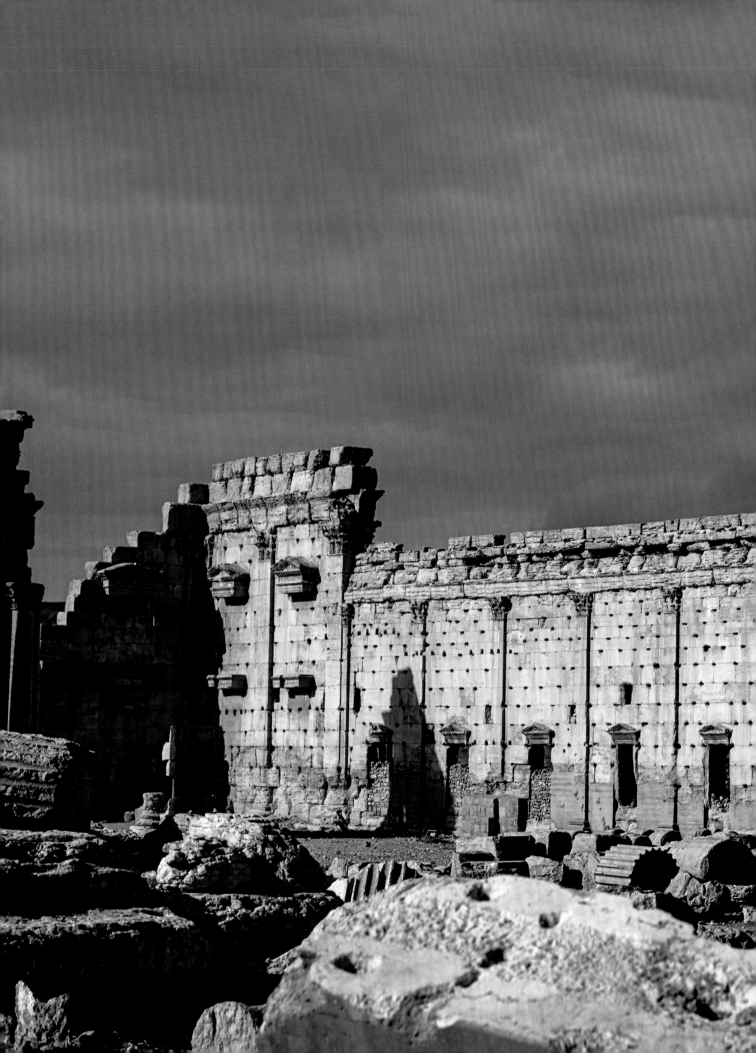

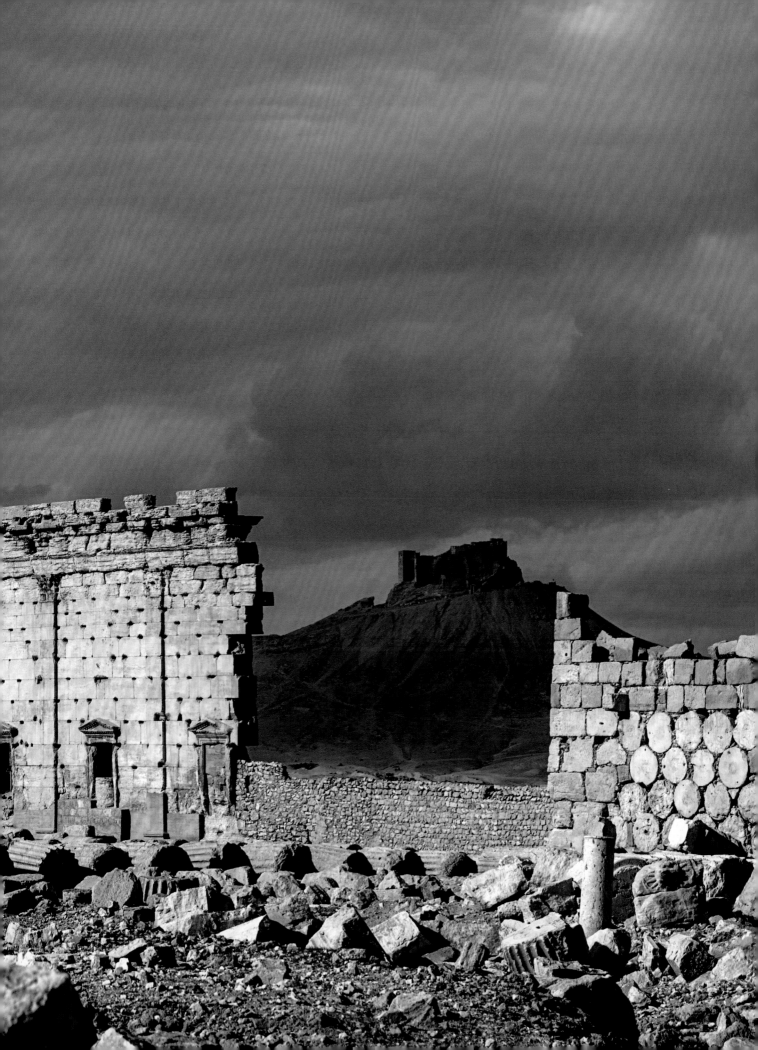

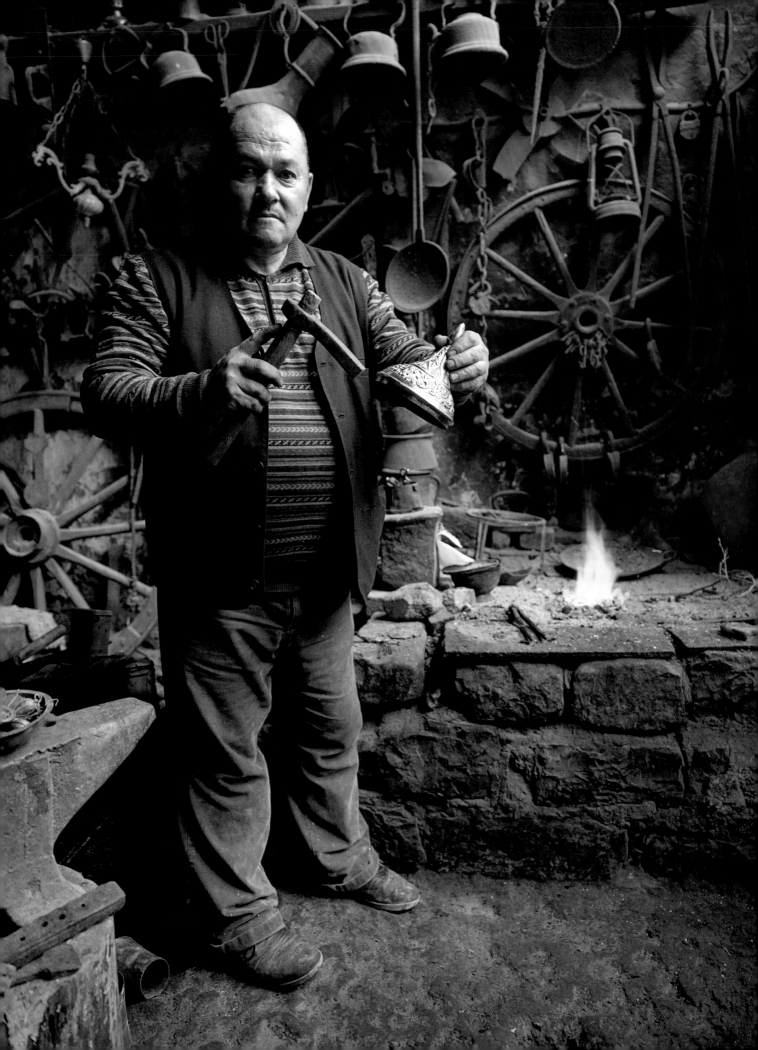

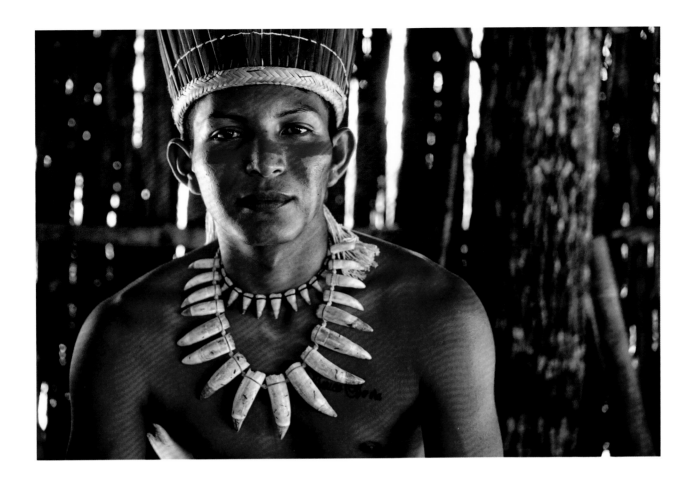

← Metalsmith, Azerbaijan 2017

Copper has forged the history of the Azeri village of Lahij. The community, nestled in the southern Caucasus, seems frozen in time. Kablemi Aliyev is a seventh-generation coppersmith, who continues a historic tradition. Lahij made its name in the 18th century, supplying the Middle East with copperware and firearms. Little seems to have changed since then. One of Kablemi's forefathers started the family business in 1725, and his own father initiated him in the art of copperwork when he was just a child.

↑ Dessana Man, Brazil, 2019

In the heart of the Amazon rainforest, the indigenous Dessana communities live in small villages on the banks of the Rio Negro. In recent years, many people have left the forest to settle on the outskirts of the city of Manaus, giving up their traditional way of life. In some places, though, heritage is retained through tourism initiatives, which help generate an income. This young man came out to meet me wearing the headdress of his tribe; they usually only don traditional dress like this for ceremonial occasions or to greet tourists, wearing shorts and T-shirts the rest of the time. The feathers are from a blue hyacinth macaw, and the teeth on his necklace are from a large Amazonian caiman.

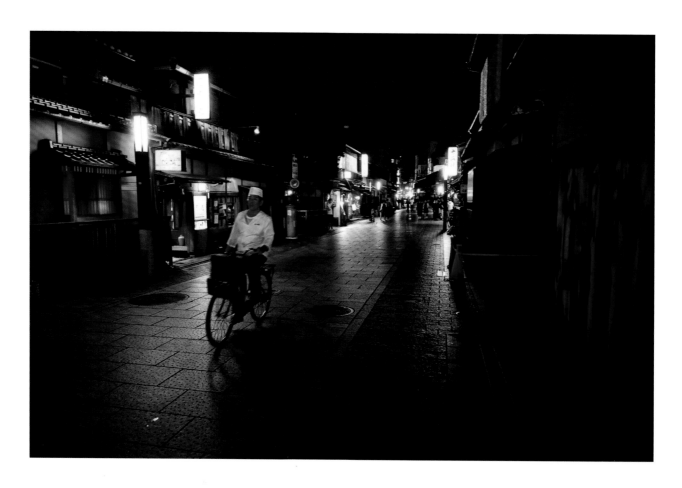

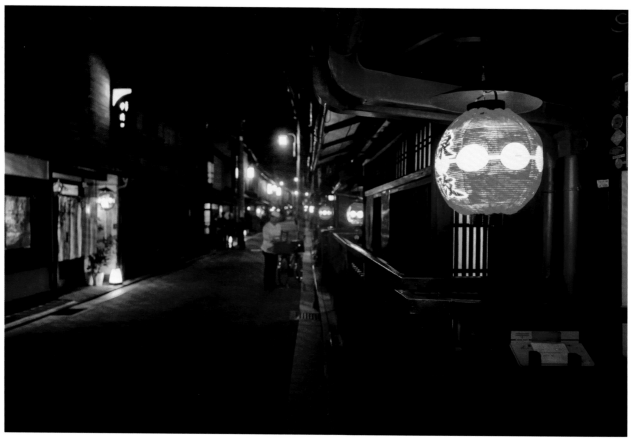

←→ Kyoto, Japan, 2018

In the charming alleyways of Kyoto's Higashiyama district, it's possible to catch a glimpse of some traditional Japanese ways of life that have disappeared elsewhere. Houses are lit by lanterns, and shrines are found at every turn. You can even spot geishas, wandering in their flowing kimonos under the cover of paper umbrellas. Japan represents a culture where old and new seem to collide everywhere in the most unusual of ways.

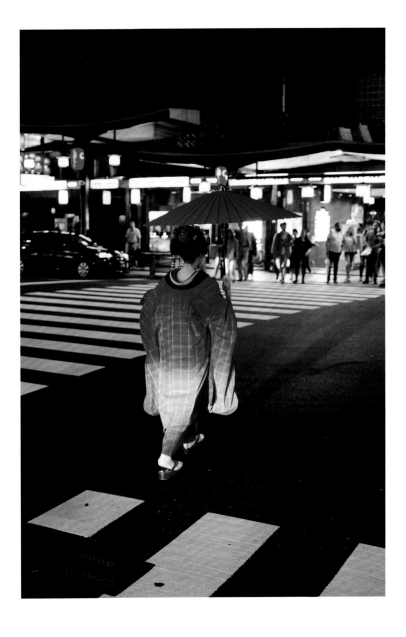

'As more and more people have access to better and better equipment, I believe that unique vision and the ability to put yourself in the right place at the right time will be what sets successful photographers apart.'

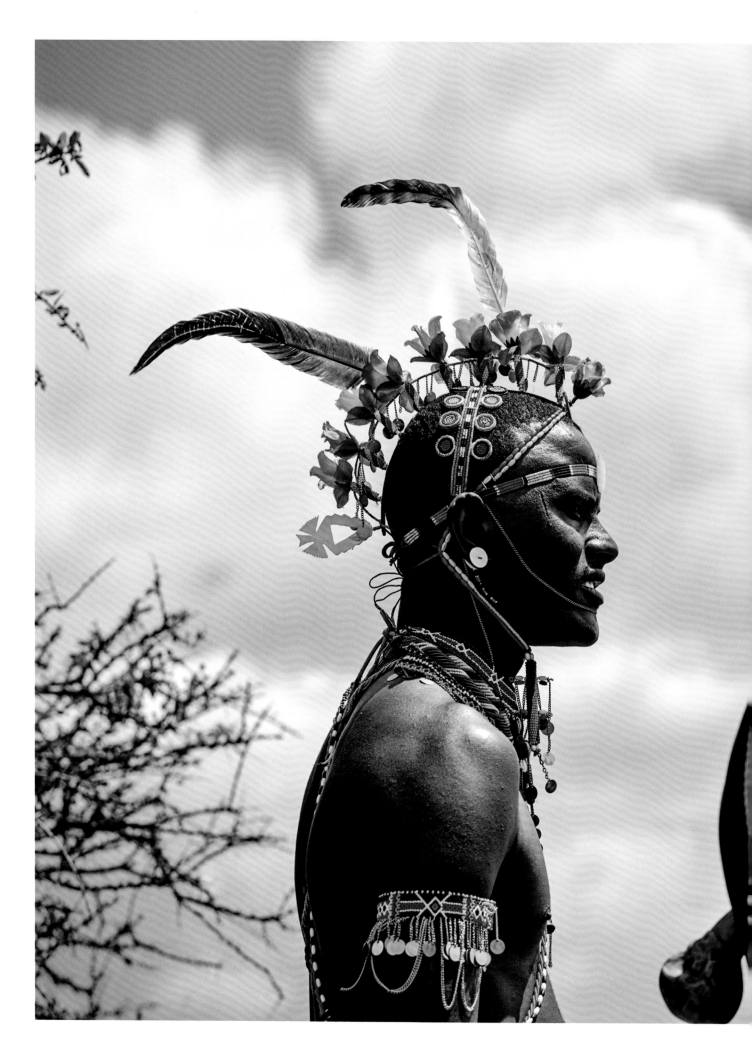

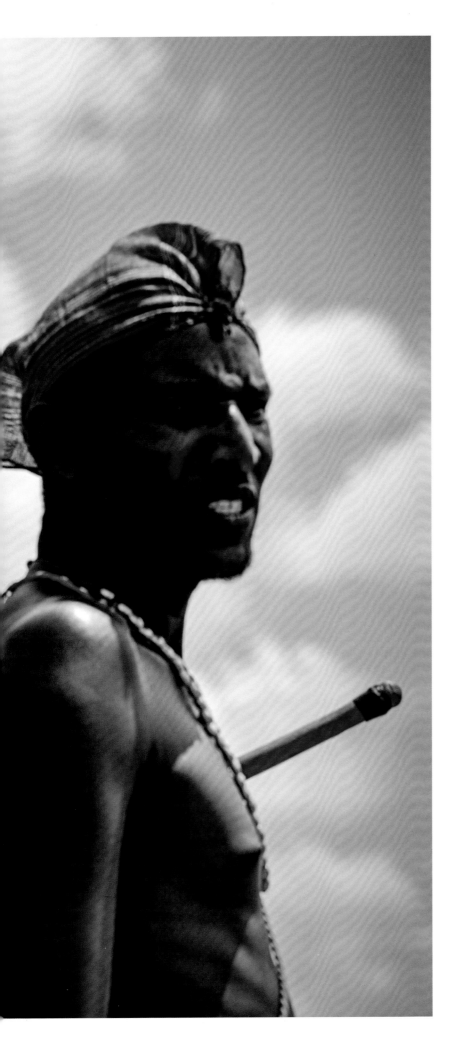

Maasai, Kenya, 2018
In Laikipia County in northern Kenya, Maasai and Samburu tribesmen still wear traditional clothing across rural Kenya (even if there are a few modern flourishes like the plastic flowers worn here). Many of these famous warriors may now have mobile phones, but they have retained a unique pastoralist culture, keeping cattle whose milk and blood they drink as a staple diet. This calcium-rich fare is said to be why the Maasai are one of the tallest communities of people in Africa.

Adab Shah, Afghanistan, 2011

Adab Shah Gouhari, a descendant of Afghan royalty, rides a stallion across the high Pamir mountains of the Wakhan Corridor in Northern Afghanistan. He acted as my guide and negotiator on an expedition in search of the source of the famed Oxus river across what is known locally as the Bam-i-Dunya – the 'roof of the world'.

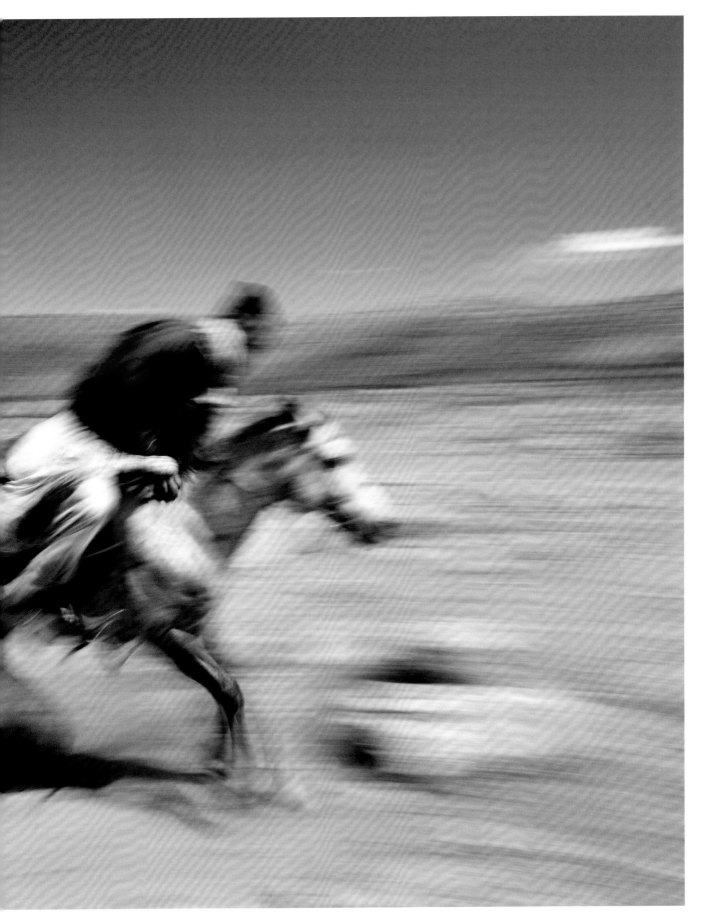

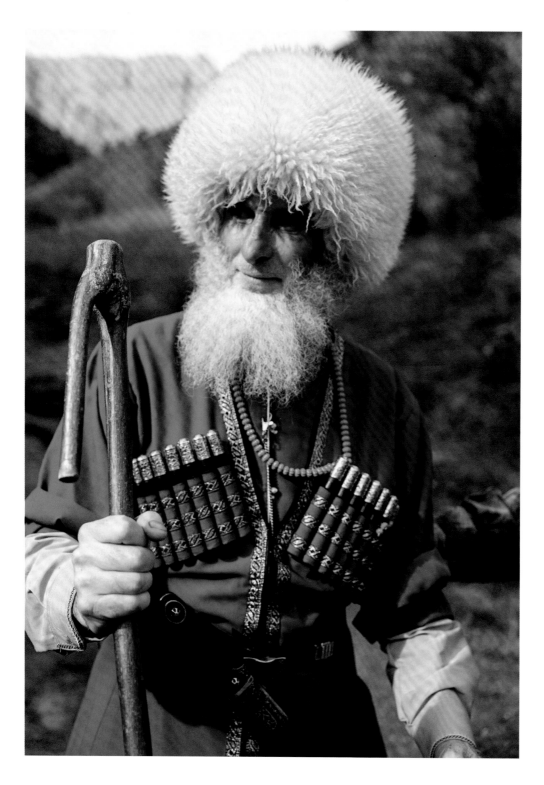

↑→ Caucasians, Russian Federation, 2017

In the mountains of the North Caucasus lie several Islamic republics where fiercely independent tribes pride themselves on retaining a separate identity and heritage despite officially being federal subjects of Russia. The Ingush and Chechens have a fierce reputation as warriors, and many still wear the traditional sheepskin hats and straight-bladed daggers of their forefathers.

In Grozny, I attended a wedding, where the wedding party wore traditional costume.

The custom is for the groom to 'kidnap' his bride. In the past, a suitor would ride off with the woman of his choice on horseback, aided by a gang of his friends and brothers. Thankfully, these days the 'kidnap' is merely ceremonial, and usually involves a motor cavalcade of the groom's side of the family. In this case, the men were all armed with Uzi sub-machine guns, and fired off a volley of bullets into the air as the convoy screeched through the city, parading the 'captured' bride.

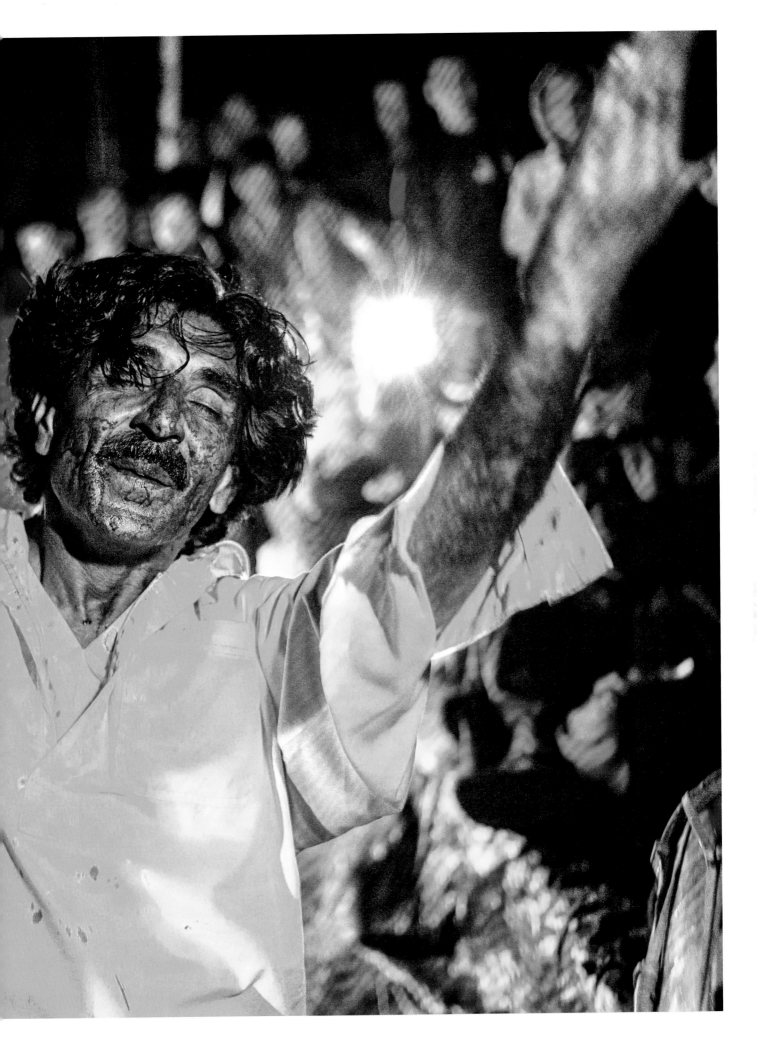

↖ Shaman, Pakistan, 2015

Under the shadow of the Karakoram mountains, in the Hunza Valley, an ancient pre-Islamic shamanism somehow blends seamlessly with Muslim practice. In some villages, shamans, known as Bitans, lead ceremonial dances. The Bitans must inhale the smoke of juniper leaves and drink the fresh blood of a decapitated goat in order to enter the spirit world as they twirl to the music and beating drums. It's a shocking and visceral thing to watch. This man ended up dancing straight into a burning bonfire but luckily escaped unhurt.

→ Golden Temple, India, 2015

In Amritsar, the glistening Harmandir Sahib is the spiritual heart of Sikhism. It was built in 1604 by Guru Arjan. Nowadays, 100,000 worshippers visit the holy shrine daily. Visitors of all faiths are welcome to enter. You are even allowed to eat and sleep, free of charge, for three days and three nights in the temple's communal accommodation. India is the world's largest democracy, and its citizens are free to worship whichever gods they choose. There are 24 million Sikhs in India, making up 1.7 percent of the population.

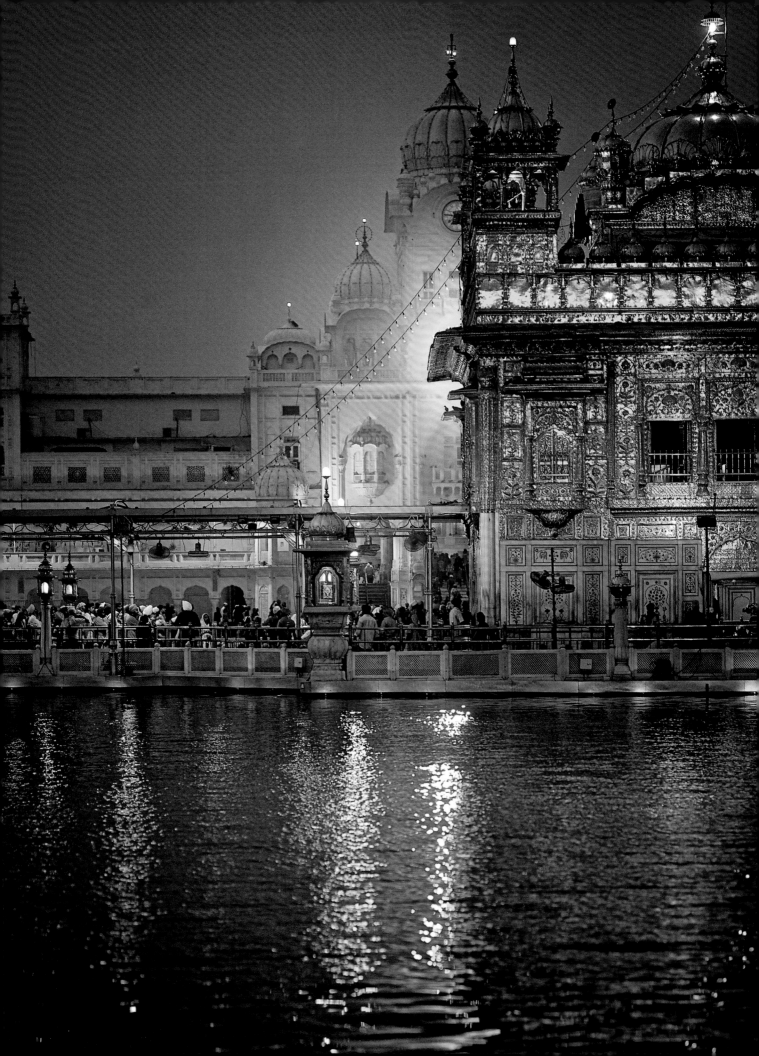

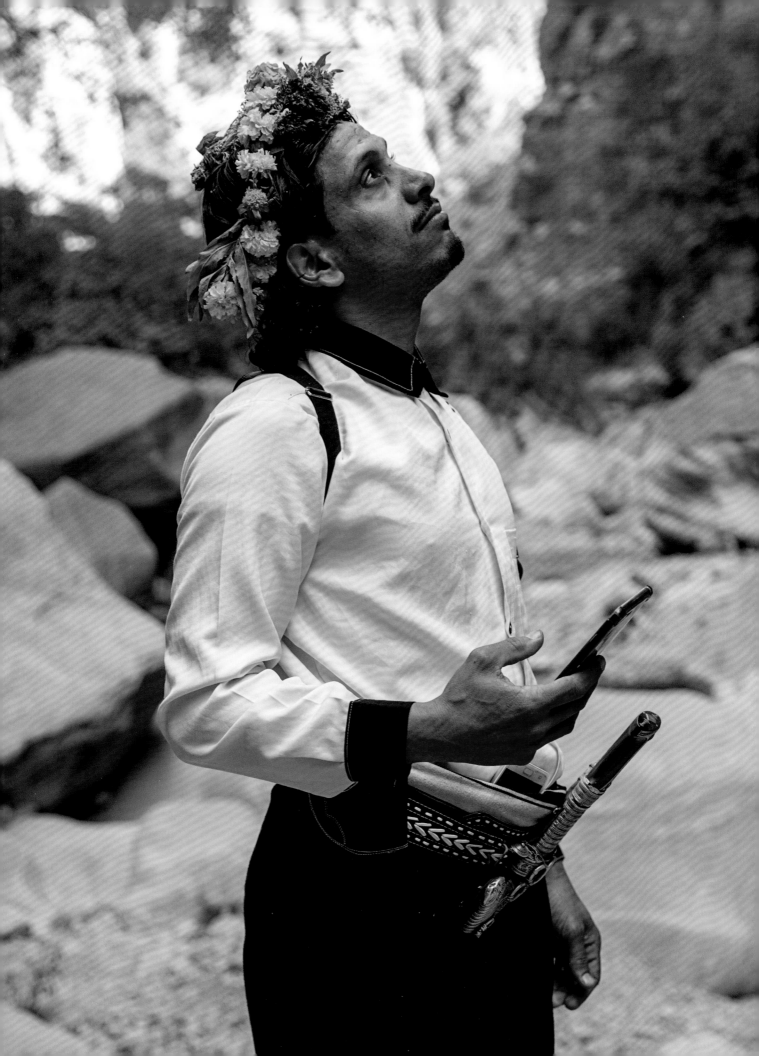

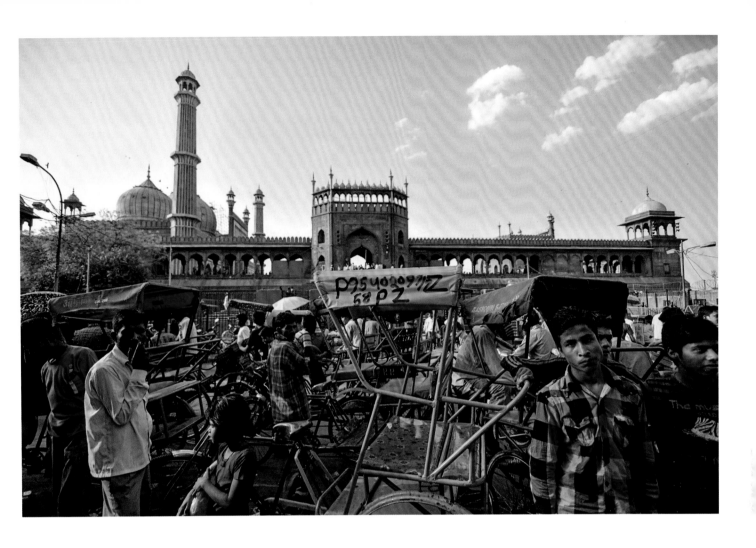

← Southi Al-Reithi, Saudi Arabia, 2018
High in the Asir Mountains, the men of the Qahtani Bin Amir tribe wear flowers in their hair as a symbol of masculinity. I met Southi close to the border with Yemen. He wore the traditional curved dagger of his ancestors and a floral garland in his hair. But, in a surreal twist, he also whipped out his smartphone and asked to follow me on Instagram. In Saudi Arabia more than 60 percent of the population is under 30, so change is coming – and fast.

↑ Jama Masjid, India, 2011
At the heart of Delhi's old city lies the Jama Mosque. Built by Emperor Shah Jahan in the 1650s, it represents one of the jewels in the Mughal architectural crown, alongside the nearby Red Fort. It's one of the biggest mosques in the world and its courtyard can hold more than 25,000 worshippers. Every time I visit Delhi, I always spend a few hours wandering around its beautiful halls and gardens to escape the chaos of the city.

'My photography is all about documenting a moment in time: capturing the essence of a person and place in harmony.'

→↘ **Pashupatinath Temple, Nepal, 2019**
On the banks of the sacred Bagmati River lies the holy Hindu temple of Pashupatinath. Every day, dozens of cremation ceremonies are performed. Bodies are stacked on the *ghats* and burned on wooden plinths, with the ashes being swept into the river. I was reluctant at first to photograph these scenes, but a grieving family member approached me and assured me it was fine. He explained that, in Hinduism, death is merely a formality and reincarnation is assured.

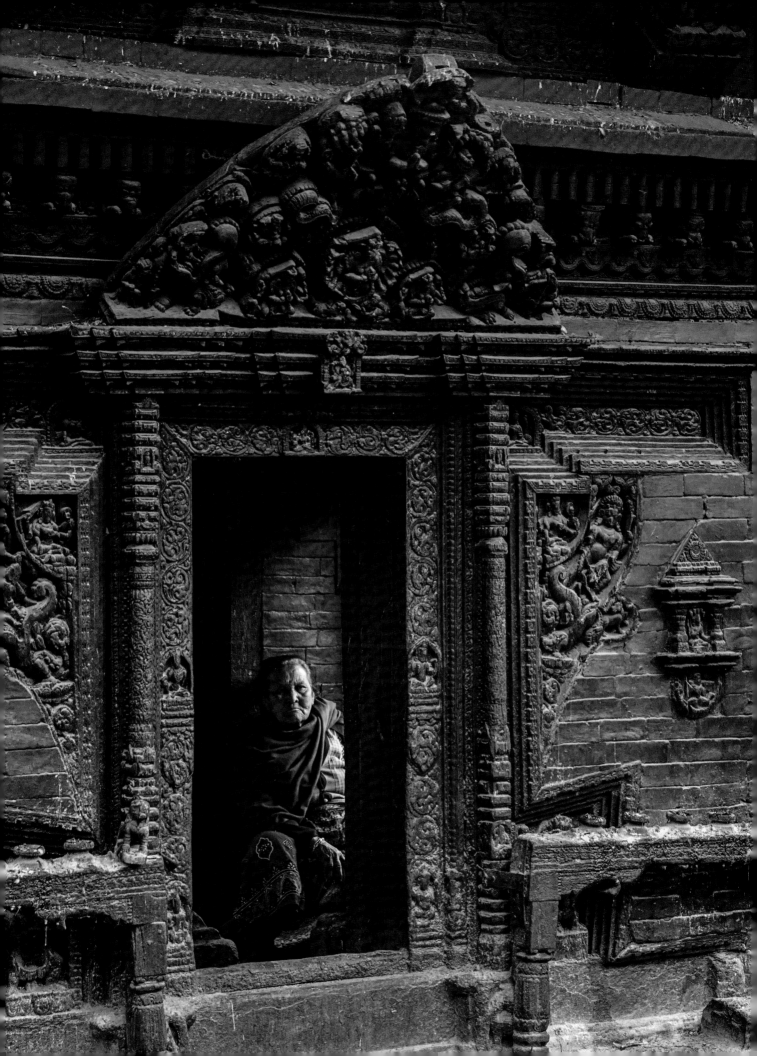

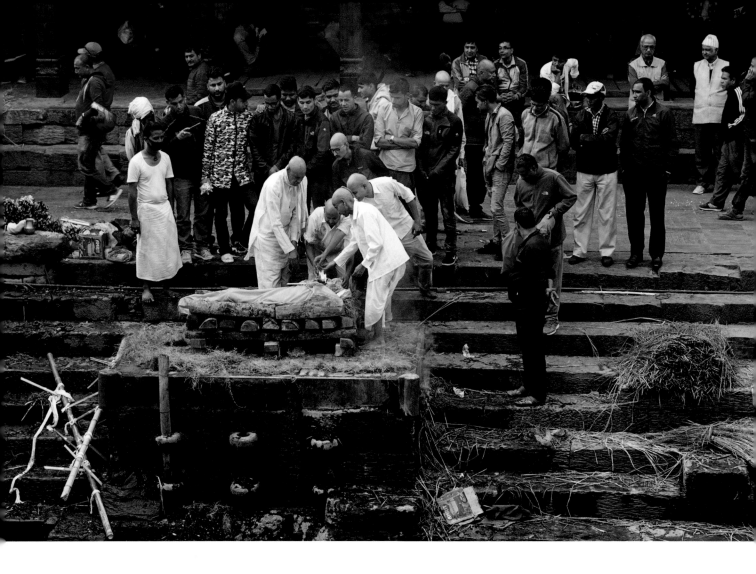

'Culture gives people a sense
of meaning, something to
hold on to and hope for.'

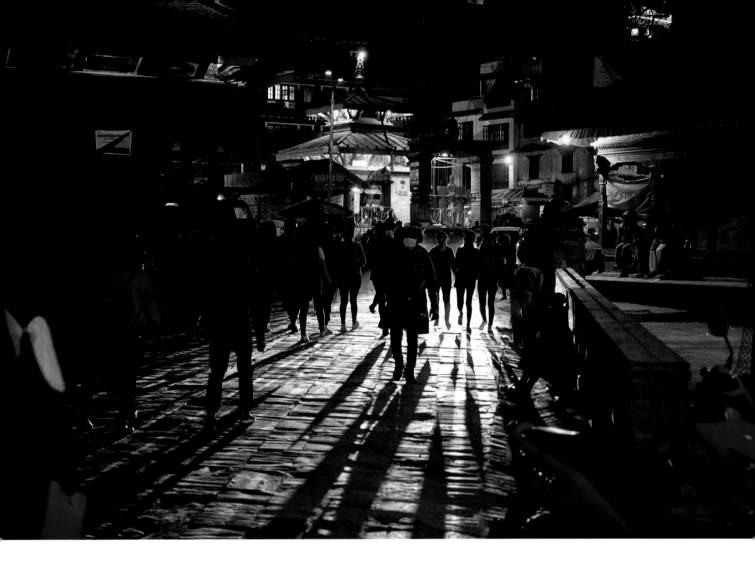

↑ Kathmandu, Nepal, 2019

Durbar Square in Kathmandu is one of the best places in the world to photograph. Filled with ancient temples and ornate doorways, it's like entering a gateway to the past. Smoke from a thousand candles fills the evening air with an aromatic haze and it's easy to while away hours watching pilgrims, monks, cows and merchants coming and going amid the hustle of this historic city. But even away from the more photographed sites, the narrow back alleys and market places make for atmospheric photography.

Kuna Lady, Panama, 2016
The Kuna tribe live in the remote
coastal areas of the Darién Gap
between Panama and Colombia.
On the San Blas islands in the
Caribbean, many Kuna have
adapted to life at sea, living in
stilted huts on tiny, rocky islands.
I met this lady selling her colourful
Molas, the famed textiles of the
region. She was shy and didn't
want me to show her face, but she
was very proud of her needlework.

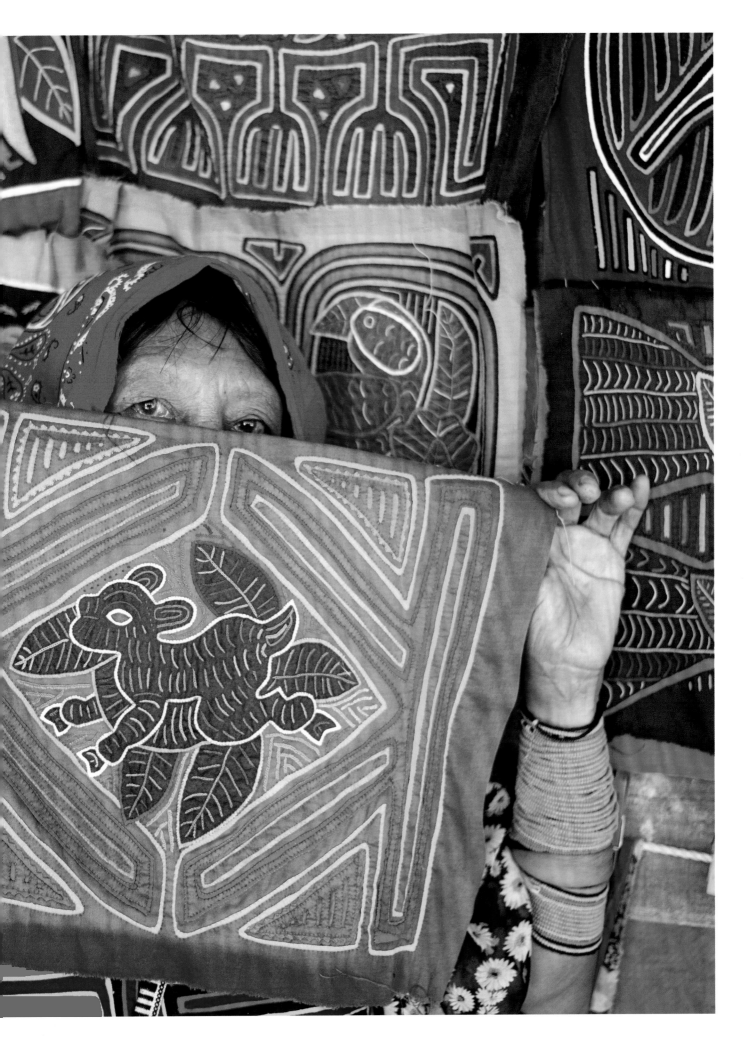

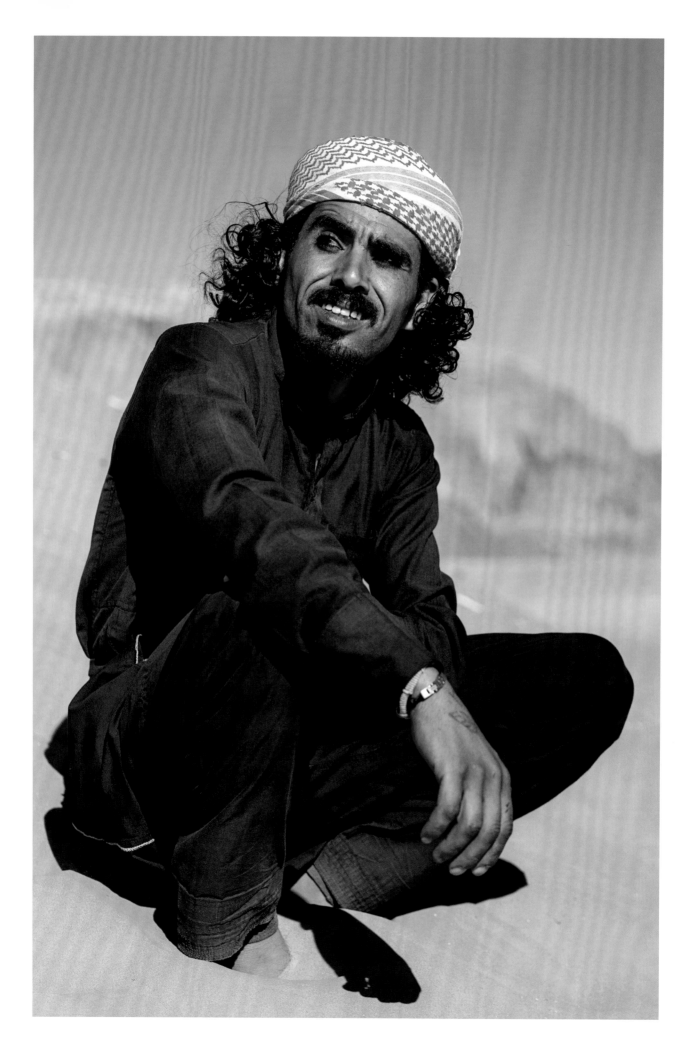

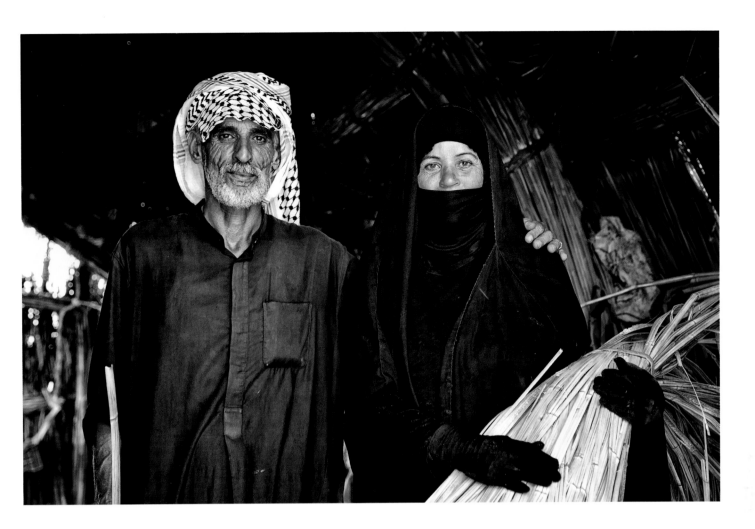

'As traditional cultures become more and more homogenized, photography is now more important than ever as a method of documenting ways of life that our children may never see.'

← **Mishael Alfaqeer, Jordan, 2017**

Mishael is a Bedouin Nomad who was born in a cave inside the ancient city of Petra. Despite his humble upbringing, he spoke fluent English, having learned to guide tourists from a young age, and he had married a Dutch woman. He loved the desert and its simplicity, and I deeply admired his humour and his philosophy, which was to live and let live.

↑ **Abu Haider and Sara, Iraq, 2017**

Living in a traditional *mudhif* thatched hut, Abu Haider and his wife live among the reeds on a floating papyrus island in the Mesopotamian Marshes of southern Iraq. Sara, dressed in the full black *abaya* typical of the Shia community in Iraq, was happy to reveal her face inside the home. They lived a very equal life, both contributing to the daily chores of collecting grasses and looking after their buffalo.

Jam Yang, Bhutan, 2015
Against the backdrop of the beautiful Tiger's Nest monastery, my friend Jam Yang is dressed in a traditional *gho*. Bhutan is considered to be one of the happiest countries in the world – arguably because it has retained its cultural legacy. All houses must conform to strict heritage regulations, which means that there are no slums or shanties in the entire country. As a result, there is little option for homelessness or youth rebellion, so people tend not to leave their village. For better or worse, it feels like a country stranded in time.

→ Kyrgyz Camel Man, Afghanistan, 2012

High in the Pamir mountains, near the border with China, live the Kyrgyz, the remnants of the armies of Genghis Khan (or so the legend goes). Now, confined by modernity to Afghanistan, they are some of the last true nomads in the world. Their ancestors were once able to move freely over the Karakoram and Pamir mountains, trading with their relatives in China, Tajikistan and Pakistan. Since the 1960s and '70s, though, as cross-border travel without a passport became restricted, this community became isolated and unable to roam. Many fled to the West, being offered sanctuary in Turkey, where they modernized and gave up their traditions, yet a few hundred remain. They live in felt yurts and live off their flocks of goats, camels and yaks, keeping to ways of life unchanged for centuries.

↘ Buzkashi, Afghanistan, 2015

The National Sport of Afghanistan, Buzkashi is similar to polo – except instead of a ball, the shaggy carcass of a sheep or goat is used. The rules at the game I witnessed appeared rather arbitrary and the aim seemed to be to simply grab the skin and run with it to the end of the field while the other players tried to grab it. Riders are frequently knocked clean off their horses and it can sometimes turn violent. The Wakhi inhabitants of this remote valley are talented horsemen, though, and learn to ride before they can walk.

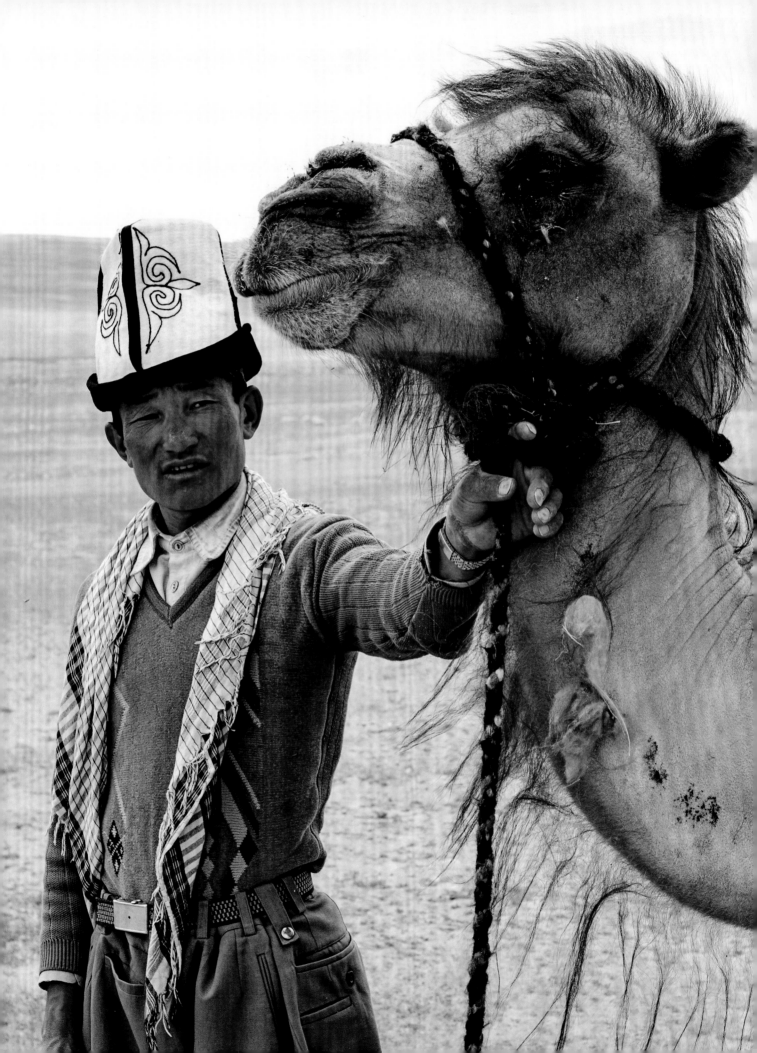

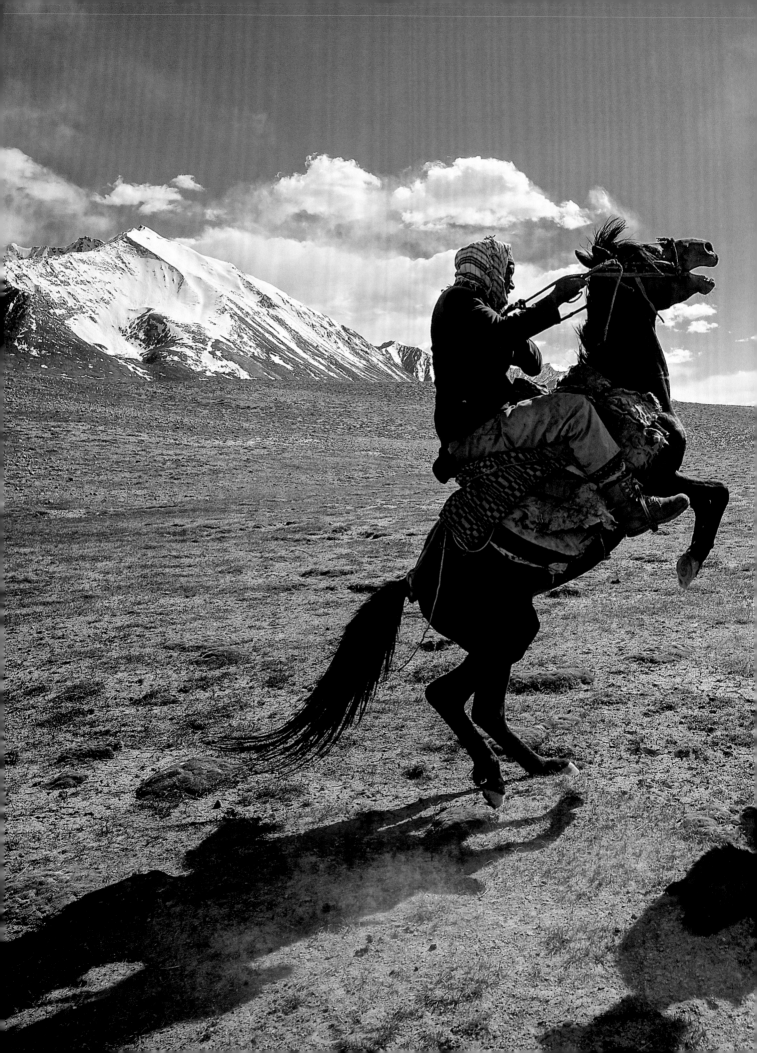

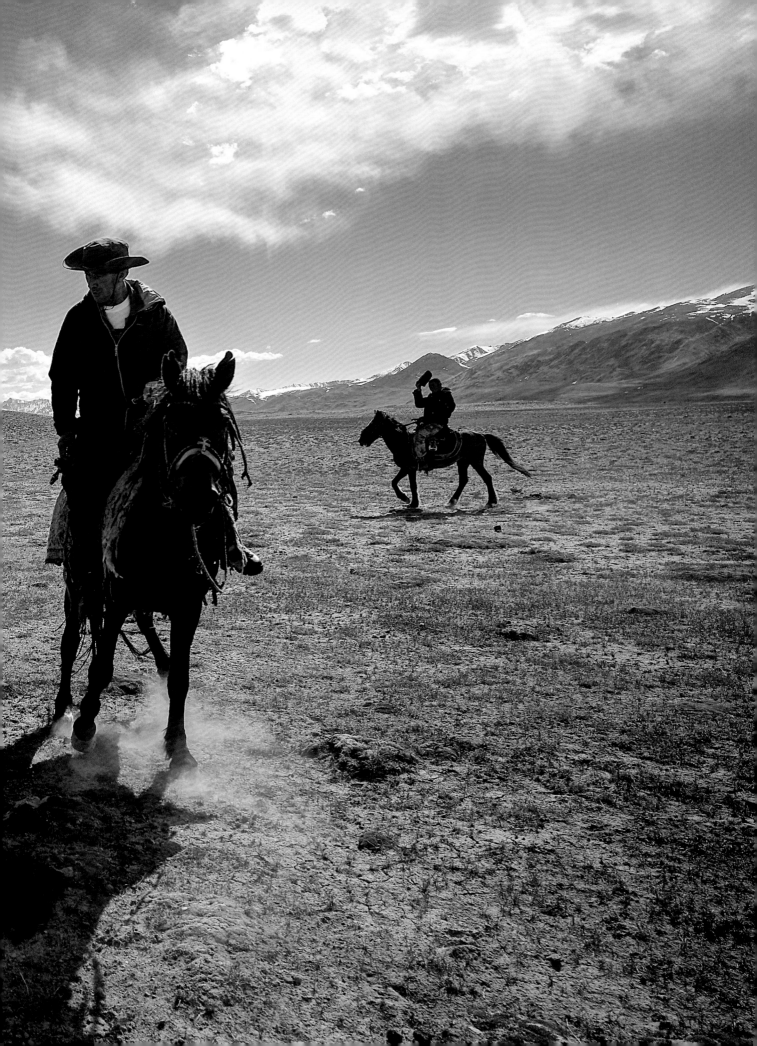

Mr Salahaddin, Pakistan, 2015
At the entrance to the magical
Baltit Fort I met Mr Salahaddin,
chief guard to this historic castle,
which dates from the 8th century
CE. It stands on a jagged hilltop
overlooking the magnificent
Hunza Valley.

Many soldiers in Northern
Pakistan and India boast
remarkable moustaches such as
the one sported by Mr Salahaddin.
This tradition dates back to the
ancient Mughal Empire, when
Persian influences spread across
the subcontinent. In the days
of the Raj, many of the British
colonialists joined in with the
trend, and there were even
competitions among the soldiers
as to who could grow the most
magnificent curls. Moustache wax
is a must-have product for many
Pakistani men, and the barber
shops do a roaring trade.

'To get in close
and understand a
person's story, you
have to make them
feel comfortable and
at ease. Sometimes
hours of work will go
into preparing and
relaxing someone for
one photo.'

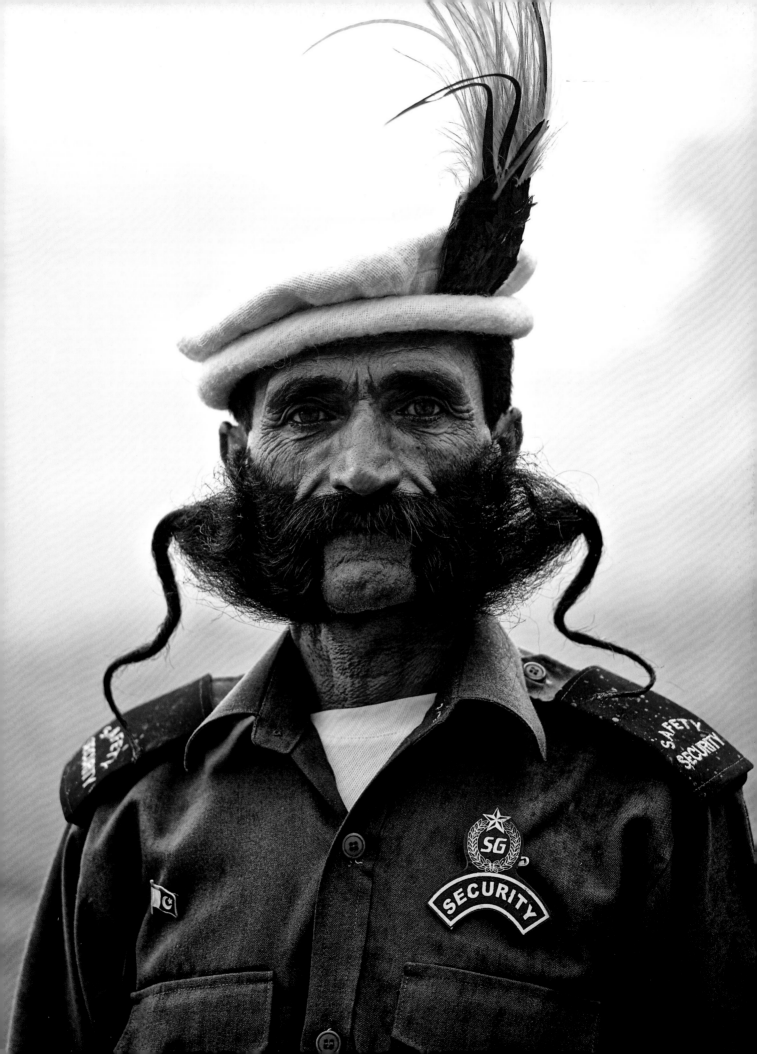

↓ Shiva Devotee, India, 2015

Every year, 17 million pilgrims descend on the town of Haridwar to praise the mighty god of destruction, Shiva. Men and women travel to the festival dressed in orange to collect the holy water of the River Ganges and make offerings at the temples. I witnessed the Maha Shivratri festival by chance as I passed through the holy city on my expedition to walk the length of the Himalayas, and was stunned by the vibrancy of colours, smells and sights. I photographed this pilgrim, who sat completely still for hours with needles in her face as a demonstration of devotion.

→↘ San Children, Botswana, 2019

The San are the original inhabitants of southern Africa and can lay claim to being the most ancient race of humans. Until very recently, these people lived a simple life as hunter-gatherers, foraging for food in the vast wildernesses of Namibia and Botswana. Today, the children go to school and learn about the modern world, but in a few remote villages surrounding the Okavango Delta and on the edge of the Kalahari Desert, remnants of this ancient culture survive in the form of traditional dress and jewellery and the use of bows for hunting, as well as the San language, which to the Western ear sounds like a series of clicks.

The children often go out foraging in the bush for bird eggs, edible roots and berries. The San also eat bush rats, snakes and small antelopes, and will even share the kill of a lion.

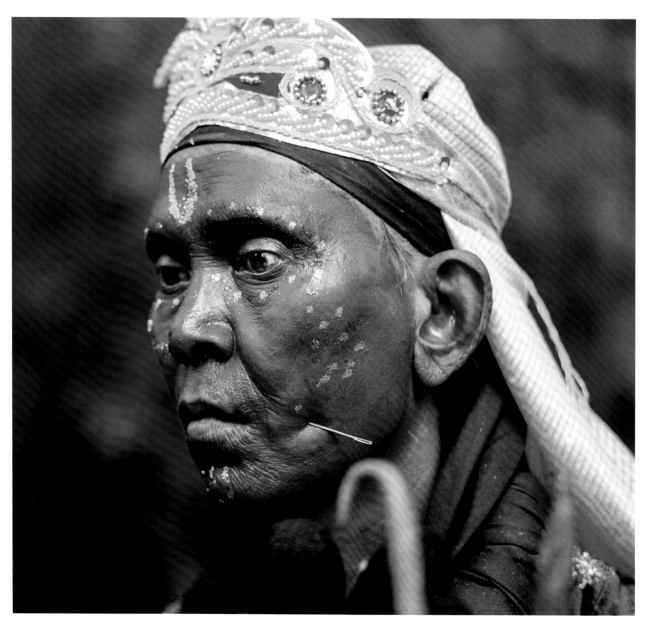

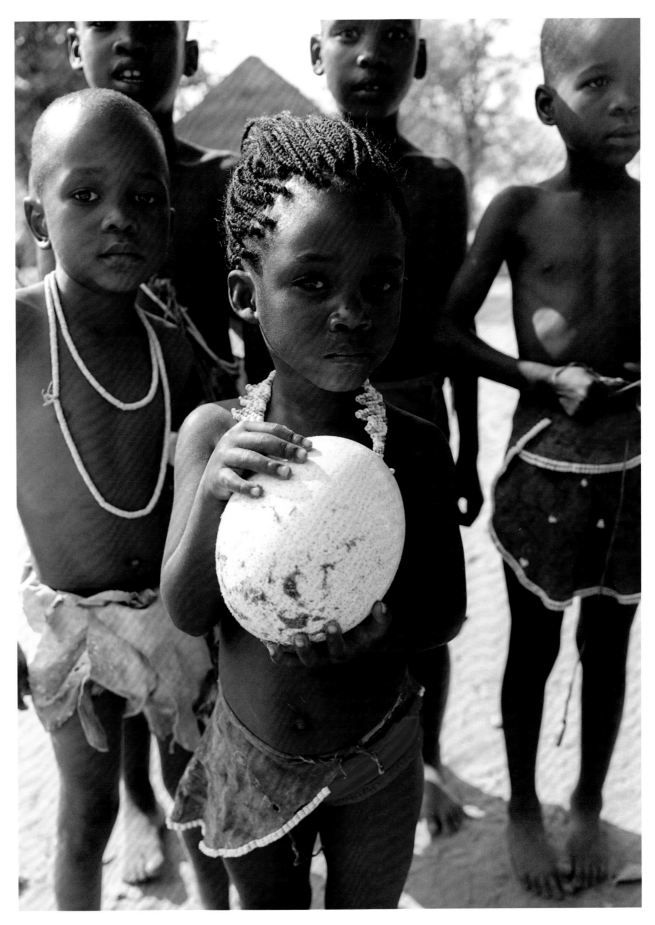

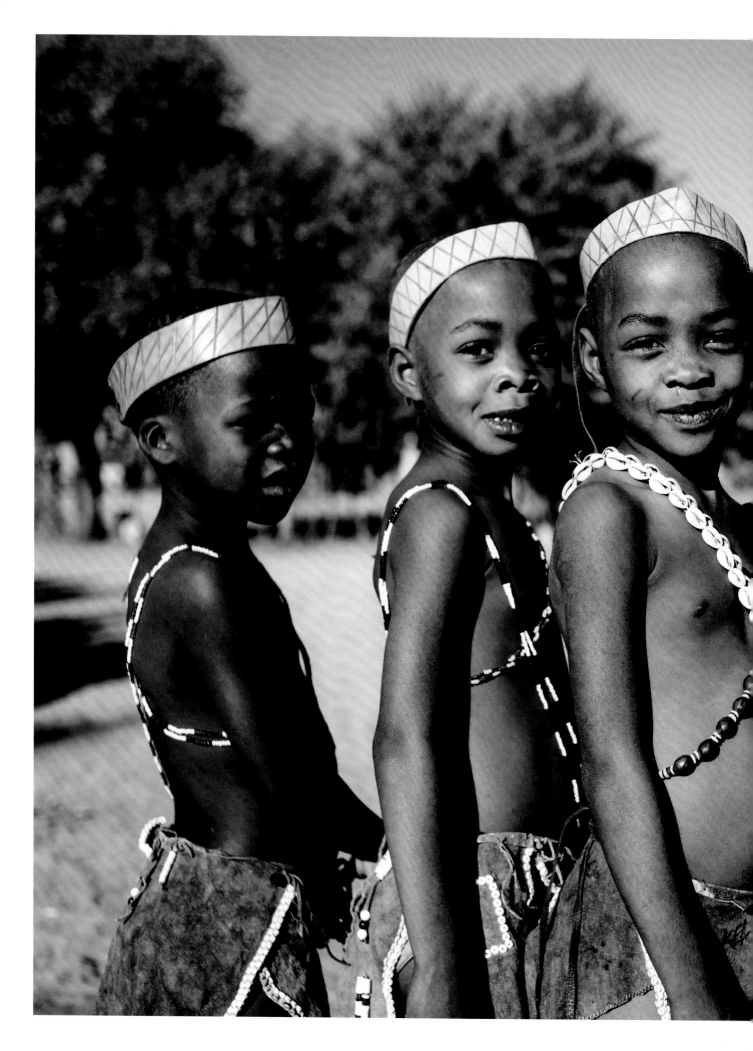

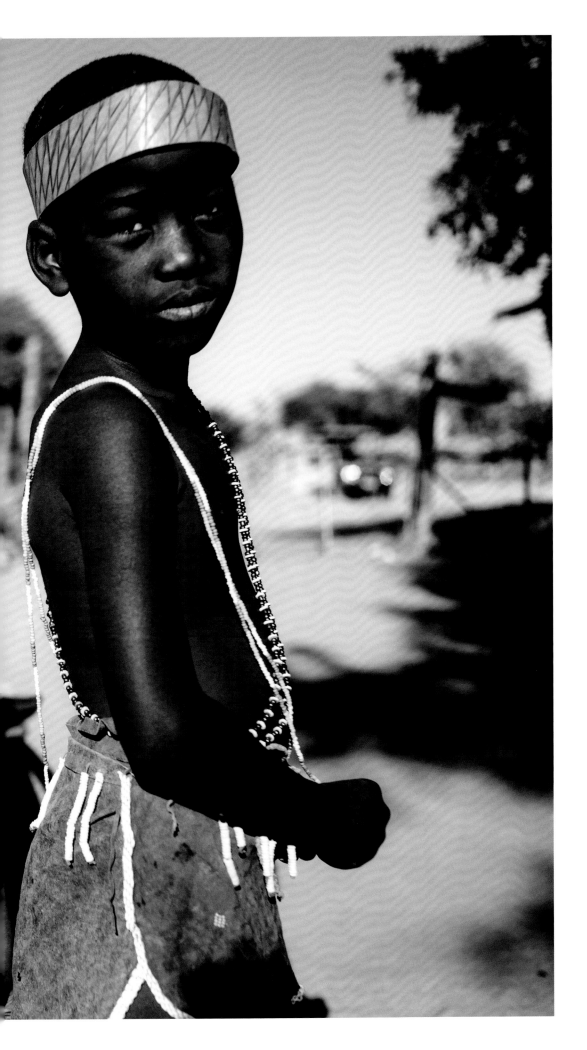

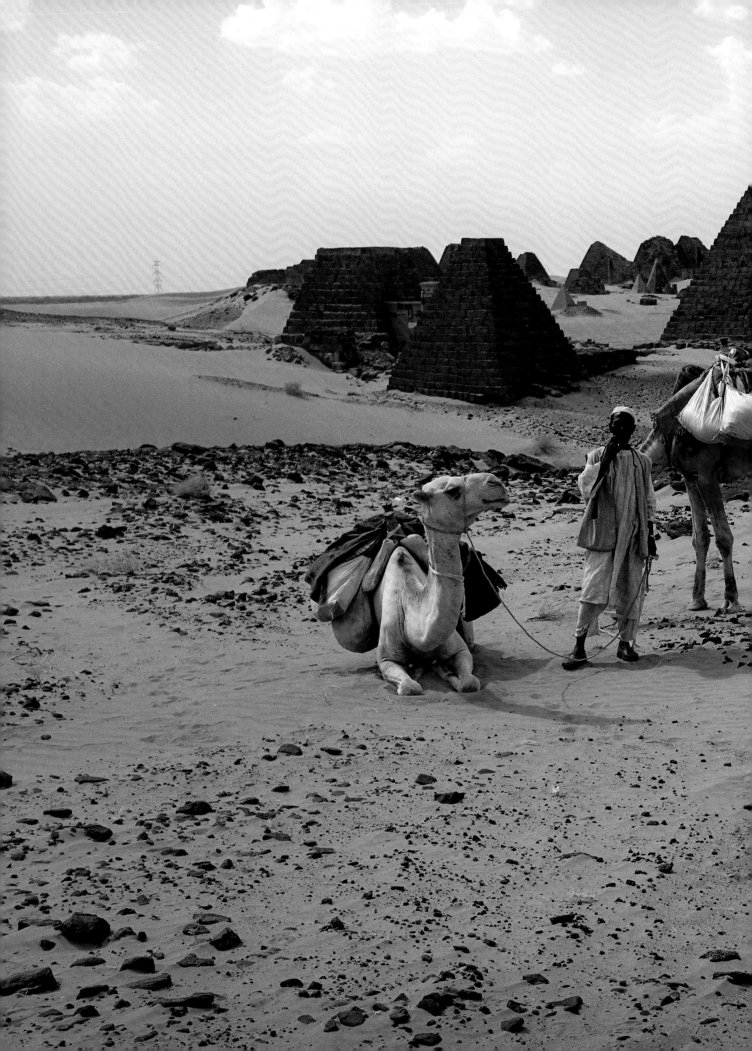

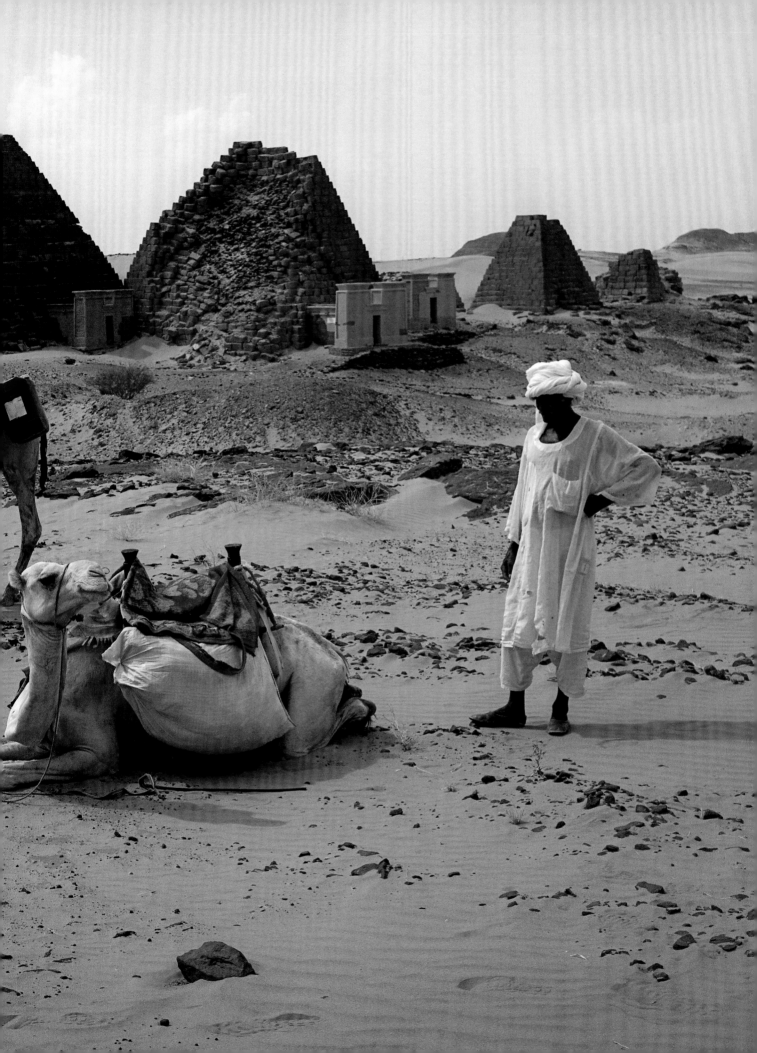

⬈ Pyramids of Meroë, Sudan, 2014
On the banks of the River Nile there are around 200 pyramids: tombs for ancient Nubian kings and queens, built some 3,000 years ago. Tourism in Sudan has been drastically affected by the civil war and sanctions from Western nations. I walked across Sudan as part of my Nile expedition and camped amongst these beautiful ruins with my camels and their Bedouin handlers, Ahmad and Ahmed.

← Tecoh, Mexico, 2016
The legacy of Spanish rule is evident throughout Mexico, but one of my favourite regions is around Merida and the Yucatan Peninsula, which is filled with 16th and 17th century churches, like this one in the village of Tecoh. In 2016, over the course of six months, I walked from the Caribbean coast, where the conquistadors landed, all the way to Colombia, following the ancient human migration route that spanned North and South America. It was remarkable to see the way indigenous culture had blended with that of the invading Europeans.

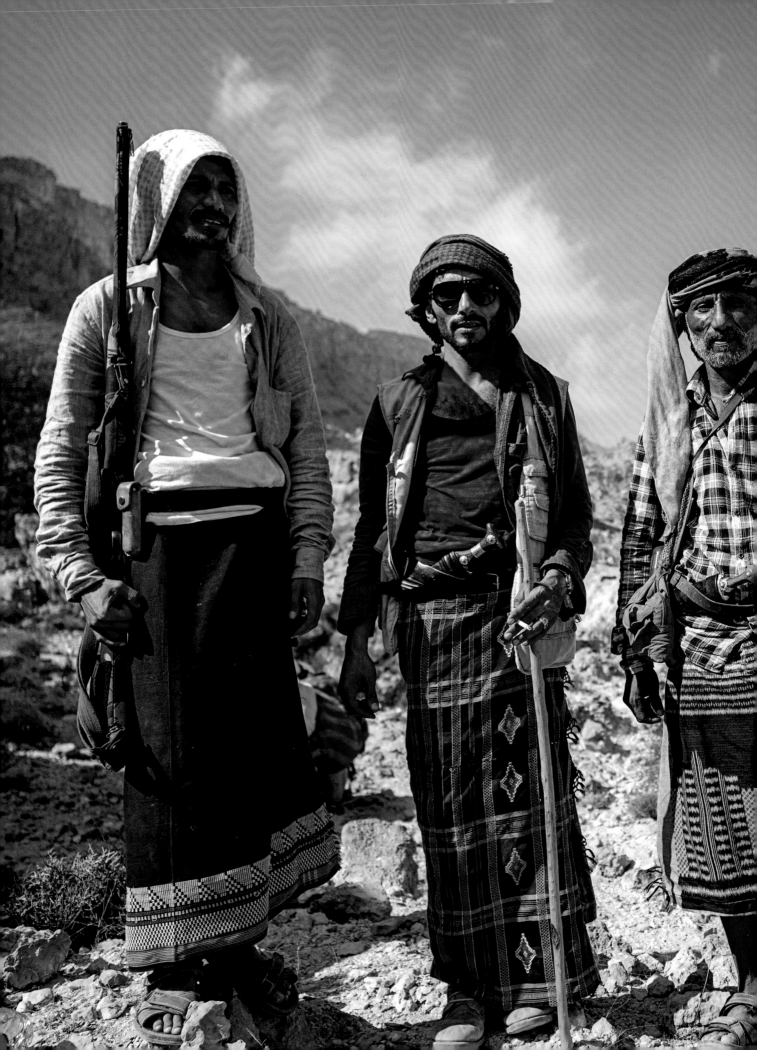

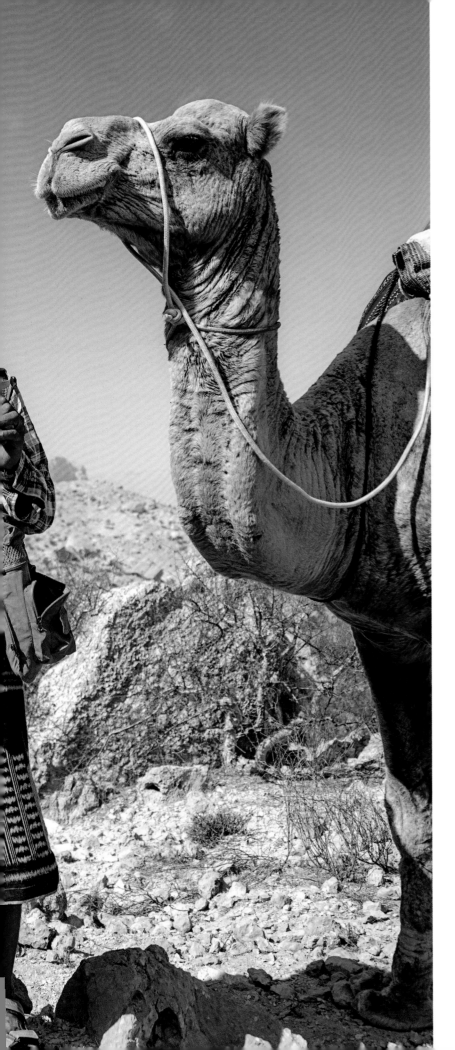

Jibbalis, Oman, 2017
The Jibbali people of the Dhofar Ridge in Oman are famed fighters. During the 1970s, with Russian support, a guerrilla force was raised to rebel against the British-backed Sultan. The war raged for years and culminated in the siege of Mirbat, where a tiny unit of British SAS soldiers defeated a much larger force of communist militants. When I walked across southern Oman, many of my guides and camel handlers were the sons and nephews of those who had fought against my own comrades. I was glad we could now travel together peacefully.

**World's Smallest Hotel,
Jordan, 2018**
In the shadow of Montréal castle,
a Crusader fortress built in 1115
by King Baldwin of Jerusalem,
sits a tiny Volkswagen Beetle,
whose owner, Mr Mohammed
Al Malaheem, dubs it the 'world's
smallest hotel'. Inside the car,
the seats have been ripped out
and replaced with a comfortable
mattress, as well as delicately
placed pillows and cushions. The
décor leaves something to be
desired, but for sheer novelty –
and location – it's hard to beat.
Jordan is a wonderful country to
visit, filled with magical deserts
and historic sites. The people,
however, are what makes it really
special, and you can't go far
without locals inviting you to join
them for a cup of sweet chai.

COMMUNITY

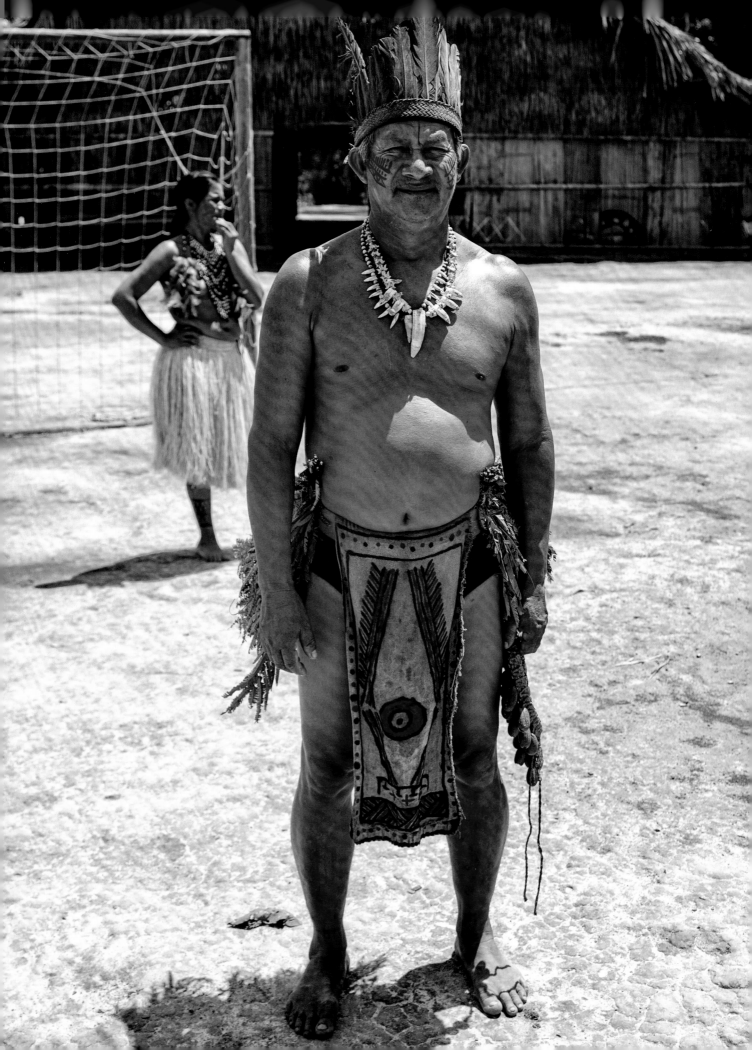

COMMUNITY

Community is a universal human truth, found across the globe and throughout history. We all require the sense of safety, security and identity that community can provide, and it is this that gives us a sense of belonging and of purpose. Humans are sociable animals. Quite simply, we need each other. This chapter explores how we interact, as individuals, as families and as societies.

I have been fortunate enough to have been welcomed into communities of all kinds on my travels. It never ceases to amaze me how people have the ability to come together and find solace and meaning despite their differences. Whether they are traditional communities that have been around for thousands of years or new hybrid and novel groupings, people find a way to combine, support each other and create bonds.

Many of the examples of community I have chosen to represent in this chapter belong to groups that have managed to resist the march of globalization more than most, whether deliberately or not. The far-reaching tendrils of Western culture continue to make their way across frontiers and borders, upending traditions, altering identities and changing ways of life forever. Furthermore, the effects of industrialization, massive population growth and climate change are forcing greater and greater numbers of people to migrate away from their ancestral lands, scattered from their places of origin and, crucially, from the heartlands of their traditional community.

Even the subtlest changes to culture and community can have knock-on effects for those who adhere to a particular way of life. I have visited many places where the sense of community is under threat, particularly in frontier lands and conflict zones, where change is exacerbated. Age-old connections have never been more vulnerable, and the old ways are under pressure from the new. But in these times of change, community has become more important than ever, both on a local and a global scale.

Humanity's success has for the most part largely been down to our ability to share, cooperate and communicate: in other words, to form communities. When times are tough, it is to members of our own tribe that we turn in order to lighten some of the load. In some of the regions to which I have travelled, I have observed that this ability to work together has created some of the world's strongest

Tatuyo Chief,
Brazil, 2019

and most resilient communities. This is especially true when they are faced with adversity, which forces people to find new and innovative ways to survive and thrive against the odds. In some of the most inhospitable terrains can be found the most hospitable people. Mountain dwellers like those in the famed nations of Nepal or the Caucasus Republic are testament to that reputation. Equally, from the deserts of Arabia and Sudan hail the impeccably welcoming Bedouin and Nubians, for whom it is inconceivable that a guest should go without a drink. In the world's marshes, forests and mountains live remarkable communities that have managed to preserve their ways of life despite repeated incursions, devastating poverty and incessant war. This final chapter builds on those that go before and I hope that it shows the resilience, fortitude and strength that people are capable of when they join together.

I try to show what makes these communities unique; the aspects of their culture enable them to continue, whether that's novel fishing methods in Sri Lanka or the cattle culture of South Sudan. I try to demonstrate the intricate and complex elements that make up such special communities. Ultimately, this chapter is about what people around the world value, what they share and what keeps them tight-knit, as well as what they consider to be their own strengths and weaknesses.

I have experienced community in its many forms throughout the world. There is great nuance in the different ways that people come together, and in the forms that our rituals and customs take. What might be a compliment in one community could be an insult in another. From the indigenous Dessana of Brazil to the Sufi of Pakistan; from the Pygmies of the Democratic Republic of the Congo to the religious pilgrims of Iraq: each of these communities has its own ways of interacting and sharing their practices with one another. I have been a part of traditional rituals in the Himalayas and spent nights with the Bedouin in the stillness of the Empty Quarter Desert. But fundamentally, everyone is the same; people come together to eat and drink, to mourn or celebrate, and to share stories and create meaning as a collective.

I have always been interested in documenting communities that maintain a tight bond even though they are living in diaspora, such as the Shia Muslims, who travel from far and wide to worship together in Karbala. The Mennonites of Central America are another striking example. As a community, they have retained their identity despite having travelled all the way from Europe over the course of five hundred years. I met a family in a small Mennonite community now in Belize: their ancestors had fled persecution and travelled through Germany, Russia, Canada and Mexico before settling here. They shun modernity, riding horses and carts instead of driving cars. They follow a lifestyle that is not dissimilar to that of their religious founders, and have preserved their community in a way that is quite remarkable.

In India, I photographed an Aghori sadhu, a monk from a group of wandering ascetics reputed to be cannibals. This sect of spiritual men make it their life's work to break taboos through smoking cannabis

'Age-old connections have never been more vulnerable, and the old ways are under pressure from the new.'

and spend their days half naked, apparently consuming human flesh – all in the name of becoming closer to God. The Aghori are reviled by many and yet, among their own kind, they share bonds like no other community I have encountered. When I look back at my time with them, it serves as a great reminder of how crucial it is for a photographer to document and represent all that they see without judgement or fear.

On all my expeditions, I have relied on local guides, fixers and translators: people who have always been eager to take me to their homes and introduce me to their families and friends. The following images are a collection of these people who have looked after me along the way.

I have always been amazed by the welcome that I have so often received, and how close-knit communities have opened themselves up to my presence with generosity and kindness. Very rarely have my requests for help, food or shelter been met with rejection, and it has often made me wonder about communities at home in the UK: how would we react to the presence of a stranger knocking on the door and asking for a bed or a meal?

Whenever I have crossed the threshold into a house, a place of worship or wherever people gather in communion, I have tried to capture the essence of what brings them together. Community is about a collective belief: it is about a way of life, and a feeling between the people who exist within it. Of course, all of these things are, by their nature, intangible and not always easy to capture through the lens of a camera. One must wait for a glance between family members, for a statement or gesture, or a particular expression during a ritual. Although it may not be an obvious or easy subject to observe and frame, these aspects of community are what can, I believe, bring photography to life: connecting the viewer with another individual, another culture, another community, that is distant in time and space. I would like to believe that good photography can be a pathway to empathy and understanding, shedding light on the incredible possibility and potential of humanity. I hope these images can enable others to feel and perceive a little of what I have been so fortunate to experience.

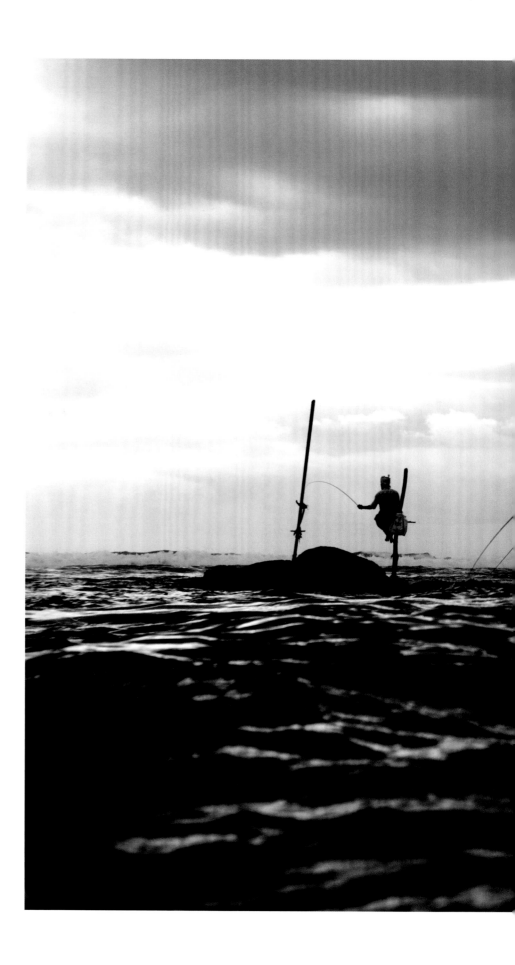

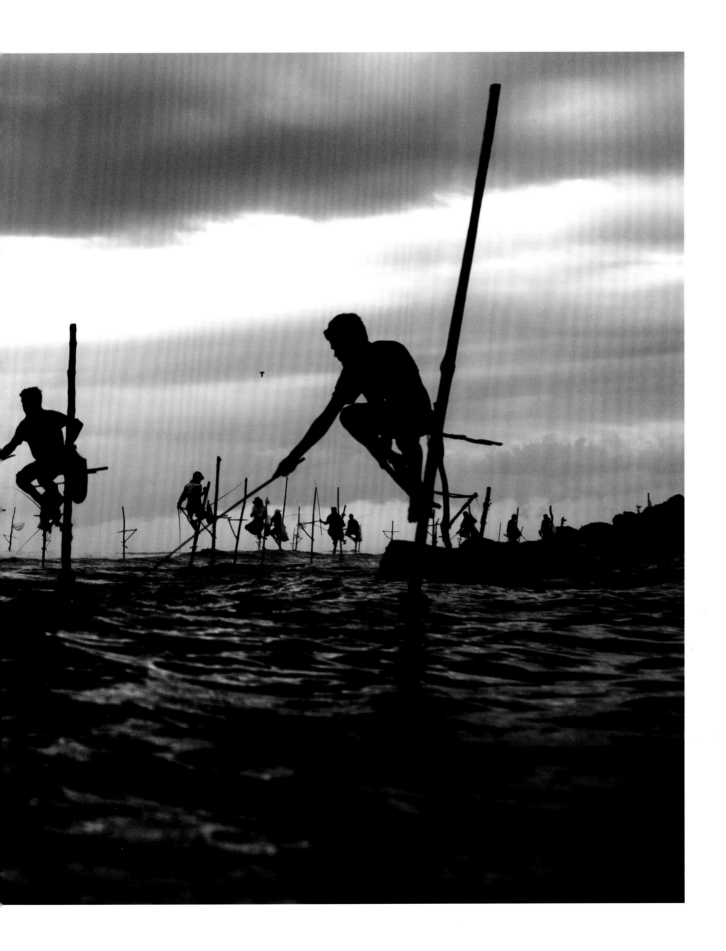

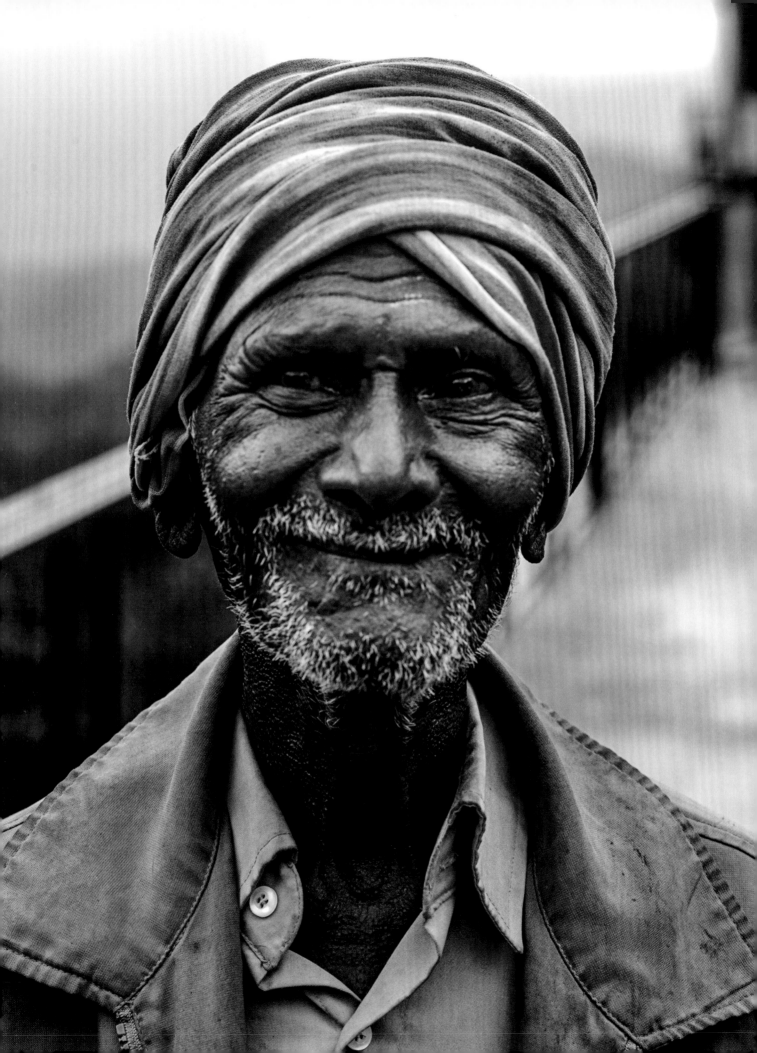

↖← Stilt Fishermen, Sri Lanka, 2015

Despite looking like an ancient practice, the Sri Lankan method of stilt fishing actually started after the Second World War, when food shortages led locals to adopt a different method of fishing. At first, the fishermen made use of the wreckage of aircraft and damaged boats left behind after the conflict to gain a vantage spot over swarming fish, later progressing to the use of these stilts. However, after the tsunami of 2004, many of the shorelines were altered and this way of fishing became more difficult. Nowadays, many of the fishermen continue to eke out a living by charging tourists to take photos, but these men were the real deal and didn't mind me hanging out with them for a few hours at dawn near to Cape Weligama. This man sat for four hours perched on his stilt and caught a bucketful of fish to feed his family.

↓ Amazon River Dolphins, Brazil, 2019

These remarkable mammals are the largest river dolphins in the world, and are found throughout the Amazon river basin. Adult males can reach 185kg (400lb) and almost 3m (10ft) long. They are also known as pink dolphins because of their colour. No one knows how many there are: they are virtually impossible to count due to their inaccessibility in the tributaries and streams of the Amazon rainforest. Here, I photographed a local boatman feeding a wild dolphin, which seemed very happy to play with humans and jump out of the water.

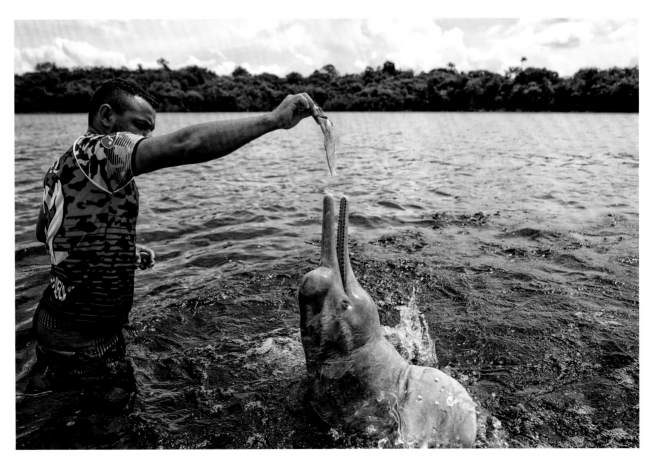

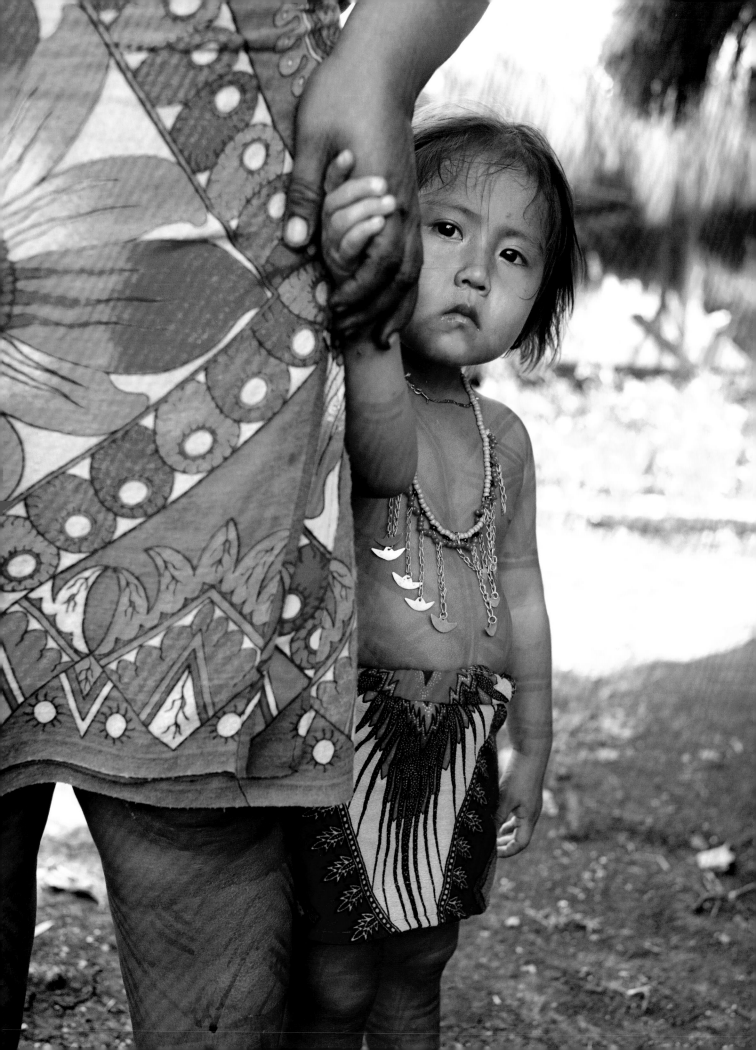

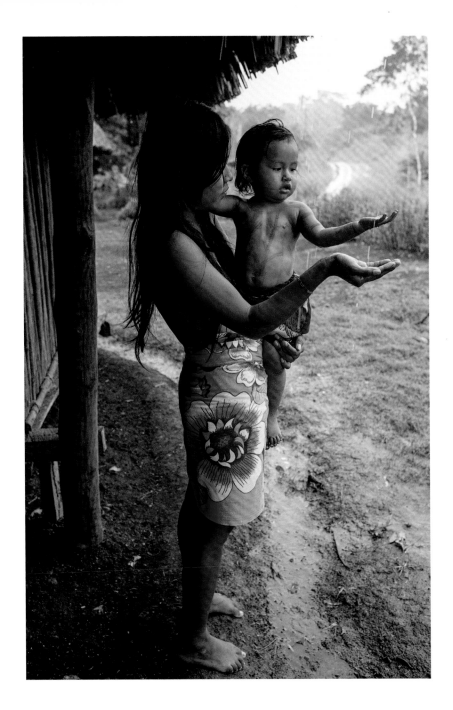

↖←↘ Emberá-Wounaan Tribe, Panama, 2016
The Darién Gap is a notoriously dangerous stretch of jungle that separates Panama and Colombia. It's the only gap in the Pan-American highway and is home to the Emberá-Wounaan people, an indigenous tribe that until recently was isolated from the modern world. The Emberá live in stilted huts deep in the forest, sometimes many days' travel by boat from the nearest road. I met a family of Emberá who had settled near to Yaviza, known as the gateway to the Darién. They use a kind of dye to cover themselves in body tattoos, which they believe gives them special powers against spirits. When the rains come, it can make life particularly tough as rivers flood and paths are washed away, isolating communities for weeks at a time. In the Emberá tribe, it is expected that everyone in the community will take on the care and responsibility of bringing up the children together.

'The very best of humanity is found at home, when people are with their loved ones, looking after one another.'

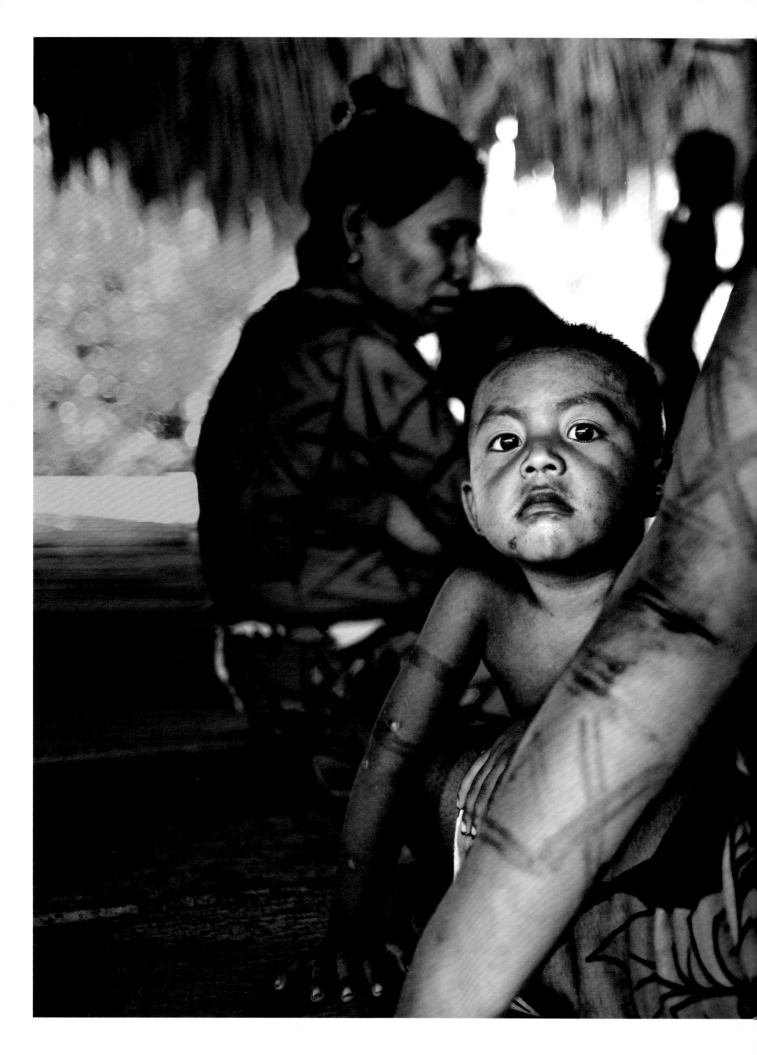

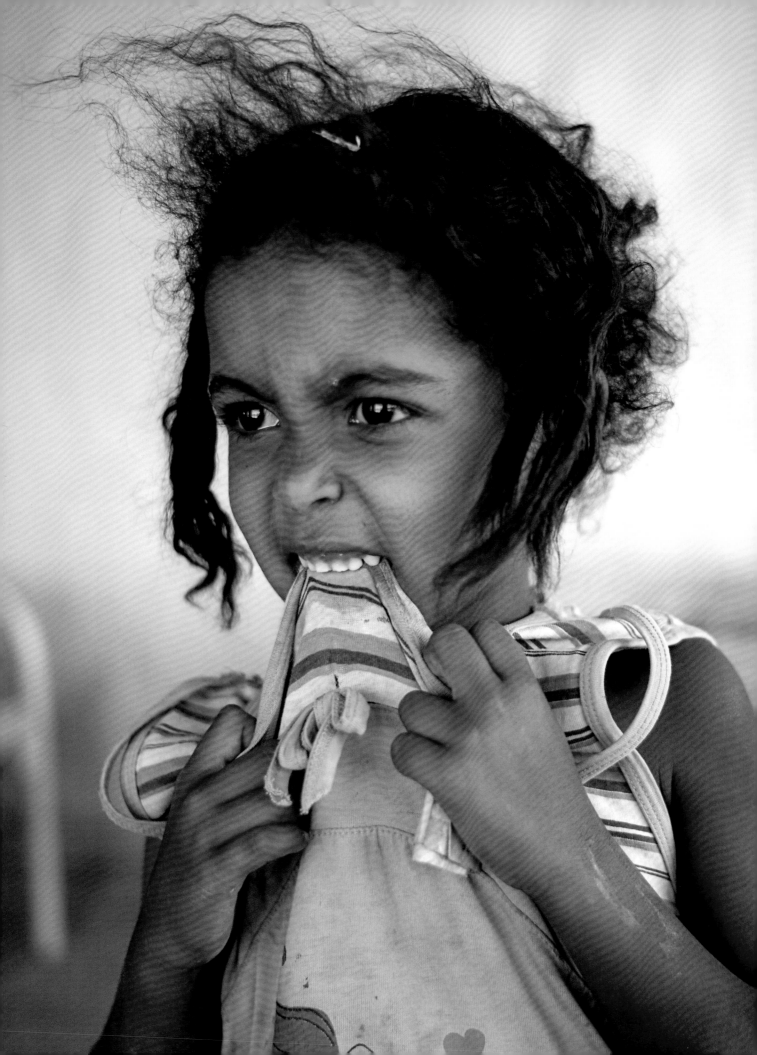

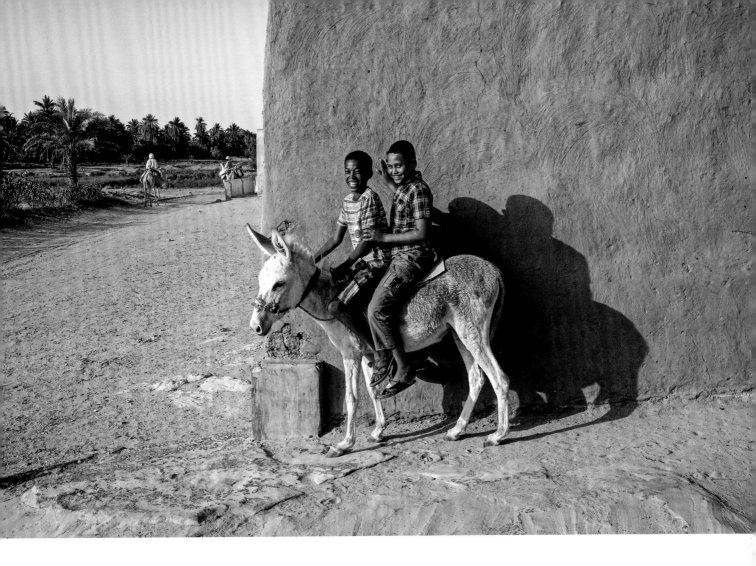

←↑ Nubian Children, Sudan, 2014

Along the banks of the River Nile in Southern Egypt and Sudan live the Nubian people. They are the indigenous people of the Middle and Upper Nile and it is believed they have farmed in the fertile floodplains for over 10,000 years. They formed one of the earliest Christian communities before the Arab conquests, when the region became Muslim. I walked the length of the Nile in 2013–14 and Sudan was an unexpected highlight. Despite its reputation for poverty, conflict and oppression, the Nubians remain, in my mind, among the most hospitable people in the world. Wherever I went, people would invite me to join them for a meal and offer me a free place to stay. The children loved to practise their English and wanted to show me where they played among ancient ruins. I never had any problems meeting local people and photographing them. The country has seen a lot of instability in recent years, but I hope that more people visit this beautiful place and experience its magic first hand.

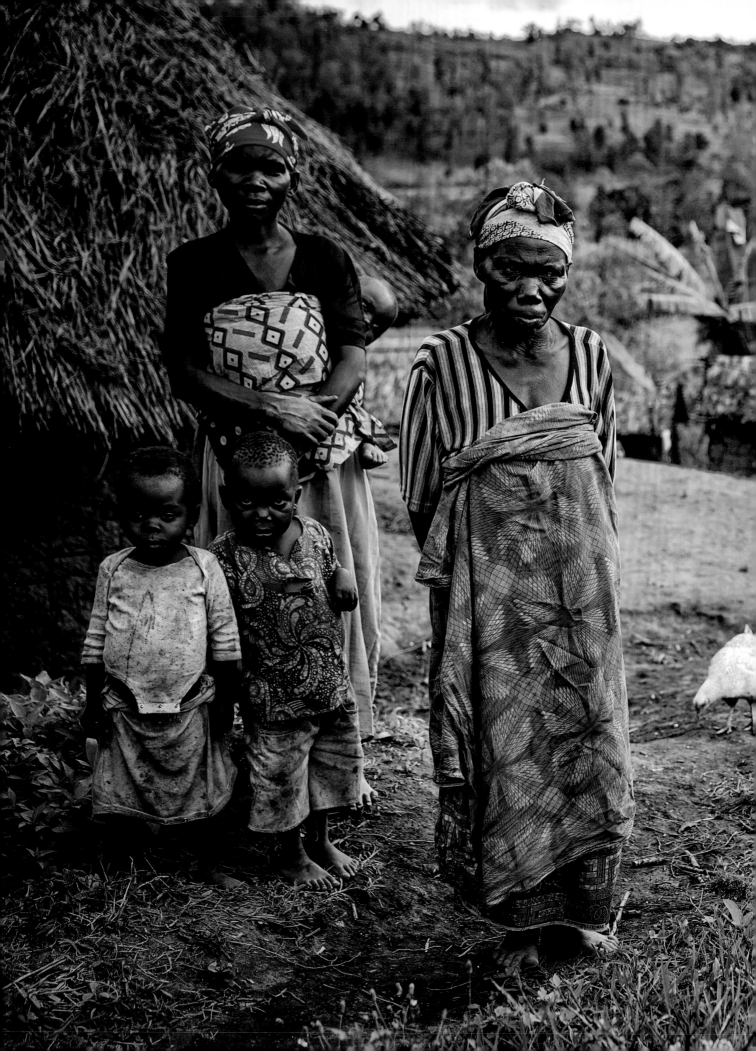

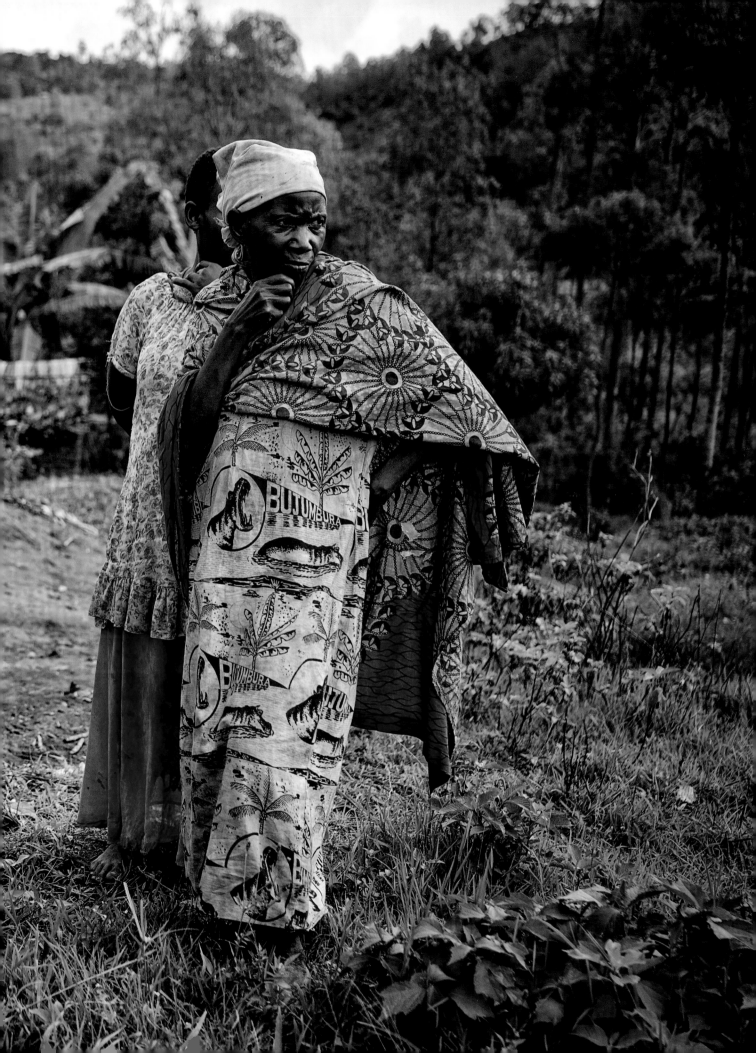

↖→ Batwa 'Pygmy' Family, Democratic Republic of the Congo, 2019

The Pygmy people of Central Africa have hunted and foraged in the forests of the Congo since prehistory, and yet their way of life is now almost annihilated. The expansion of Bantu tribes has seen Batwa culture and traditions come under increasing threat, and the Batwa have been marginalized and persecuted by their neighbours for generations, with many being forced into slavery. Ironically, nowadays one of the biggest threats to their ways of life comes from wildlife conservation efforts. In the second half of the 20th century, many African countries forcibly moved Pygmies out of the forests and into reservations or towns. I met this community on the island of Idjwi on Lake Kivu in easten DRC. They are isolated in their villages, where they grow subsistence crops like beans and cabbage, and yet they still attempt to retain some of their culture by going on occasional spear hunts. All the monkeys and larger mammals have long since been eaten, so now they are forced to settle for rats.

'Photography can preserve a moment for posterity and also change the future.'

↘ Game of Mangura, Democratic Republic of the Congo, 2019

In the city of Goma, teenagers play a game using a carved board and wooden marbles. The youngsters, who are former soldiers, are encouraged to use play, art and crafts to help them move on and heal from their former existence. It was hard to imagine that, just a few months earlier, they had been at war, living in the bush with nothing. Now, traditional games are enabling them to reintegrate into normal society.

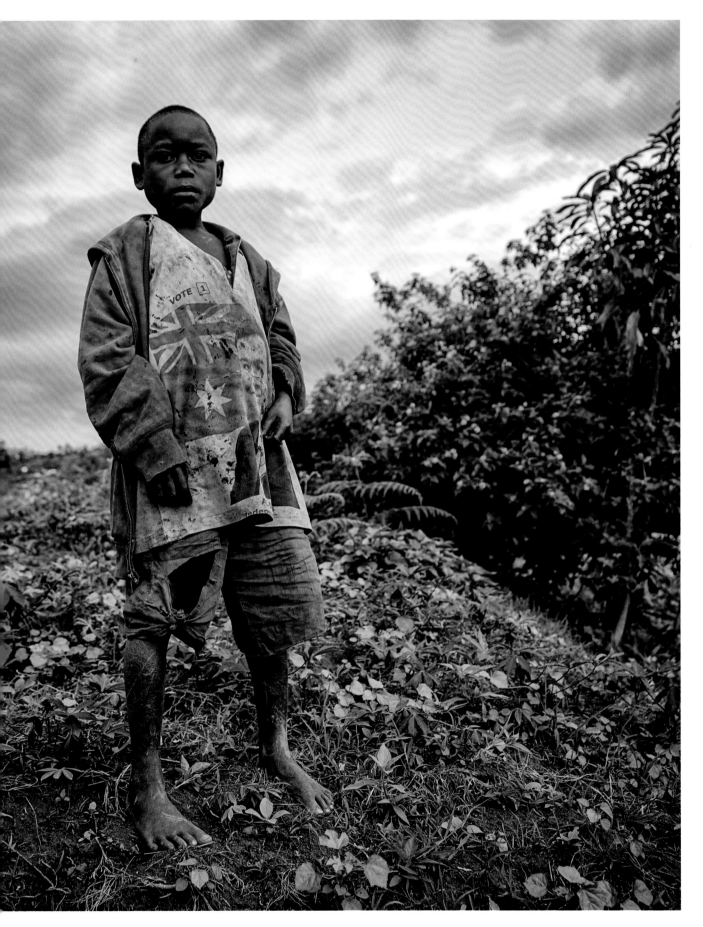

↑ Old Versus New, Botswana, 2019

Jameison, the village chief of Parakarungu in central Botswana, was a wonderful host, letting me stay in his sister's hut for the night. As we sat around the fire, he told stories about how elephants come and raid the village crops and cause damage to the trees and houses. I couldn't resist taking this photograph when he took a little break from his oratory to check the football scores on his phone. He was a keen Arsenal fan.

↑↘ Sufi Festival, Sudan, 2014

In the village of Kadabas, thousands of Sudanese people gather to worship at an enormous festival to celebrate their saints. Sufism is seen as a mystical branch of Islam. Its followers pursue a personal, inner path towards God through absolute absorption in worship. They aim to achieve this through music, dance and spinning in circles, and sometimes smoking marijuana, which can induce enough fervour to enter a heavenly trance. The festival was one of the most extraordinary gatherings I have ever seen. Food was given freely by volunteers and subsidized by donations from wealthy pilgrims. Dervish elders performed incredible ritual dances with swords, and at night the entire desert glowed a luminescent green, while music blasted out from singers and speakers alike. It lasted until dawn.

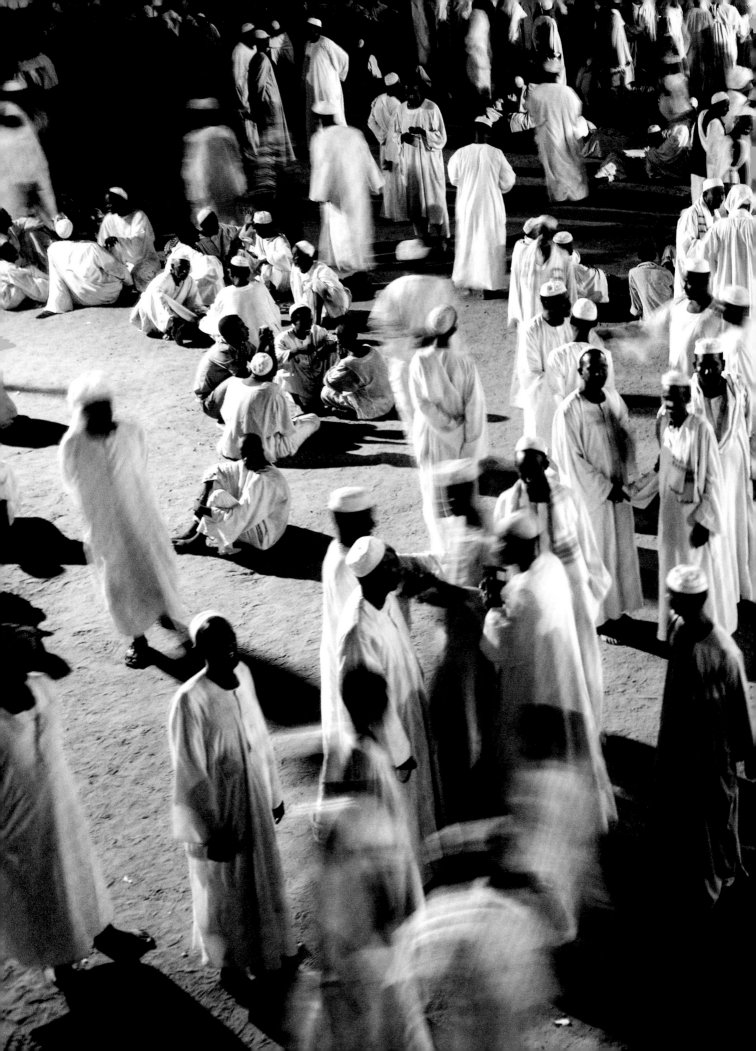

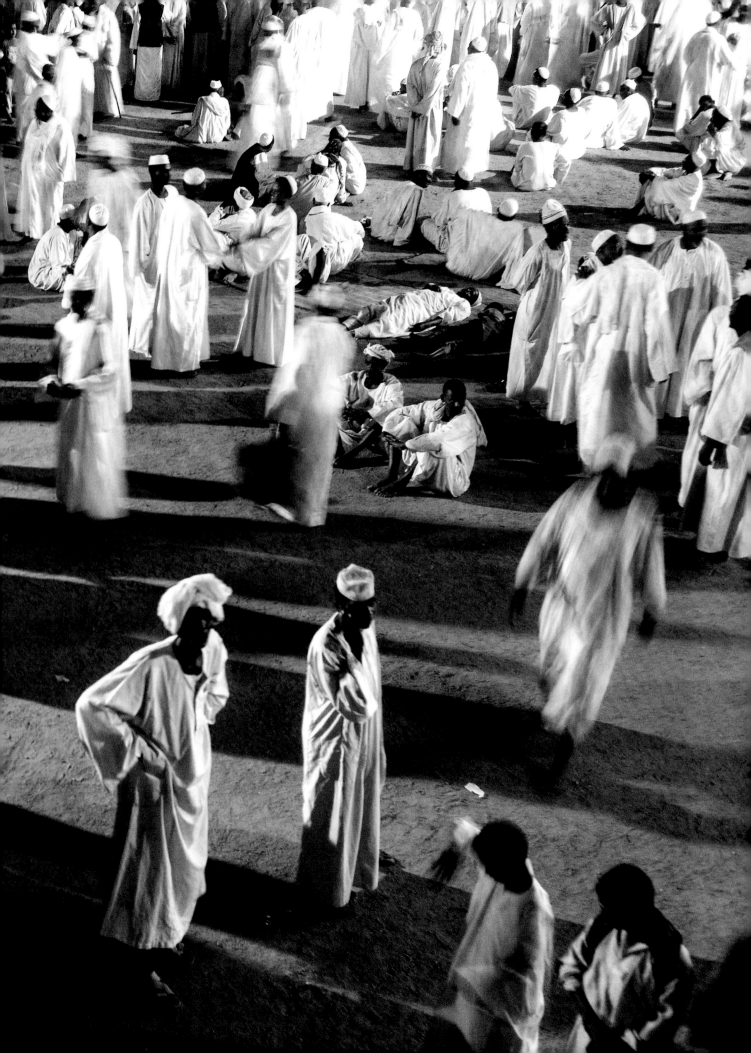

Karbala, Iraq, 2017

At the Holy Shrine of Imam Husayn, Muslims gather every year for Ashura. This marks the anniversary of the death of the third Imam, grandson of the Prophet Muhammad, who was martyred in 680 CE in the Battle of Karbala. It's one of the holiest sites in Shia Islam, and I was invited to witness the gathering as hundreds of thousands of pilgrims arrived from across Iraq and Iran.

This sheik welcomed me to take his photograph before explaining how Islam, Christianity and Judaism were all part of the same religion. He said that we all worship the same God, and that all religions are equally valid.

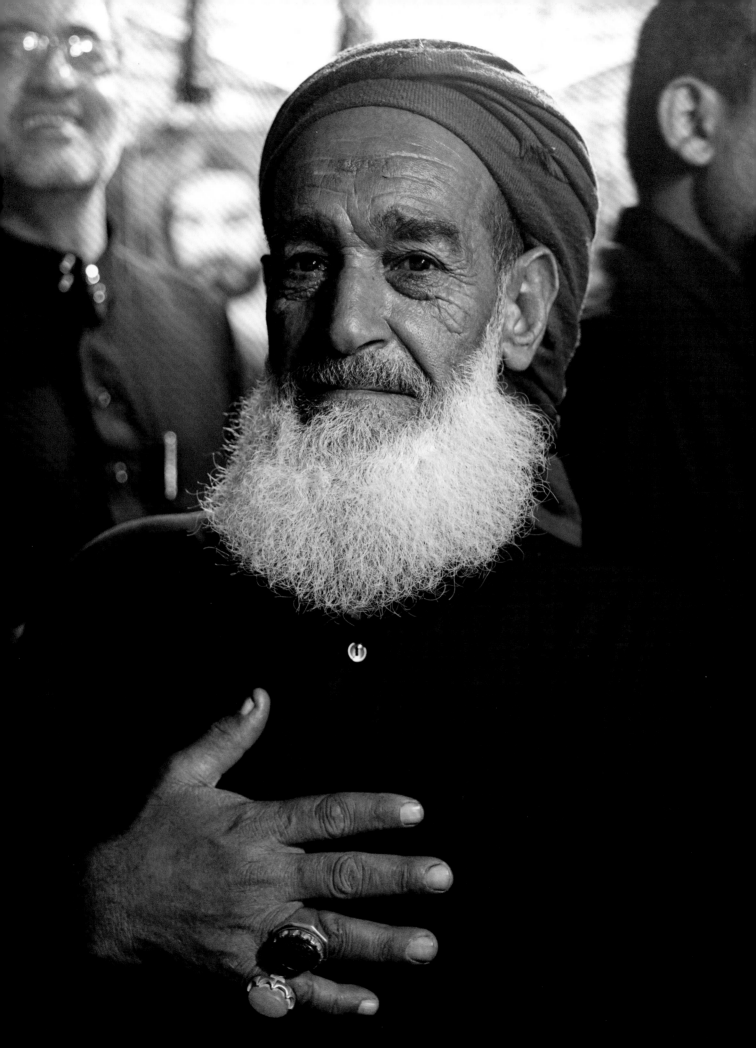

↓ Cow Urine Shower, South Sudan, 2014

The Mundari tribe, who live in the Sudd marshes of South Sudan, often take a 'shower' from the back end of a cow. The urine contains uric acid, which turns hair a deep red colour, regarded within the tribe as a sign of beauty. The urine is also sterile, so most of the people use it to brush their teeth and wash their faces, too, in preference to the water of the river, which is filled with crocodiles and too dangerous to bathe in.

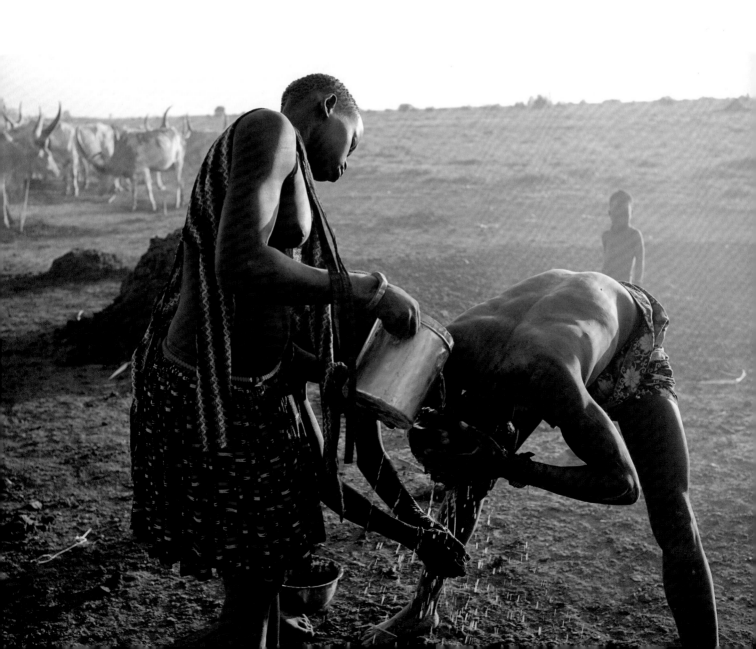

↓ Dinka Family, South Sudan, 2014
The Dinka tribe form the largest ethnicity in South Sudan, a country that gained its independence from the north in 2011. Fighting broke out just two years later, resulting in a widespread conflict across the country, mainly across ethnic lines. Most people, however, simply try to get along in peace and their only concerns are looking after their families and their cows.

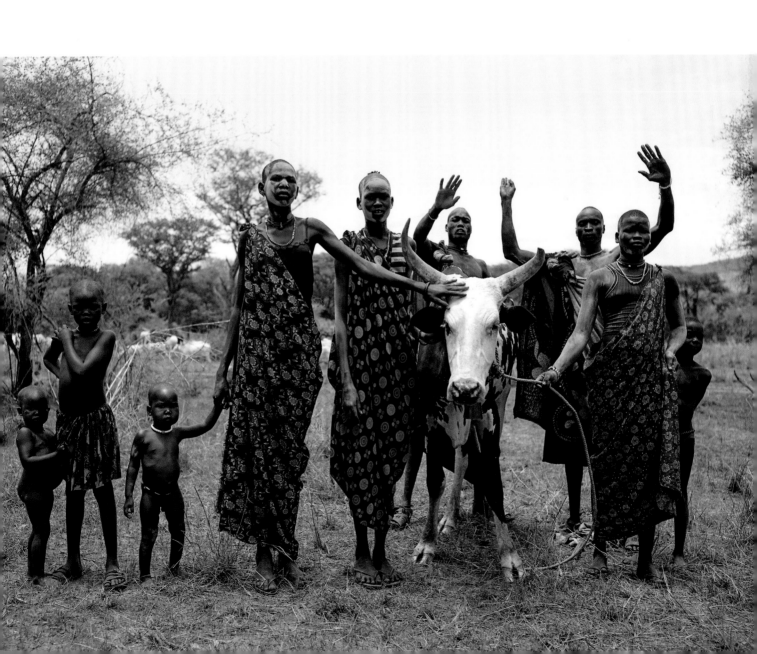

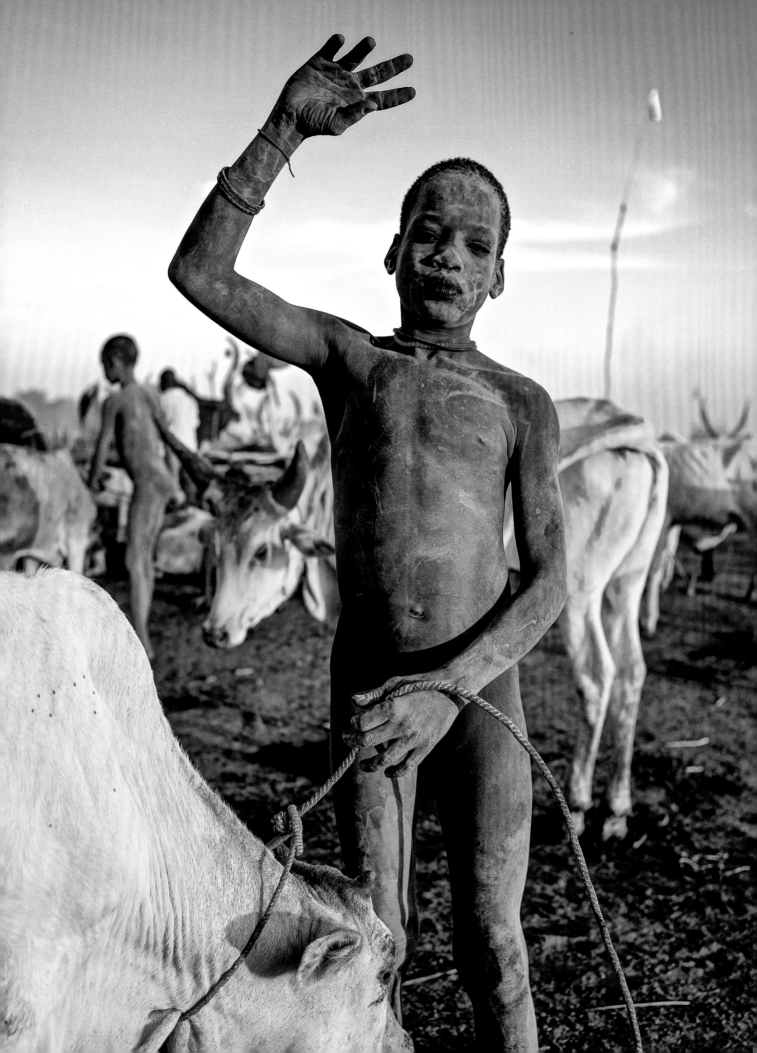

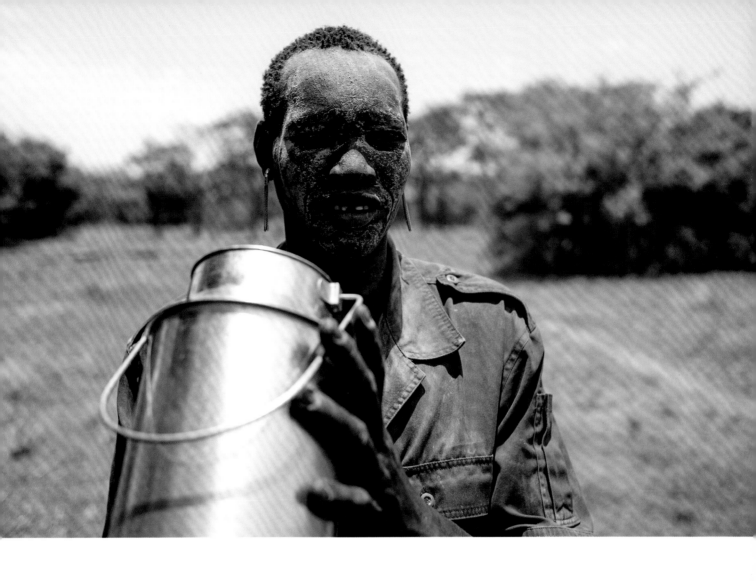

←↑ Cattle Culture, South Sudan, 2014

Cattle play an important part in the culture of all the ethnic groups in South Sudan. They are used as currency and status symbols: a man is judged by how many cows he owns, and if he wants to marry, he must pay the woman's family a dowry of dozens of cows – or even hundreds, if she comes from a rich family. Cattle raiding is common and many wars have been fought over this animal wealth. As the tribes have acquired guns, the number of deaths has risen.

Wadi Araba, Jordan, 2017
In the crags and valleys of Jordan, camel racing goes on despite attempts by the government to crack down because of health and safety concerns. Often, these races are arranged at the last minute in hidden dry river beds, and villagers will sneak out from their homes to bet on the winners of this age-old sport.

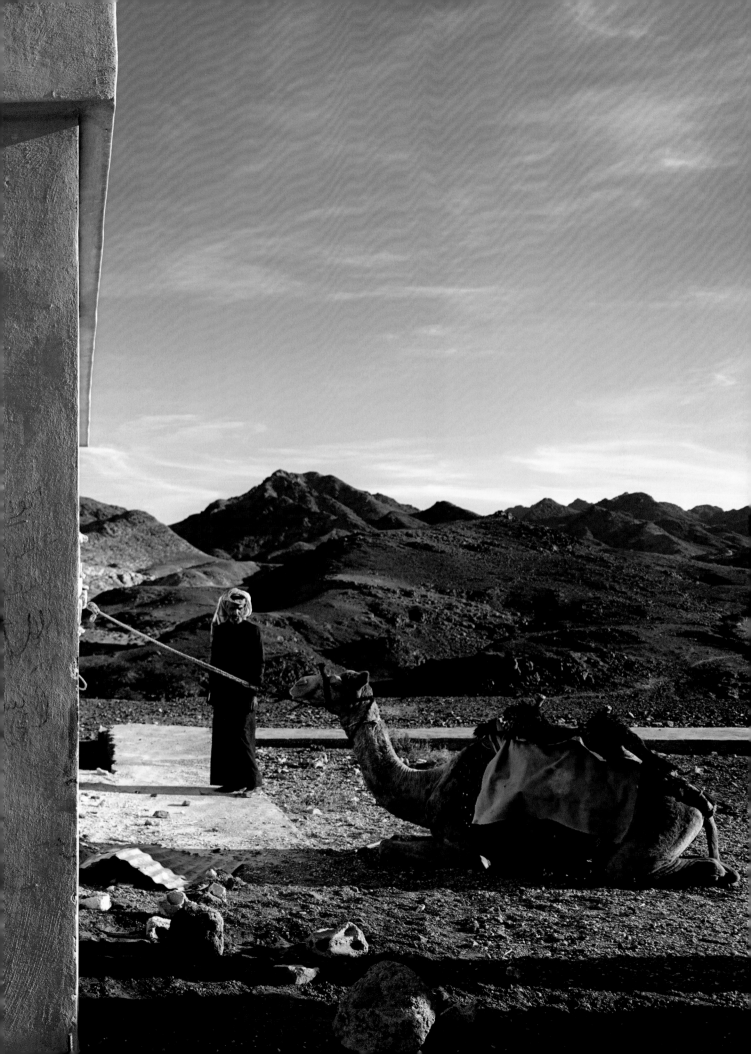

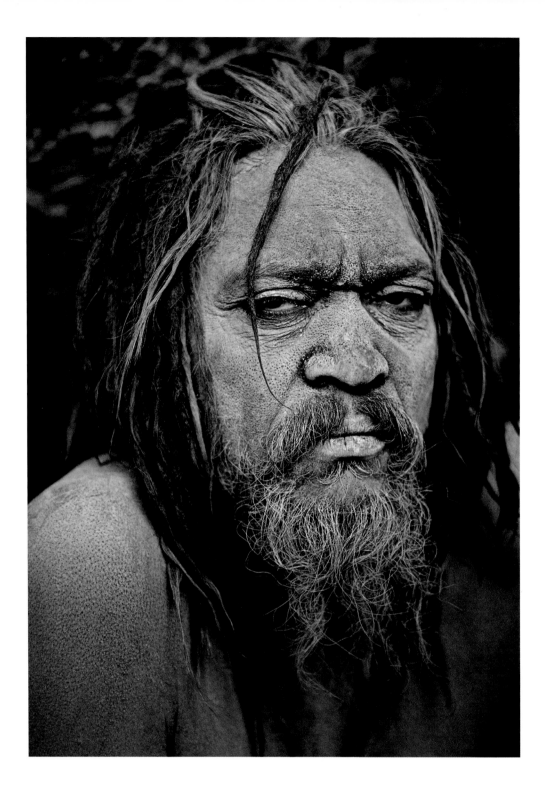

↑→ Aghori Monk, India, 2015

Across India, *sadhus* walk from place to place, seeking enlightenment and communion with God by adopting an ascetic lifestyle and rejecting materialism. I met this Aghori holy man on the outskirts of Haridwar on the banks of the Ganges River. The Aghori have a unique worship practice that involves death rituals. They live in burning sites, cover themselves with ashes from human cremations and use bones and skulls from corpses to drink from. Some are even said to eat the remains of half-burned people, earning them a mythic reputation as cannibals. This gruesome practice is part of their devotion to Shiva and demonstrates their belief that all opposites are illusory. By embracing filth and pollution, and breaking taboos, they aim to attain a higher state of consciousness.

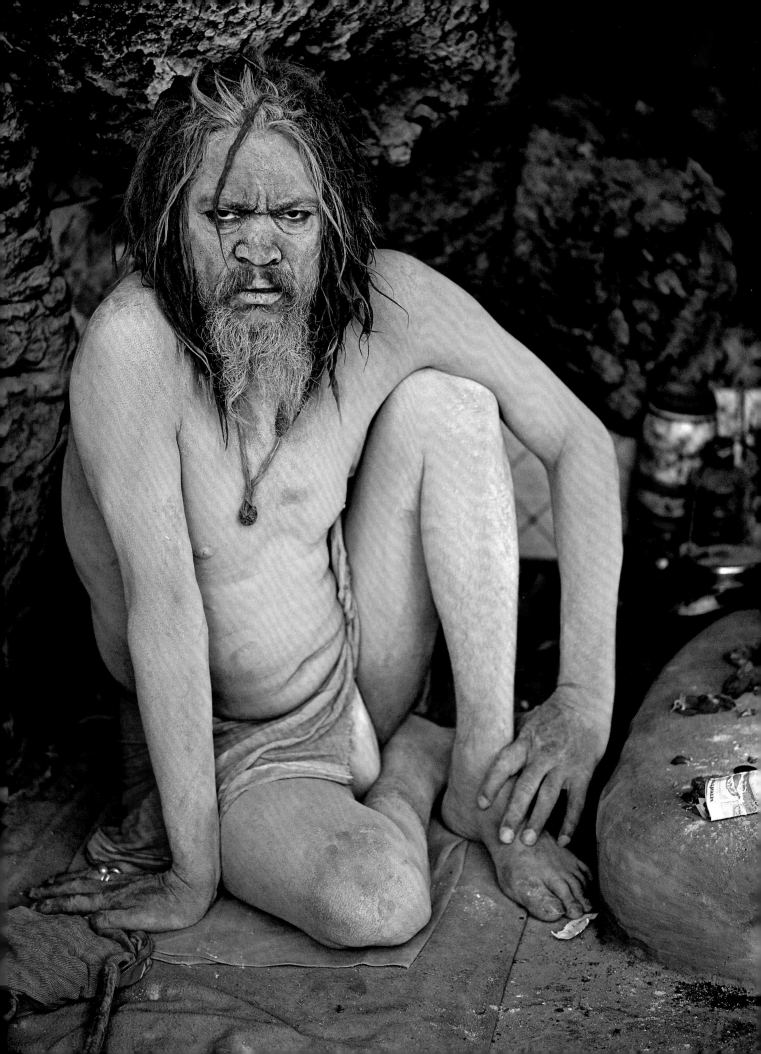

↑ The Garden of Eden, Iraq, 2017

Where the Tigris and Euphrates rivers converge, near the
Mesopotamian Marshes, lies the spot that Iraqis claim to
be the original site of the Garden of Eden. Today, it's a
tarmacked car park with concrete picnic tables surrounding
a large tree, which these friendly policemen told me was on
the exact spot where Adam, the first human, was tempted
by Eve's apple. It's normal for men in many Middle Eastern
countries to hold hands and is a gesture of friendship rather
than sexuality.

↑ Street Cleaner, Saudi Arabia, 2018
I met this man, a migrant from Nepal, as he was cleaning the road outside a petrol station near the northern Saudi town of Tabuk. Saudi Arabia employs thousands of workers, mainly from the Indian subcontinent, to do menial jobs in construction, maintenance and cleaning. He told me that he had had his passport confiscated and was not allowed to leave the country until his contract expired, which would be at least a year. Still, he said that this work paid better than anything he could get in his home country, and he was prepared to make the sacrifice so that he could send money home to his wife and family.

'As long as people retain a sense of wonder, there will always be mysteries left to explore.'

Poacher, Uganda, 2014
This man freely admitted that he would go out to poach bushmeat from the forests near his village on the banks of Lake Victoria. Here, he holds the head of a small buck, which he had shot the day before. He said he needed the meat, and was prepared to risk jail in order to feed his children. Poaching is responsible for the massive decline of indigenous wildlife across the African continent. The root cause, it seems, is the rapid human population explosion, which means more people are encroaching on wild land and hunting or poaching there to feed their families. In Uganda, women have an average of five children each, so it's no wonder that the animals are disappearing.

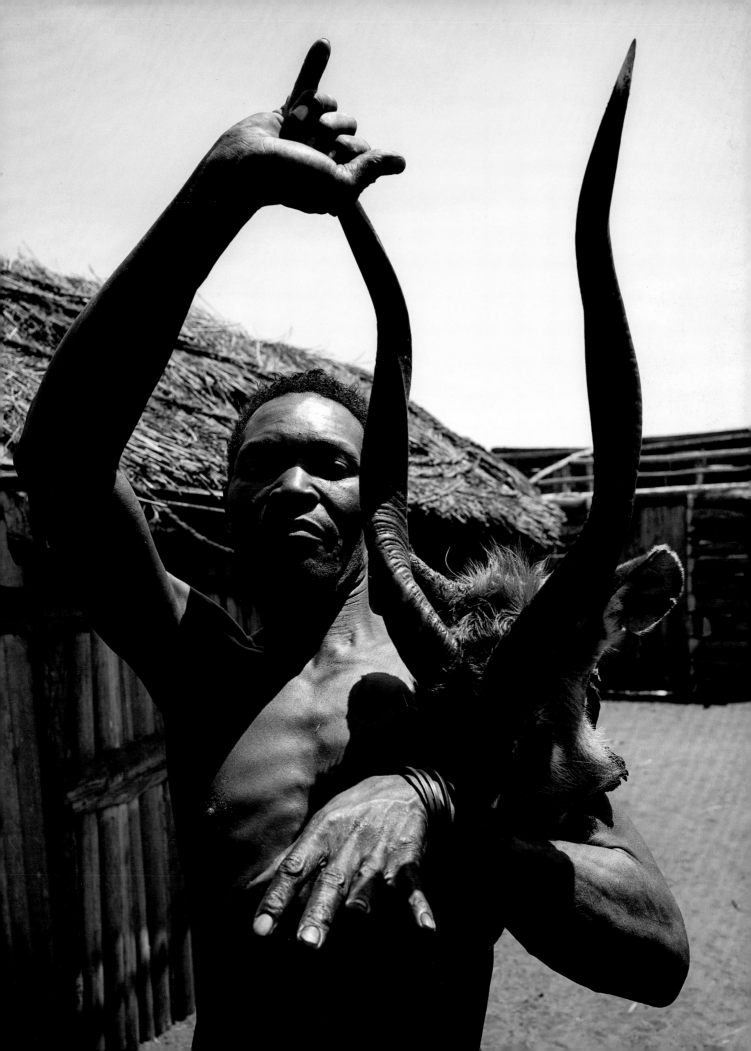

Fishermen on Lake Kyoga, Uganda, 2014
Like poaching, illegal fishing has decimated
fish stock across African lakes. I photographed
these locals inside the Lake Kyoga protected
area as they paddled away to avoid detection.
I was accompanying a patrol of Ugandan
Wildlife Authority officers. Needless to say,
without an engine, these poachers didn't get
far. The rangers caught them, destroyed their
boat and arrested the men.

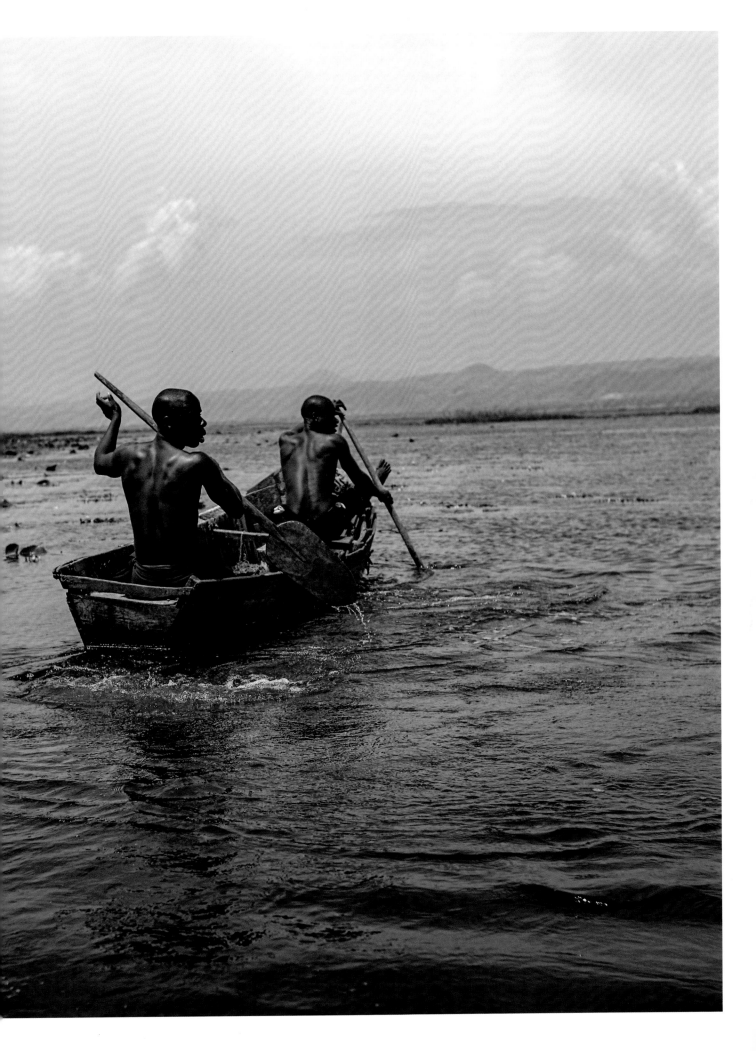

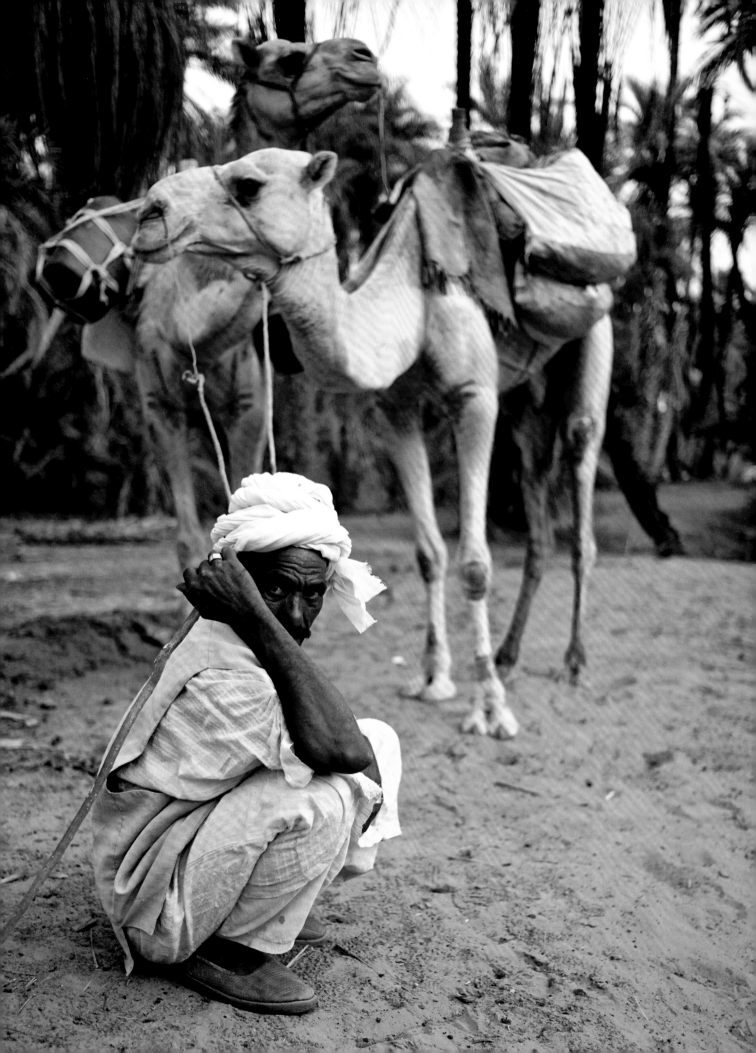

← Ahmed, Sudan, 2014

I spent two months with Ahmed and Ahmad, Bedouin nomads who served as my camel drivers while I walked the Nile. I caught this image of Ahmed as he was in the midst of a strop because I wanted to walk close to the river. He, being a Bedouin, preferred the open desert and disliked being near vegetation, saying there were too many mosquitoes. The reality was that, as we walked along the river – the only inhabited part of the country – the Sudanese hospitality was so overwhelming that, in every village, we were invited in for free food and accommodation. This slowed us down considerably. Ahmed wanted to get the expedition over and done with so that he could go home and see his family. We ended up compromising and alternating between river days and desert days.

'Photography trains the eye. It gets you seeing, thinking and framing the world in a different way.'

↘ Weighing In, Democratic Republic of the Congo, 2019

I visited a UNICEF-sponsored vaccination clinic on the outskirts of Goma in North Kivu province in this impoverished country. DRC has seen a terrifying cholera epidemic in recent years as well as the more well-publicized Ebola outbreak. Education and outreach programmes have meant that more and more families are now able to bring their children to be immunized against and treated for diseases.

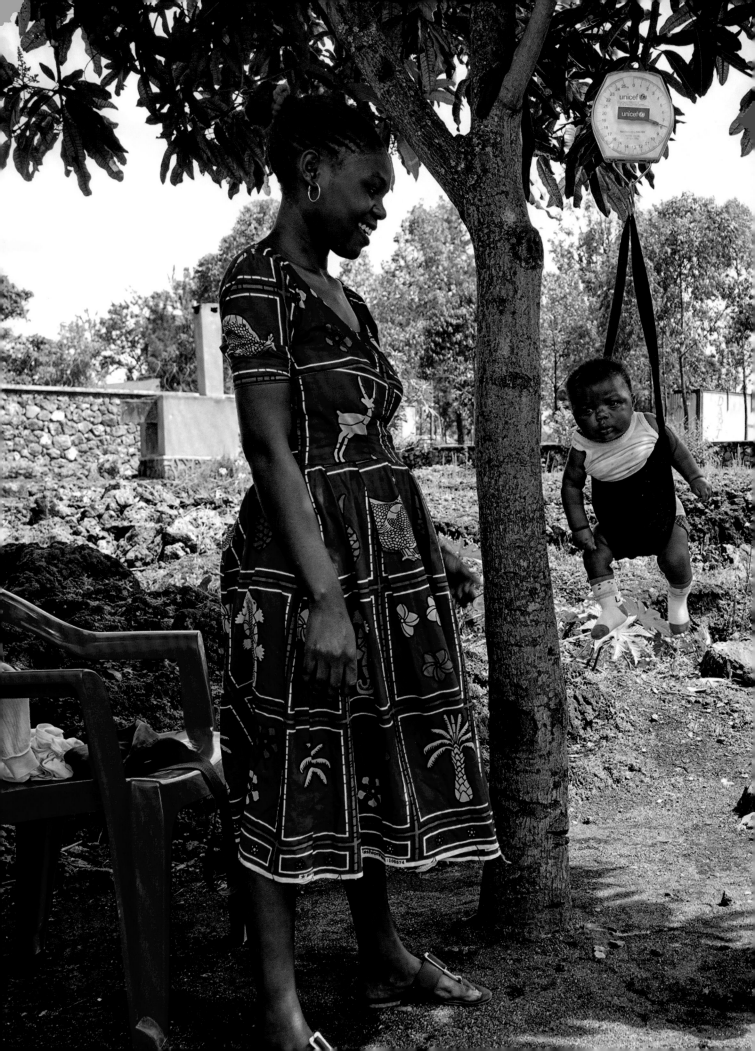

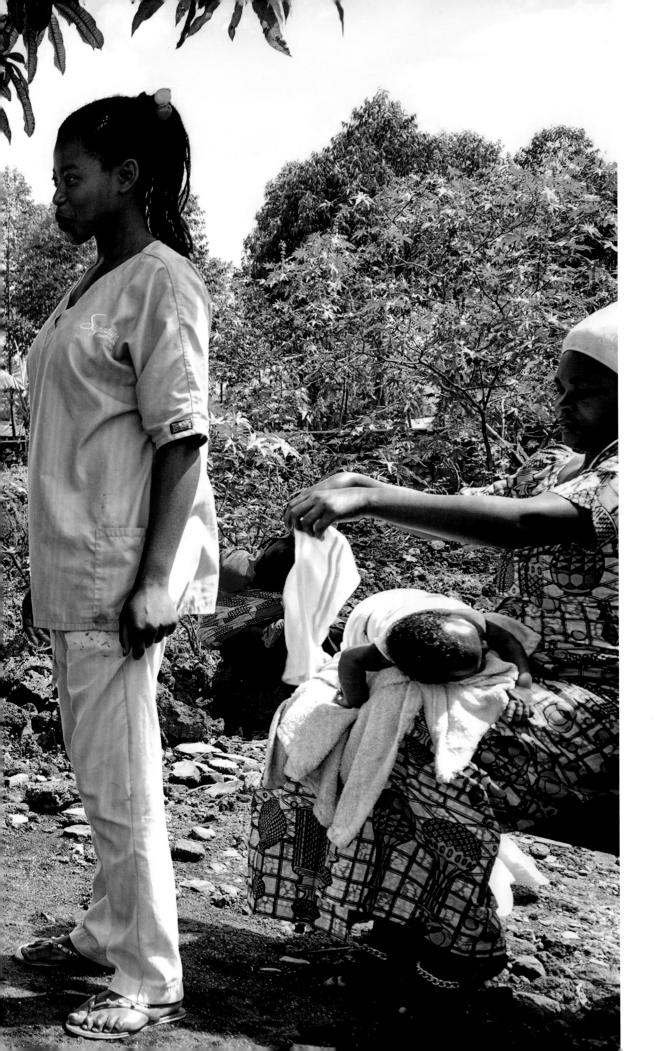

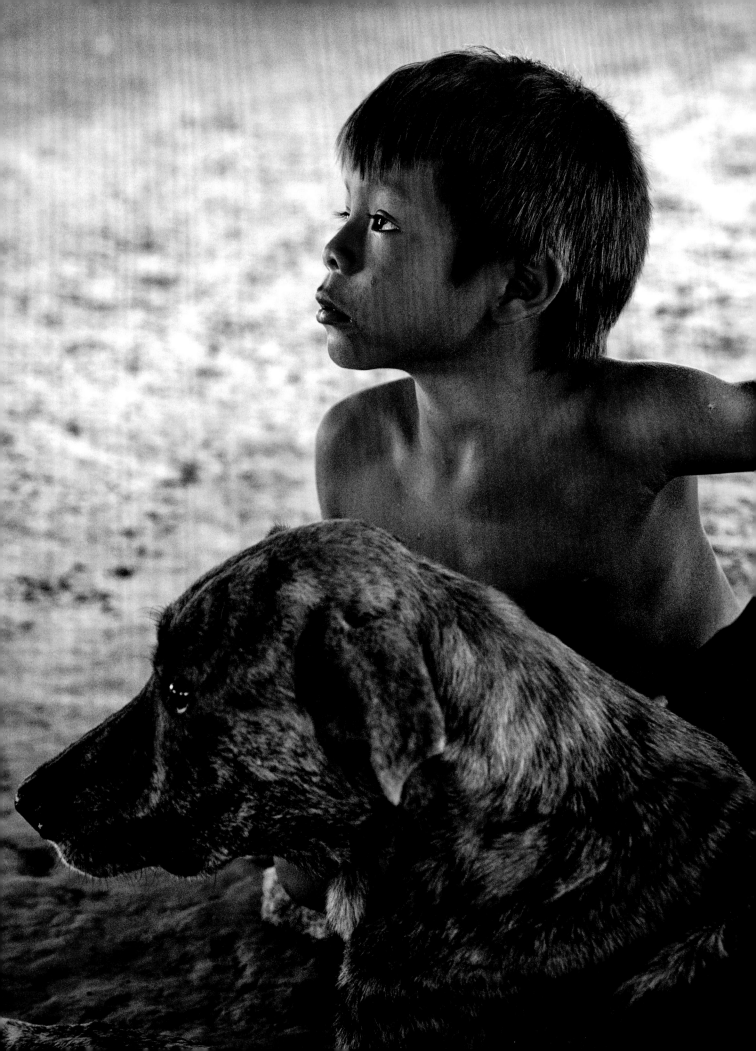

← Tatuyo Boy and Dog, Brazil, 2019

The Tatuyo communities that live on the banks of the Rio Negro in the Amazon rainforest have a deep affinity with their pets. This young boy was never far from his dog, who seemed to tolerate the rough-and-tumble play of his four-year-old companion. I spent a week photographing the people of this remarkable jungle community, who spend their time collecting açai berries, fishing for piranha and making handicrafts to sell at the local markets. They speak their own indigenous language, although in recent years the Brazilian government has made it compulsory for the children to go to school and learn Portuguese.

↓ Mennonites, Belize, 2016

I stayed with this family as I passed through the town of Spanish Lookout, a unique agricultural collective set in a vast clearing in the Belizean rainforest. The Mennonites came to Belize in the 1950s and '60s after centuries of forced movement. They originally came from what is now the Netherlands in the 1500s, but they were persecuted and settled in Russia, where they became their own ethno-religious group. In the years after 1873, thousands of them left Europe for the New World and settled in Canada, the USA and Mexico. They are known for their conservatism and rejection of modernity. This family, however, had a more progressive outlook and didn't wear the overalls and bonnets of the more traditional communities, who refuse to use motorized transport and really do not like being photographed. These Mennonites make a living through agriculture, trading melons and milk.

Stuck in the Past, Georgia, 2017
A Georgian man reminisces
about the 'good old' Soviet days
over a bottle of homemade
'*chacha*' vodka. Living in the
old manganese-mining town of
Chiatura, he lamented the fall of
the Soviet Union. He said that
at least in those days the mine
was open and there were jobs.
Nowadays, he just sat around
with his friends, also unemployed,
drinking this strong alcoholic brew.

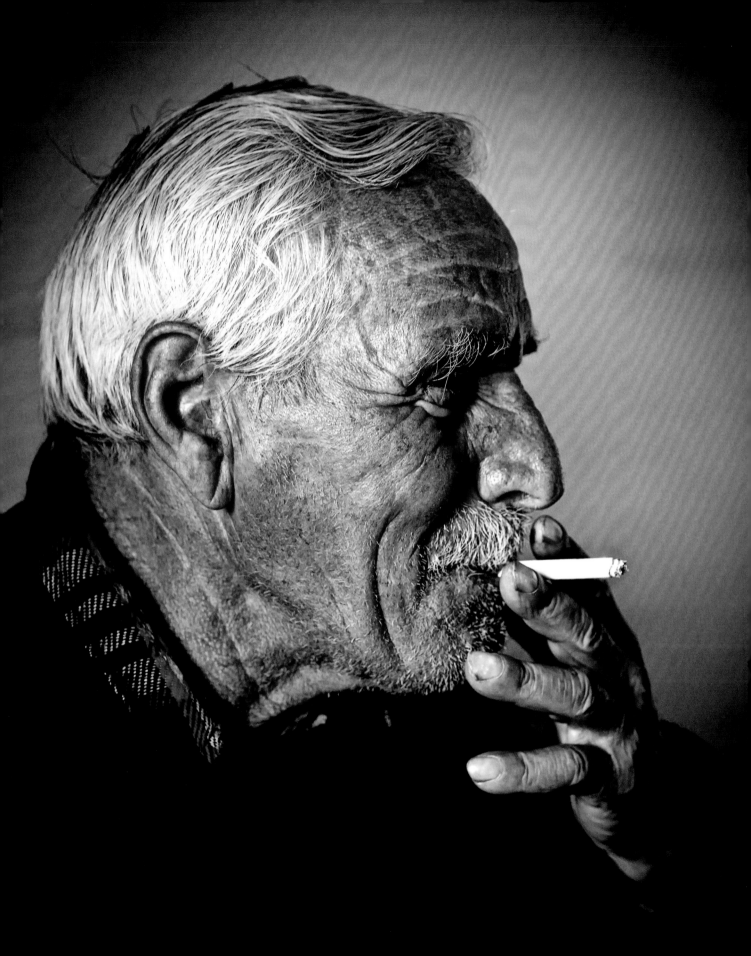

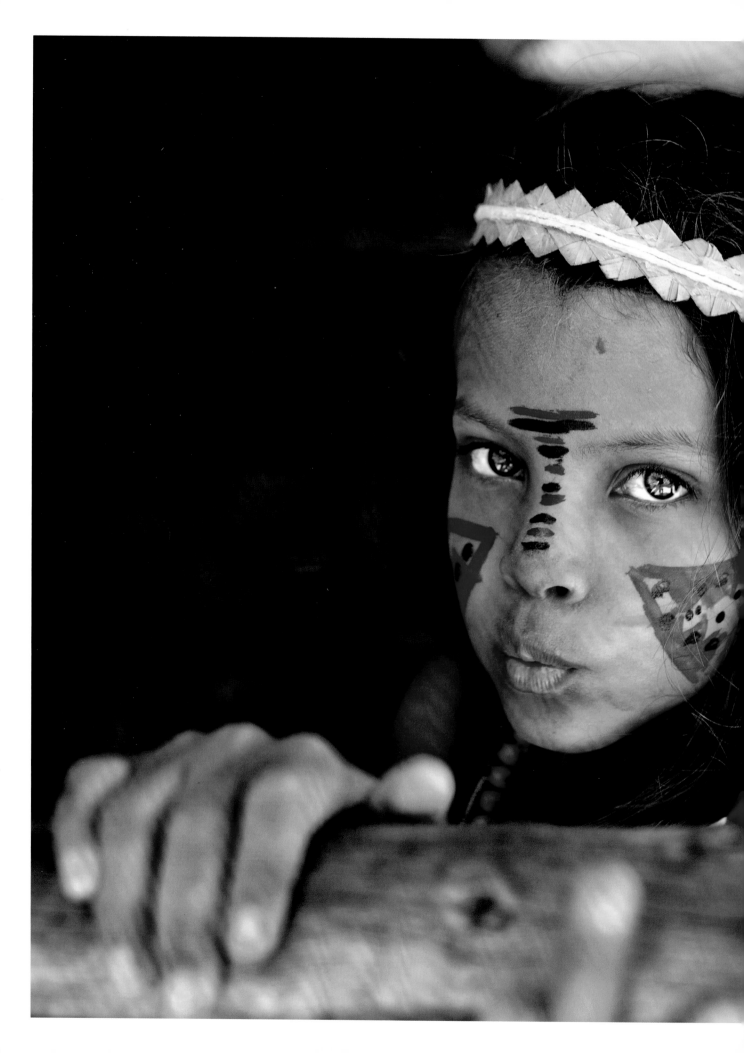

'I would like to believe that good photography can be a pathway to empathy and understanding, shedding light on the incredible possibility and potential of humanity.'

← **Elouisa, Brazil, 2019**

I met this young girl in a small village on the banks of the Rio Negro, a tributary of the Amazon River near to Manaus. She spoke a few words of English that she had picked up from school, although many of her family only spoke the tribal Dessana language. When I photographed her, her striking eyes stood out to me: she looked different to the other children. Her mother explained that, somewhere in her family history, the indigenous blood had been mixed with what she called 'the white man'. Brazil is one of the most ethnically varied countries in the world, with a huge European influence. In the 20th century, vast numbers of Germans, Italians and Eastern Europeans settled across South America and married into indigenous communities. Elouisa was a beautiful reminder that, wherever you go in the world, we are all related and we are all human.

This book is the result of fifteen years' work, and so thanking all those who have joined me on my photographic journey would be impossible. That said, there are certain people along the way who have inspired, motivated and pushed me to keep taking photographs, and it is to them that I am eternally grateful.

I must firstly thank Alberto Cáceres. Were it not for his generosity and mentorship, I wouldn't have been able to get to this point. I am indebted to Jason Heward, and all the team at Leica Cameras in the UK. I'm very proud to call myself a Leica ambassador, and I appreciate the many years of support they have given me (despite the several cameras I've somehow killed along the way). Thanks to Don McCullin, too, for the lifelong inspiration.

My utmost appreciation as well goes to all those who have accompanied me on my photographic journeys along the way: Dave Luke, Neil Bonner, Simon Buxton, Ash Bhardwaj, Will Charlton, Chris Mahoney, Ceci Alonzo, Johnny Fenn, Mark Brightwell, Kurt Seitz, Tom McShane, Kate Page, Tom Bodkin, my brother Pete and my parents.

I am indebted to all those who helped with the research and editorial process of the book: Alex Eslick, Kate Harrison and Charlotte Tottenham.

As ever, I owe the book to my fabulous agent Jo Cantello, as well as all the team at Ilex and Octopus Books; especially Alison Starling, Ben Gardiner, Rachel Silverlight, Frank Gallaugher and Peter Hunt for their amazing support and patience in getting this book out there and in believing in me as a photographer.

Finally, my gratitude to all the people around the world who let me into their homes and their lives so that I could photograph them and share their story.

An Hachette UK Company
www.hachette.co.uk

First published in the UK in 2020 by ILEX, an imprint of Octopus Publishing Group Limited
Carmelite House
50 Victoria Embankment
London, EC4Y 0DZ
www.octopusbooks.co.uk
www.octopusbooksusa.com

Distributed in the US by Hachette Book Group
1290 Avenue of the Americas, 4th & 5th Floors
New York, NY 10104

Distributed in Canada by Canadian Manda Group
664 Annette St, Toronto, Ontario,
Canada M6S2C8

Publisher: Alison Starling
Commissioner: Frank Gallaugher
Managing Editor: Rachel Silverlight
Art Director: Ben Gardiner
Senior Production Manager: Peter Hunt

ISBN 978-1-78157-757-8

A CIP catalogue record for this book is available from the British Library

Printed and bound in China

10 9 8 7 6 5 4 3 2 1